27—

Japanese Prints
300 YEARS OF ALBUMS AND BOOKS

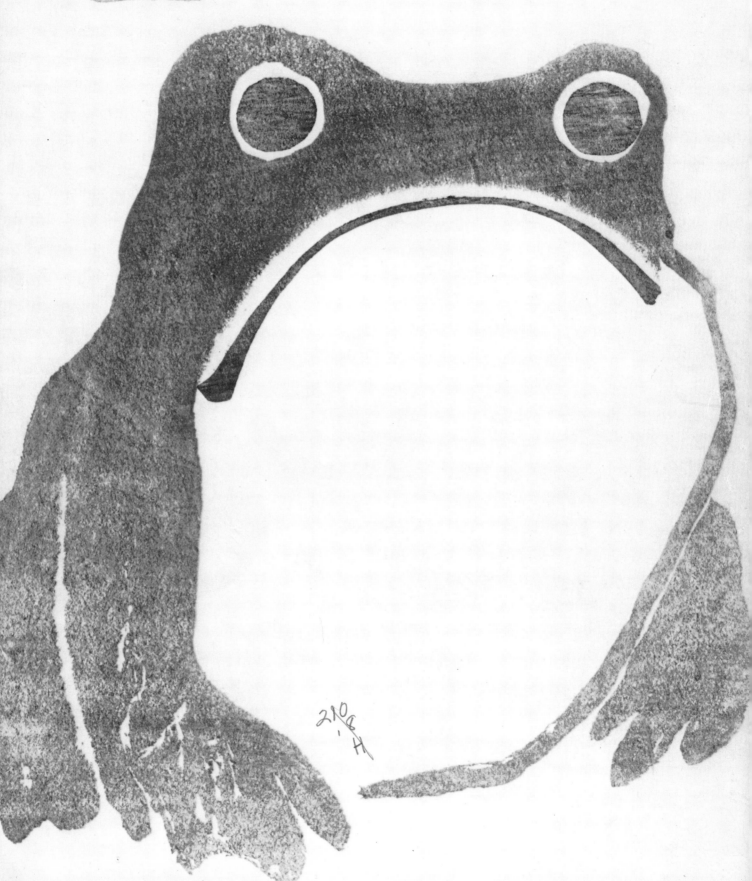

Japanese Prints

300 YEARS OF ALBUMS AND BOOKS

JACK HILLIER
AND LAWRENCE SMITH

Published for the Trustees of the British Museum by British Museum Publications Limited

NE1321.8
H55

Published by British
Museum Publications Ltd.
6 Bedford Square, London,
WC1B 3RA

Designed by Roger Davies

Set in Photina and printed
in Great Britain by Balding
and Mansell, London and
Wisbech

Jacket and cover: 'Women at
the New Year' by Shumman
(1757–1820) from *Ehon
Uta Yomidori*, 1795

British Library Cataloguing in
Publication Data

Hillier, Jack
 Japanese prints.
 1. Prints, Japanese –
Catalogs
 2. Illustration of books –
Japan – Catalogs
 3. British Museum –
Catalogs
 I. Title II. Smith, Lawrence
 769'.952 NE771

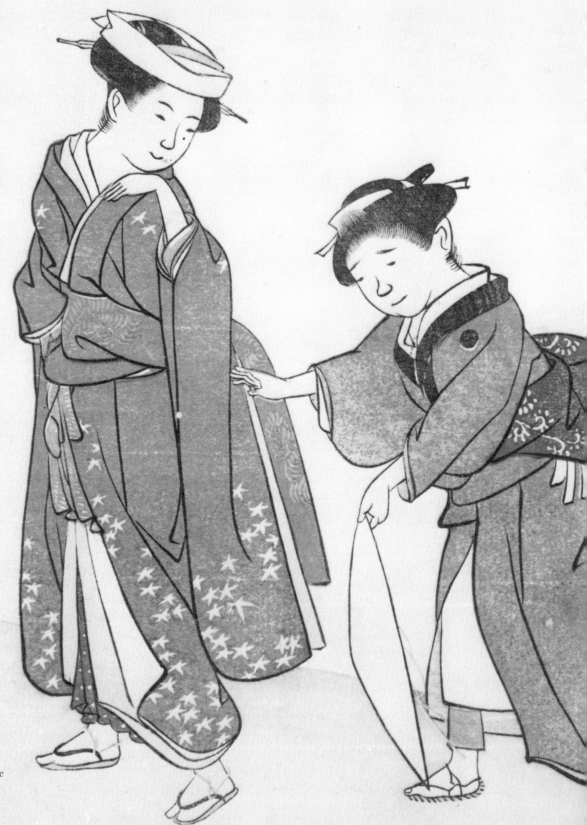

Contents

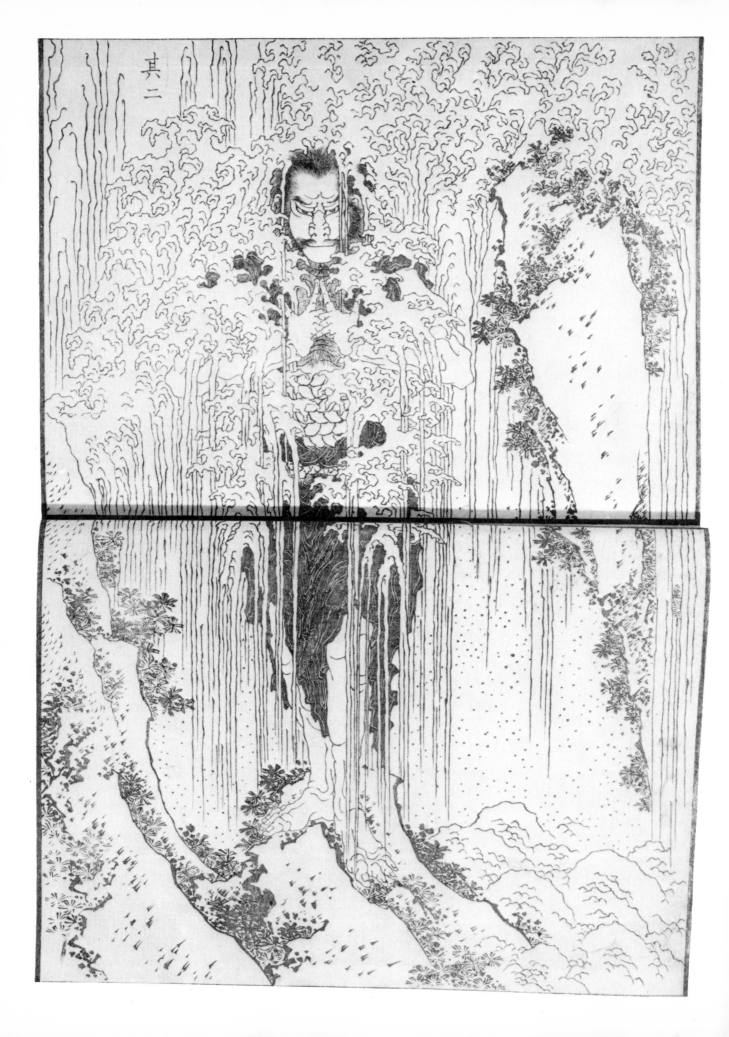

Preface

The acquisition in 1979 of Mr Hillier's great collection of Japanese illustrated albums and books was one of the major additions to the British Museum's collection of Japanese two-dimensional art. It was comparable in importance to the acquisition of William Anderson's paintings in 1881, Arthur Morrison's prints in 1906, and his paintings in 1913. This great collection of nearly 600 items was made by Mr Hillier over a period of almost thirty years, at a time when he was one of the few people fully aware of the artistic significance of printed albums and books. He was thus able to collect material in first-class impressions and in very good condition. Added to the albums and books already held by the Museum, they now form one of the very best and most comprehensive collections outside Japan.

It seemed right to celebrate the acquisition by a publication in which the finest items from the Collection could be used to illustrate the importance of albums and books in Japanese art. We have therefore chosen 150 representative items for which full bibliographical details are given and all of which have one page or opening illustrated in colour or black and white; the Introduction places them in their art-historical context. These 150 items also form the contents of a major exhibition at the British Museum.

The selection and the Catalogue are the work of Mr Hillier who has given unfailingly of his time, knowledge and energy, and has always been a model of courtesy and helpfulness. The Introduction is by myself. However, this is a collaborative book, and we have commented on and amended each other's contributions. In addition to Mr Hillier's work, a great deal of help has been given by Elisabeth Burdon, of the Department of Oriental Antiquities, who has been responsible for the 'good housekeeping' of the Collection since it arrived in the British Museum. The photography was taken by the British Museum Photographic Service. We also wish to thank Mr Kenneth Gardner and Mrs Yu-ying Brown, of the Department of Oriental Manuscripts and Printed Books in the British Library, who provided much scholarly information, and Sheila Nightingale who typed the Introduction.

LAWRENCE SMITH
Keeper of Oriental Antiquities
June 1980

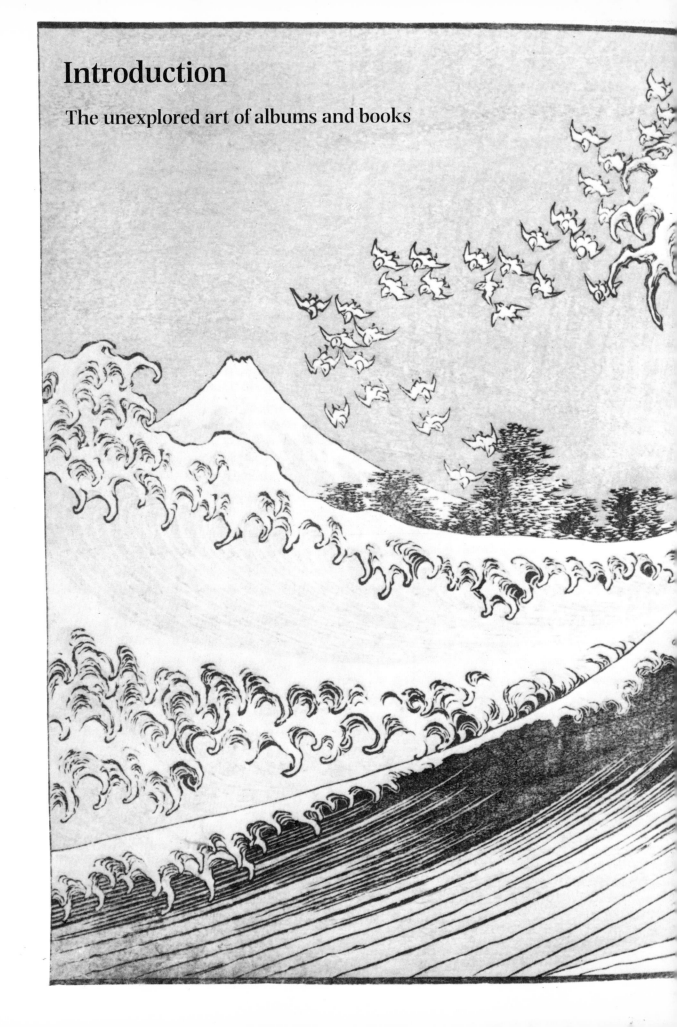

Introduction

The unexplored art of albums and books

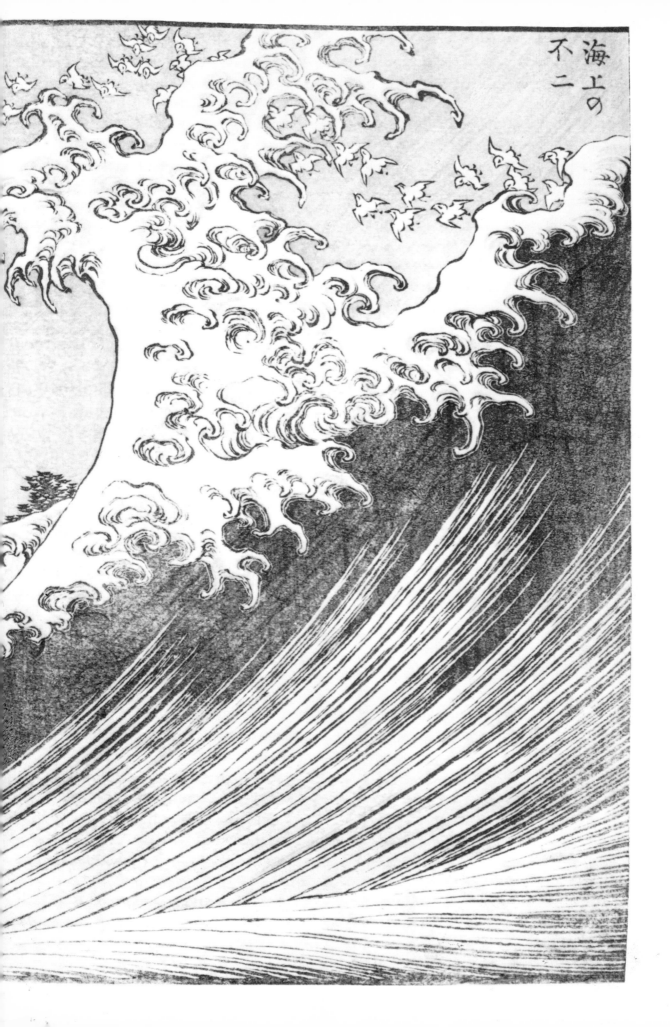
海上の不二

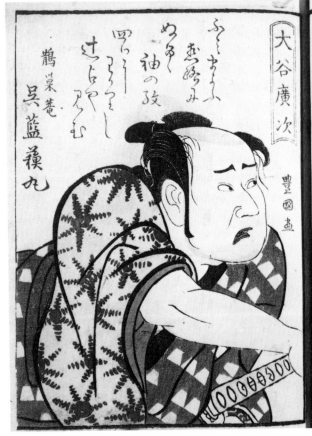

(*Note*: Throughout this book Japanese personal names are given in two ways, as has become customary. Up to the end of the Meiji period (1868–1911) they are written in traditional style with the family name first, for example, Kitagawa Utamaro; after 1911 they are written in the Western manner, for example, Kōshirō Onchi.)

A TRADITIONAL Japanese book (*hon*) or album (*chō*), even without illustrations, was at its best a work of art in itself. The paper, the cutting and printing of the woodblocks, the dyeing and decoration of the cover were all of the highest standards of Japanese as well as world craftsmanship. Such books were both tasteful and unpretentious in a way which was almost unique to Japanese culture.

Even more Japanese was the co-operative nature of book production, which made the books themselves representative of a finely integrated culture. The publisher was dependent not only on authors but also on a large number of different suppliers and craftsmen, who in turn were dependent on him and his colleagues for the work he provided; at the same time all depended on the wealth, leisure and discrimination of the very literate Japanese public, especially in the cities, and the goodwill or at least the tolerance of governments, which until 1867 felt able to interfere in every detail of life to suit their policies.

When illustration began to form an important part of many books during the seventeenth century, it is not surprising that they gradually became the vehicles of a form of graphic art which at its best reflected the high aesthetic values of traditional Japanese culture. It is certain that illustrated books were seen by more people than ever saw the better-known sheet prints, and that they more accurately recorded the peaks, the troughs and the average levels of taste and achievement. In this book we try to show many of the peaks and to demonstrate what and how good the average was at various periods; but we only hint at the lower levels of publishing standards, for this account is of Japanese book illustration since the beginning of the seventeenth century regarded as art. Art, in societies which have a word for and a concept of it, implies a movement towards standards of excellence. Japan had both the concept and the achievement, and the books and albums reproduced and discussed here are chosen to demonstrate this excellence.

To explain to Westerners without some knowledge of Japanese history, language, material culture and art the significance of book illustration is a complex task. One cannot understand the books or the work of their artists without basic information on the materials available, the publishers, their public and their tastes, the history of printing itself, the types of Japanese literature, the peculiar circumstances of the Isolation (when for over two centuries (1640–1853) almost all foreigners were banned and no travel abroad was allowed), the effects of the system of writing, the background of Far Eastern painting, or the nature of the landscape, to mention only some of the most important factors. To relate these various aspects to the books reproduced this introduction is divided into a number of topics, all of which mention specific books. Bibliographical details of all the books reproduced can be found in the Catalogue. Since the physical presence of a book consists very largely of paper, the first topic discussed is the great Japanese craft of paper-making which is only now beginning to be fully investigated by scholars in the West.

87 Ike no Taiga (1723–76) and Ifukyū. Lakeside village; from *Ifukyū Ike no Taiga Sansui Gafu*, 1803, vol. 2.

93 *Left* Utagawa Toyokuni (1769–1825). The actor Ōtani Hirotsugi. *Right* Utagawa Kunimasa (1773–1810). The actor Ichikawa Omezō; from (*Nigao Ehon*) *Yakusha Gakuya Tsū*, preface dated 1799.

The Japanese paper industry and its relationship with publishing

Most of the books catalogued and illustrated were produced in the Edo period (1603–1867), and it is clear that the great outburst of publishing, print-making and production of stationery of all sorts which took place over that period provided a very large market indeed for the paper-making industry. The average number of titles published per year over that period, including reprints, cannot have been less than 1,500 and was probably more. These figures are based on the great Japanese bibliography *Kokusho Sōmokuroku* (Tokyo, 1970–7). Assuming, very moderately, an average edition of 200, and even more moderately twenty double sheets per title, then we have 6,000,000 sheets per year. In fact, the figure must have been considerably greater, especially from the Genroku period (1688–1703) onwards when literacy and literature began to flourish extraordinarily. This does not take into account the special decorated and dyed papers used in the covers of books or in their title slips.

It is true that the double sheets were not very big. An average novel, like *Nihon Etai-gura* (no. 16), had sheets measuring about 260 × 360 mm when opened out; but the biggest sheets regularly produced by traditional methods can hardly have been more than about one square metre (see p. 13), and current practice in Japanese paper-making villages is to produce sheets individually very much according to function. It is therefore likely that publishers, being major customers, would have been able to order their paper to approximate size specification. A glance at the dimensions in the Catalogue will show a wide uniformity of ordinary format books, which must have been influenced by the customers' expectations and convenience of storage, the sizes to which usable woodblocks could be cut, and the gradually established practice of the paper-makers.

A study of the sheets as they actually appear in books reveals that they were nearly always trimmed on all four sides, and that the characteristic 'flaring' edge of fibres which occurs naturally when the paper comes off the tray is absent. It is therefore difficult to calculate how large they were when they arrived from the makers. Further trimming would usually have been necessary at the sewing-up stage (see p. 15) to ensure a neat final appearance.

Book publishing would have accounted for only a fairly small part of paper production. Fine papers were used in great quantities for the sliding doors of houses (*shōji*), for painting and calligraphy (the latter very much practised by amateurs), the writing of letters, the wrapping of parcels, and the production of sheet prints in increasing numbers as the eighteenth century progressed. These were all important aspects of ordinary town life in the Edo period in Japan.

What is so astonishing about the quantities of fine paper used is the great amount of labour needed to produce it; for no concessions at all seem to have been made to the obvious temptation to reduce quality. Native accounts of how paper was made (for example, in Kunisaki Jihei's *Kamisuki Chōhōki*, Osaka, 1798) correspond almost exactly with modern methods in traditional paper-making villages, and it is clear that in terms of numbers of workers this was one of the most important industries of the period after

agriculture. It was also very important as a cash industry, which like publishing itself was a way out of the hopeless life of a subsistence feudal agricultural system. Publishing offered to many people their only hope of a better life under a government not at all sympathetic to the concept of personal happiness. It was therefore more than simply a means of instruction or entertainment; it was typical of major social trends during the Edo period.

The qualities of Japanese hand-made paper

The paper used in the majority of books (though not usually in albums) was the ordinary *kōzō* (mulberry) paper. In the Edo period it was made in many places and wherever the essential ingredients were present. These were pure, fresh, fast-running mountain water, soil capable of growing the paper mulberry and the *tororo-aoi* plant, cold winters, and an abundance of skilled labour prepared to work hard in lonely and physically demanding circumstances.

The mulberries were grown on the spot, and the young stems were cut in the winter each year before they had grown too big and coarse. This annual harvesting encouraged growth in the next season. Next the stems were tied in bundles and left for a long period in a running stream to loosen the bark. In some places steaming or other methods were used. The bark was then stripped off and the dark brown outer skin removed as far as possible. The stripping was often done by women who trampled the stems in the freezing water and then sat in bitterly cold conditions laboriously picking off the dark outer skin. The white inner bark was then boiled in vats to break it down, washed and steam-bleached, and the impurities and remains of outer bark most painstakingly picked out. After this process, for which there is still no short cut, the material had to be beaten into individual fibres. There were mechanical methods available, such as water-wheels, but more often men using wooden beaters performed this back-breaking work, which had to be done with extreme care so as not to destroy the long, silky fibres that gave the paper its special strength.

Next the pulp was washed and placed in a large bath. To it was added the mucilage, prepared with similar care from the *tororo-aoi* plant, the vital ingredient which spread the fibres evenly in the solution and allowed them to knit firmly into a strong paper. The solution was then ready to be 'trayed', the most skilful operation of all and nearly always done by women. A thin layer of solution was lifted out of the bath in a tray. In it was a finely made rattan mat consisting of very narrow bamboo slats running horizontally and joined by slightly thicker vertical slats. The mat trapped the fibres and allowed the water to run away. The mat lines, both horizontal and vertical, are clearly visible in the paper of the books. The wet sheet was then removed and added to a pile of those already trayed. Finally the sheets were dried, preferably in the sun since it gave them a crisp surface.

The end result was a semi-transparent paper of a slightly off-white colour and with a very pronounced and visible watermark (though this was simply the impression of the mat and no form of identification of the maker). It had no impurities and therefore faded only very slowly indeed in book form; it was absorbent but firm; it was very strong, the fibres being very long and

closely knit together in all directions, and did not tear easily; it had a soft, living texture, almost like a fabric; and it was light in weight.

The influence of the paper on books

Given paper of this sort, then the format of the Japanese book becomes understandable. First, it was thin and semi-transparent, so the printing showed through so strongly on the other side that only one side could be used. Thicker paper was expensive and unsuitable because it needed more printing pressure and wore out the woodblocks much more quickly; so the obvious solution was to fold each sheet in half, place the *folded* edge to the outside, and sew all the unfolded edges at the centre. The effect was rather like an old European book with uncut pages. This type of format was called *fukuro-tōji* ('bag binding'). It had existed in Japan since the Kamakura period (1185–1333) and had derived, like most printing ideas, from China where similar hand-made paper had long existed. It had not become common, though, until the seventeenth-century Japanese publishing explosion, when its advantages, as described below, gradually led publishers to prefer it to any other and to use it for all ordinary books.

This system effectively doubled the thickness of paper through which the printed matter showed and so diminished the 'shadow' of the design on the verso. Nevertheless, strong printing sometimes showed through strongly, and this can be particularly disturbing when illustrations rely on the typical Japanese device of using blank spaces. *Koya Bunkō* (no. 78) is a striking example. Occasionally collectors and owners inserted sheets between the double pages to reduce such visual interference, and this was done before taking the photographs for the reproductions in this book.

The Japanese, however, seem to have preferred on the whole not to interleave. One reason may have been aesthetic. A prominent feature of Japanese art and culture is a frank and willing acceptance of the limitations of materials. In calligraphy a good example is their delight in the successive darkening and lightening of the ink as the brush is loaded and used, whereas the Chinese admire much more an even, black tone. It is certainly true that in *Koya Bunkō* one is led on to the next page before reaching it by its ghostly image showing through, and this may have been the publisher's intention.

The stronger reason, however, was probably practical. Interleaving would have seriously thickened the book, and it would not have then lain flat when opened. Furthermore, it has been shown by paper conservationists that any interleaved sheet, however carefully shaped, chosen and inserted, will if left in place eventually cause a slit along the folded edge. Now this folded edge could have been slit in the first place by the publishers and would not have reduced the desired effect of double thickness. It was left uncut because the system of folded sheets in fact gave stability to the book. If resewing had to take place, which it often did, then there was only half the number of sheets to align. More importantly, the fold provided a support to the paper each side of it, so that it buckled or creased much less easily than a single sheet. In addition, the very fibrous papers tended to cling together in a way that made turning single sheets very difficult. The greater weight of the double sheet helped to overcome this problem.

14 Attributed to Sugimura Jihei (*fl. c.* 1680–98). Page of fine calligraphy; from *E-iri Shin Onna Imagawa*, 1700.

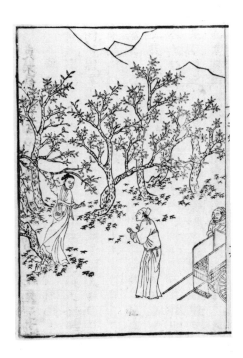

3 The Lady Lu Qiujie; from *Shinkoku Kō Retsujo Den*, 1653, vol. 5.

Thus paper played a major part in the development of this folded format which Westerners sometimes find so surprising; but it also influenced the style of binding, which consisted of no more than two limp covers, the whole sheaf being simply sewn together with thread, usually up the height of the book about 5 mm from its 'spine'. It was a simple but flexible threading system, often using as few as four needle holes through the sheaf of pages, and the suppleness and softness of the paper accommodated the 5 mm ridge thus formed. When a well-sewn book was laid open, the opened sheets would simply curve gently up and over from the ridge without creasing or cracking and without the two sides standing up in butterfly fashion. With the brittler paper of the West this would be impossible. Similarly, stiff covers would have prevented this flexibility, so none was used in Japanese books; besides, so tough, flexible and well integrated was the good-quality Japanese book that no hard cover was necessary to protect it. In a fine copy of a great book like *Kyōchūzan* (no. 123) the materials are so soft and compatible with each other that it is a pleasure simply to handle it.

Book format and graphic design

A book opening therefore had a central 'well' which can be very clearly seen in most of the illustrations, for example, *Suiseki Gafu Nihen* (no. 122; in colour p. 93). This was not a disadvantage found in the album format (*chō*), for example, *Rampō Jō*, no. 112, which had quite a different construction (see p. 29).

Nor was the 'well' a disadvantage in the simply textual book, which until the seventeenth century was normal in Japan, and indeed in China from where this form of book derived. One must not overlook the simple and important fact that the Chinese characters and the Japanese syllabaries, used separately or in combination for writing the Japanese language, were normally written downwards (see *E-iri Shin Onna Imagawa*, no. 14) and from right to left. A book or album therefore began from the right, and the eye naturally moved leftwards across an illustration. That is why the birds in *Suiseki Gafu Nihen* (no. 122) or the women in *Hyakunin Jorō Shinasadame* (no. 20) are moving leftwards. When there was only text, then the natural movement lay downwards, and there was no feeling of strain in crossing the central division. It was natural to the writing system for the reader to cross from the bottom of one page to the top of the next. By contrast, in a horizontal Western text there is always that slightly unnatural jump when crossing from one page to another.

The earliest illustrated books, copying the Chinese manner, ignored the disadvantage by restricting the picture to one side of the opening which resulted in a vertical format. *Shinkoku Kō Retsujo Den* (no. 3) is a typical early work actually copying a Ming Chinese original. The square frame round the picture is an old convention, also found round the pages of text, and seems to have its origins in the very early days of Buddhist printing in China when a frame was necessary as a reference scale to keep the vertical lines of text straight. This remained very useful to the cutters, and it must have been a good guide for aligning the sheets correctly when sewing up the book.

There is no apparent reason why a vertical panel should have been particularly restrictive to the artist, since it reflected in miniature the shape

of the painted area of a hanging scroll, for which there was a tradition of design in the Far East going back many centuries. *Hasshū Gafu* (no. 6) in fact reproduces in black outline a number of such paintings, each with a Chinese poem calligraphically written within a similar frame on the other side in the manner of a pair of complementary hanging scrolls. There is, however, nearly always a slightly constricted appearance about these printed sheets.

There are several main reasons for this. One is the sheer smallness of scale, which seems too tiny a reflection of what a great scroll should be. A very small print cannot reproduce the scale of a hanging scroll, of which the painted part might have a height ranging from 30 mm or less to 3 m or more in extreme cases. Nor can it catch the subtleties of the original brushwork when the scale is much reduced. Modern publishing practice has shown precisely the same effect with small reproductions of large paintings.

There is, perhaps, a more important reason for the style which emerged in Japanese books. Although, as already mentioned, the movement of the text is up and down, this is not true of a picture in a book opening. Where a hanging scroll is bound by its own limits and implies space on each side of it, which the quiet silk mountings are designed to emphasise, the single-sided illustration actually *has* space to one side of it, and the Japanese viewer may feel unconsciously dissatisfied if it has not been used.

There are, of course, exceptions to this general tendency, and we illustrate some of them. In a book of portraits, such as the series of the thirty-six most famous poets of Japan, much play could be made of a satisfying pairing of portraits which would set each other off across the opening of the book. No. 2, *Sanjū-rokkasen* (c. 1610), is an excellent early example, and one can see its origins in the painted hand-scrolls and albums which had previously been the main format for portraying the poets. In these albums (admittedly for aristocratic or rich patrons only) there was long experience of pairing the portraits effectively, and it was this tradition that was adopted in the printed books. In the eighteenth and nineteenth centuries it had a splendid late flowering in the great books of Kabuki actor portraits of Suifutei (no. 51), Toyokuni and Kunimasa (nos. 93–4). (The popular Kabuki drama was very widely patronised in the great cities, and the principal actors were among the great celebrities of their day.) *Suifutei Gigafu* (no. 51) makes very telling use of two characters of different temperament facing each other across the opened book, with an off-centre placing which is most effective. In none of these books does the frame round each sheet appear as any sort of barrier to the artist.

Nor was the frame a barrier in other portrait-books, such as those of the beautiful women of the great cities which had tremendous popularity with both women and men. Sukenobu's *Ehon Asakayama* of 1739 (no. 23) depicting the charms of the ladies of Kyoto is a good example, and so is Koryūsai's 1777 volume of studies of fashionable courtesans, *Azuma Nishiki Matsu-no-kurai* (no. 47). Sukenobu's book has a frame round each portrait, but Koryūsai has dispensed with frames altogether so that the book seems more like an album of sheet prints. Single prints of upright format did indeed derive from a desire to detach and separate the delightful illustrations of women first found in books, and as a consequence Koryūsai's work has, unfortunately, often been divided up. This is even more true of Masanobu's sumptuous *Yoshiwara Keisei Shin Bijin Awase Jihitsu Kagami* of 1784 (no.

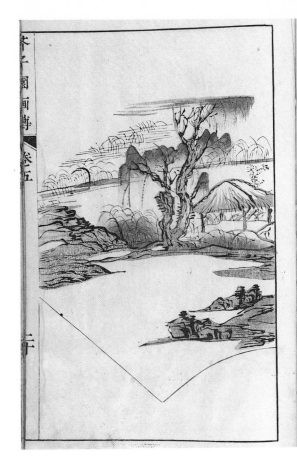
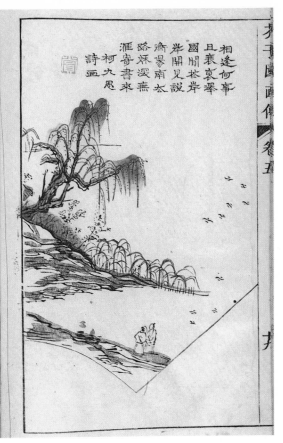

30 Chinese lakeside
landscape; from *Kaishien
Gaden*, 1753, vol. 5.

29 Magnolia; from
Kaishien Gaden, 1748,
vol. 4.

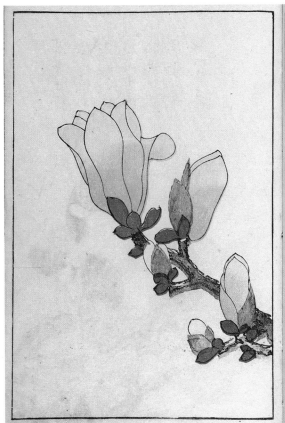
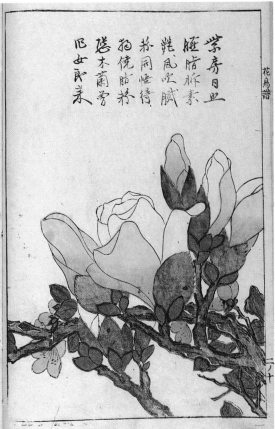

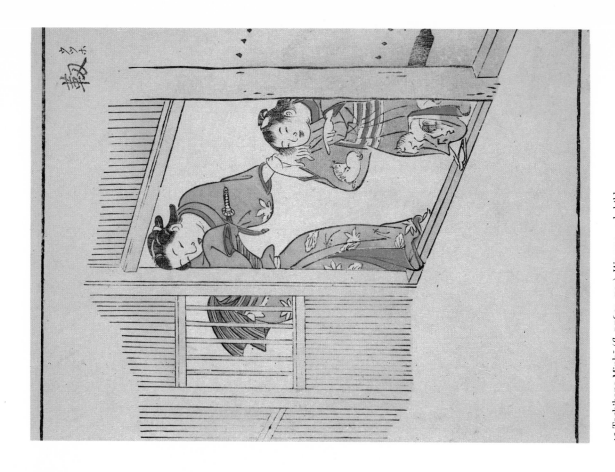

42 Tachibana Minkō (*fl.* 1760s–70s). Woman and child awaiting a quiver-salesman (detail): from *Saiga Shokunin Burui.* 1770, vol. I.

35 Katsuma Ryūsui (1711–96). Autumn landscape: from *Wakana.* 1756.

53), but this is a special case since it is in fact an album constructed out of separate sheet prints which were later issued individually.

The tradition of an illustration faced by a page of text derived from Chinese books, and it lingered on into the nineteenth century in novels where the pictures were merely illustrative and not meant to be deeply attractive in themselves. Artists soon began to see the advantage of the double-page picture (see below), but there was always an occasional successful return to the more limited early format. Among the most beautiful are the poetry books illustrated by Ryūsui – *Wakana* of 1756 (no. 35) and *Yama no Sachi* of 1765 (no. 36) – where the illustrations are so subtly suggestive of the sheets of poetry opposite them that they seem to draw strength from each other. The same effect was achieved as late as 1946 by Kōshirō Onchi in *Shinshō Fuji* (no. 150). In no. 64, *Ehon Miyako no Nishiki* (1787), the splendidly broad landscapes by Masayoshi also seem to be able to stand on their own in spite of having only half an opening each.

Crossing the central barrier

From the early seventeenth century until the late nineteenth century most Japanese books were produced in the sewn format (see p. 15). In spite of the difficulties of the central barrier provided by the 'well' and the printed frames on each side of the opened page, artists seem to have preferred to use this format once they had decided to take their illustrations across the whole of the opening instead of restricting them to one side. One might wonder why they did not insist on the album format (see p. 29) which gave an uninterrupted double sheet, as in Moronobu's *Tōkaidō Buken Ezu* (no. 10) which in 1690 is one of the earliest examples. But there were, in fact, economic and practical reasons against the widespread use of the album, and the publishers cannot have welcomed it except for *de luxe* productions.

A glance at the representative selection of books reproduced here will confirm that the standard *hon* much outnumbered the albums, and that the artists clearly accepted economic and practical necessities. It will also show that right up to the end of the nineteenth century the printed oblong frames were retained, even in books which were purely pictorial, like Sōkyū's witty and entertaining *Kishi Empu* (no. 90) published in 1803. Although, as we have explained, the frames were useful in aligning the sheets for printing and sewing up, these difficulties could have been overcome in other ways, which would no doubt have been used if pressure from individual artists of high repute to dispense with the frames had been strong. It clearly was not, and we must conclude that artists accepted and even welcomed the disadvantages of a central space and two straight black lines down the middle of each spread. This is proved by the very small proportion of books in sewn format which dispense with the printed frames. Sugimura Jihei's *Yamato Fūryū Ekagami* (no. 13) of 1684 is one example, though this may have been issued originally in hand-scroll form. It is equally significant that in this representative selection there is only one instance – no. 123, *Kyōchūzan* (1816) – where an attempt has been made to carry the design physically through the central well.

Anyone lucky enough to have looked through many Japanese picture-books will have been struck by the sheer success of artists of almost every

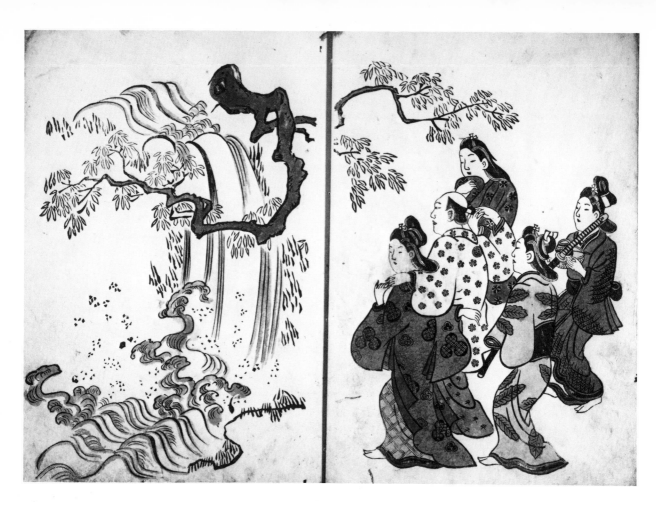

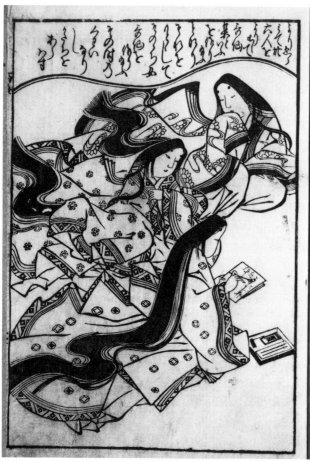

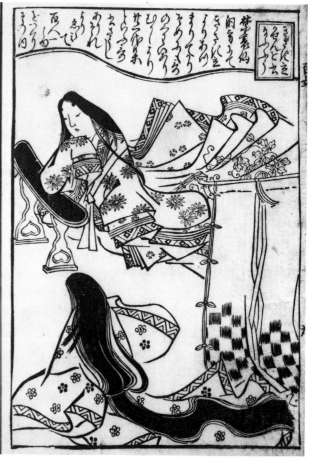

school in translating their various styles into designs which look perfectly right, natural and effective across the double page. The standard does not seem to fall in spite of the very different demands of landscape, figure subjects, urban views, animals, bird and flower subjects; or of the basically different effects of pure ink printing and colour printing.

It is illuminating to look hard at a selection of the best examples and to see how their success was achieved. One of the earliest and most effective is no. 8, Moronobu's loving and sensuous account of contemporary women, *Ukiyo Hyakunin Onna* (1681). The *Ukiyoe* School of popular urban art arose in the great cities in the seventeenth century to provide paintings for the new, rich townsmen whose interests were in the glitter of the passing fashionable scene. *Ukiyoe* was the first to break into graphic printing on a large scale, because the demand was simply too great among the fast-increasing city populations for individual painters, however low-grade, to supply. Printed picture-books therefore quickly became profitable to publish. It is significant that *Ukiyoe* artists were also the first to make it standard practice to expand across the central division into double-page illustrations, for there was indeed something expansive and optimistic about their whole school. Yet their methods did not evolve independently, and Moronobu had early in his career to look to the classic past of the *Yamatoe* style to find a way to construct his compositions. No. 8, a scene of rather modernised court ladies involved in the ever-fashionable pastime of composing poetry, is a rhapsody in black and white. Moronobu used the immensely long hair admired in aristocratic circles to form a glorious pattern of thick, sinuous black lines, none of which in fact crosses the centre of the page opening but all of which give the total composition strong and simple focuses and directions. His instinct was absolutely sound – this was one way to make the viewer forget the frames, to provide a design with the visual power to weaken the impact of those straight vertical lines.

Moronobu's instinct was also right in adopting a style which had been devised for long, narrative, painted hand-scrolls in which the illustrations alternated with sections of text. Such pictures had to be horizontal in movement, and there were well-tried methods for achieving this effect. One was to look down on interior scenes from a very high point of view, as if the roofs of the houses were transparent. The one-storey Japanese house spread naturally in a horizontal movement, and the high viewpoint enabled it to be used artistically. The fact that people sat or reclined on the floor added to the sideways movement, and Moronobu made great use of it. The great hanks of women's hair also spread sideways, and the artist took every advantage of their emotional and visual impact.

The brilliant use of black and white was inspired by the *hakubyōga* ('white drawings') painting style first developed in the fourteenth century. This was a method of using very lustrous black ink and no colours at all in miniature paintings for scrolls or albums. In these the ink was used for solid areas as well as outline, and it is no accident that most extant *hakubyōga* include court ladies with magnificent black hair. Moronobu turned to this tradition as a way of increasing the impact of a black and white print, for he was a pioneer in the field. Fifty years later the *Ukiyoe* artist Sukenobu, working in a now thoroughly mature and confident tradition of urban art, was able to use much larger human figures to dominate his book

13 Sugimura Jihei (*fl. c.* 1680–98). Townsman viewing waterfall, supported by entertainers; from *Yamato Fūryū Ekagami*, 1684.

8 Hishikawa Moronobu (*c.* 1618–94). Court ladies watching the composing of a poem; from *Ukiyo Hyakunin Onna*, 1681.

illustrations. The delightful view of maidservants on an outing from his 1723 critique of female beauty *Hyakunin Jorō Shinasadame* (no. 20) breathes confidence – in his design, in his technique, in his delightful patterns of contrasting *kimono*, and in his awareness that this is what his public wanted. These young women eliminate the central frame by walking across it with such purpose. The figures are large in relation to the page, symbolic of the increasing importance of human values in an urban middle-class society.

Moronobu himself had begun this process earlier in, for example, his *(Shimpan) Bijin Ezukushi* of 1683 (no. 9), where a scene from the *Tale of Genji*, which had been a subject of painted scrolls and albums since the twelfth century, is dominated as never before by the dramatically large figure of Prince Genji on the right. Both this book and Sukenobu's, however, demonstrate an important point about this sort of design in the *Ukiyoe* School: for they are linked across the opening by the diagonal lines of the buildings, in the one, interior, and the other, exterior. These diagonal lines were a natural outcome of the high point of view adopted in classical *Yamatoe*. The book illustrators found them very useful to link their compositions across the page, leaving the spectator's eye free, as it were, to concentrate on the human interest. Later and even more mature examples of this diagonal movement in full-colour printing can be seen in Toyokuni's *Yakusha Sangaikyō* of 1801 (no. 94) and Utamaro's *Ehon Shiki no Hana* (no. 59) published in the same year.

The use of the background to hold the two sides of the composition together cuts out the need to spread a human figure across the central division. The background consisted not always of buildings or streets; it could be a boat, as in *Yakusha Natsu no Fuji* (no. 45), Shunshō's account of actors at leisure published in 1780, and Hokusai's 1809 illustration to the novel *Hida no Takumi Monogatari* (no. 106); or it could be landscape, as preferred by that open-air enthusiast Kiyonaga in *Ehon Monomi ga Oka* (no. 52), published in 1785, a pretty series of pictures of the richer citizens of the city of Edo (modern Tokyo) relaxing on the riverside and in the leafy suburbs. There is no doubt that artists did on the whole avoid splitting human figures down the middle. The reason is obvious enough. A thin, upright vertical figure could hardly be divided in two, however confident the artist might be, and there could be no question of dividing a face; but there were exceptions, and Toyokuni's massive and compelling figure of the actor Zōhachi in *Yakusha Sangaikyō* (no. 94) is one of them. A few other examples will be found among the illustrations – the reclining lady on a riverside outing in Sukenobu's *Ehon Tokiwagusa* of 1731 (no. 22) and the brawling street-vendor in Koryūsai's racy *Konsatsu Yamato Sōga* of 1781 (no. 48) – but their rarity speaks for itself.

One advantage of not dividing figures down the middle was that each half of the composition could stand as a satisfying picture in itself. It is astonishing how often this was achieved by the better artists, even when the material was on the face of it unpromising, such as landscape or bird and flower subjects. One has only to compare books by artists of very different schools to see how widely true this was. The *Ukiyoe* artists were easily able, with their well-peopled scenes, to make each half a very satisfying composition. Either side of the delightful morning interior in Toyokuni's

20 Nishikawa Sukenobu (1671–1759). Maidservants going out; from *Hyakunin Jorō Shinasadame*, 1723, vol. 1.

94 Utagawa Toyokuni (1769–1825). Kabuki actors in the dressing-rooms. The central figure is Arashi Zōhachi; from *Yakusha Sangaikyō*, 1801, vol. 1.

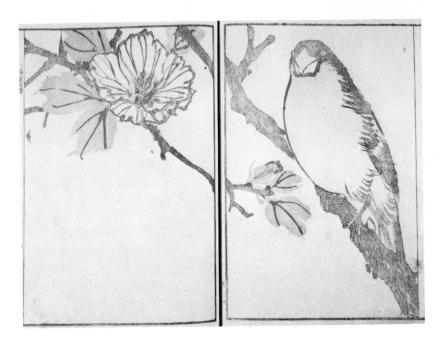

117 Kawamura Kihō (1788–1852). Finch on bough; from *Kihō Gafu*, 1827.

Ehon Imayō Sugata of 1802 (no. 95) could stand very adequately as a single print; yet, as discussed earlier, neither would look so good with a sheet of text opposite. The same is true of Sukenobu's *Hyakunin Jorō Shinasadame* of 1723 (no. 20) in spite of the unusually decorated corners of the outer frames. On a broader scale the *Kanō* artist Sekien, who was Utamaro's teacher, has achieved a very amusing balance between the mythical demon-queller Shoki on the right and the two very quelled demons on the left in no. 46, *Sekien Gafu* (1774), although the heavy line of the officially approved *Kanō* style seems ill-equipped to produce a feeling of liveliness.

In a much less literal vein *Nanga* and some *Kanō* artists designed 'sketchy' landscapes in what they considered to be the Chinese style. Landscapes may need visual unity, but the *Kanō* artist Morikuni, for one, was able in his lakeside mountain scene in no. 24, *Umpitsu Sōga* (1749), to produce in each half of the composition a very pleasing balance. The same is true of the lively *Shijō* School scene by Chinnen in his 1829 volume *Azuma no Teburi* (no. 133) or in the self-satisfied finch on a bough in the rather chunky *Kishi* style by Kihō in no. 117, *Kihō Gafu* (1827).

This stems partly from an inherent sense of balance among Japanese artists: they preferred wherever possible to make every part of what they designed harmonious. It also derives from the physical nature of the books and how people looked at them. Some eighteenth-century sheet prints show women kneeling and looking at books which are lying open on the floor. Others show them kneeling and holding books in their hands. In the latter position it would be natural to leaf quickly through a picture-book like no. 83, *Yamato Jimbutsu Gafu* (1800), where the artist Soken has made each half illustration so amusing in itself that it makes the viewer want to see the complete opening. This was perhaps even more crucial when customers were leafing through books at booksellers. Again we have pictorial evidence that there was no more room in these shops for browsing in a very relaxed manner than in their modern counterparts.

It is likely, also, that the construction of the books from folded sheets influenced this tendency to see the two halves separately. The designer knew that each block would be carved with the second half of one opening and the first half of the next opening. He would not, however, have drawn his designs in that way, for we know that the original sketches were transferred by copyists on to thin paper sheets which were pasted face down on to the blocks. It was at this stage that the designs were physically divided in half. They were then cut round by the carver, who thus destroyed them while using them as guides; but checking by the artist of the first pulls from the blocks must have made him extremely aware of the impact of each half, since the halves did appear separately at that stage of the process.

This, however, is only one possible way of looking at the problem. There are many double-page designs where the need of the composition or the subject itself to transcend the central division has produced an effect of unity so strong that it is actually almost opposite in approach to that described in the previous paragraphs. In examples of this kind, such as Bumpō's starkly powerful picture of a mounted traveller in the snow – no. 113, *Bumpō Gafu* (1807) – the two halves make sense only together. This is one of the simpler ways of overcoming the central division; the rider moves leftwards and diagonally towards the top left-hand corner. The line is strong and expressive, the direction sure.

There were various simple but effective devices of this sort developed by artists during the eighteenth century, that is to say when the dependence on Chinese models or on classical traditions had been slowly outgrown. One was to use the powerful outlines of a mountain in landscape, as in Masayoshi's great design of Mount Fuji as viewed from near the town of Yoshiwara. The book from which this comes, no. 66, *Sansui Ryakuga-shiki* (1800), includes some of the greatest masterpieces of the landscape print, predating by a generation the sheet prints of Hokusai and Hiroshige which to most Westerners are the best-known examples of Japanese landscape art. It was indeed the discipline of the illustrated book which showed the way to the landscape print. Hokusai himself first achieved landscape design of

66 Keisai Masayoshi (1764–1824). The town of Yoshiwara, near Mount Fuji; from *Sansui Ryakuga-shiki*, 1800.

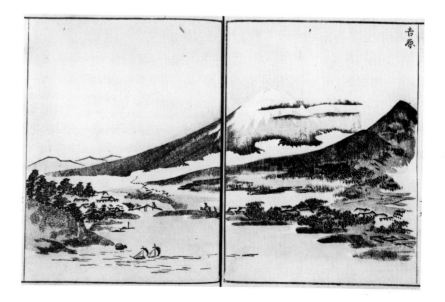

real grandeur in books such as no. 108, *Hokusai Sōga* (1820), in which the snowy view is likewise based on a simple mountainous sweep (see p. 117).

Or is it so simple? Close scrutiny shows that the causeway across the bottom of the picture forms a continuous visual line to the village at the right, which changes direction and goes by way of pine-trees up to the mountain at the top left-hand corner. A valley from half-way up the summit descends again towards the little travellers, on whom the eye may well have first settled. The eye therefore travels round and round from the travellers to the great peak above them. The use of black and white shapes adds to the complex unity of the whole. The black lake in snowy banks at the right is, after all, very similar in shape to the white clouds in the black sky above.

In his most famous book, the *Fugaku Hyakkei* (no. 110) which was published in three volumes in 1834, 1835 and *c.* 1849, Hokusai uses every imaginable device to vary his scenes and to make them fit the standard format. It is a dazzling performance of black and white design. Sometimes the artist's resources are strained by the demands of this long series of views of Japan's most famous mountain, but in general he produces page after page of the most compelling compositions. The illustration reproduced on pp. 8–9 and 118 is one of the very strongest; it is an extremely dynamic view of Fuji seen through a great wave. The wave wells up from the bottom left, carries over to the top of the right-hand page, breaks and turns back again over the central division in a welter of spray. This spray merges into a flock of plovers, which has come across from behind the wave, top right, and heads straight for the small but dominating peak of Fuji. By these devices the central lines are virtually eliminated from our vision.

This circular movement is a most satisfying one, and it appears in a number of other designs in very different styles. It is very clearly there in the much simpler and earlier study of a rat on a giant radish – a rare stencil print by Sekkōsai from no. 41, *Saishiki Gasen* (1767) – where the leaves of the vegetable curve up and back over the centre in exactly the same way. It appears in a slightly subtler form in Ransai's elegant pheasants in the snow in no. 50, *Ransai Gafu* (1801), this time the tail of the larger bird forming the turn-back; and in a much more complicated way in no. 145, Gyōsai's vivid reworking of John Tenniel's drawings for *Aesop's Fables*, *Tsūzoku Isopu Monogatari* (1875). Here the movement is from the cowering figures, bottom left, up to the Monkey King, top right, and then back over again by way of a small monkey hanging from a bough.

Perhaps the most satisfying and delicate use of a circling design is in the quietly atmospheric scene of a traveller watering his horse in the moonlight provided by Bumpō for no. 115, *Bumpō Sansui Gafu* (1824). Although this beautiful print (reproduced in colour on p. 94) makes exceptionally effective use of transparently lucid pale blues, greens and browns on a very fine *kōzō* paper, itself semi-transparent, it holds together because of its solid, underlying structure, in this instance that of a double circle. Each circle moves upwards and outwards from the double tree trunk, one curving back towards the moon, which then points back to the starting-point down the rocks and bamboo, while the other crosses the centre, and arches over and down to the horse and his owner. The shining moon at one corner is reflected in the bright water of the other.

A more complicated version is found in a book with graphic re-creations

of paintings by that most typical of Japanese artists, Ogata Kōrin (1652–1716). The book, *Kōrin Gashiki* (no. 125), was designed by one of Kōrin's admirers, Aikawa Minwa, in 1818. The illustration (p. 126) is of the old Zen Buddhist subject of the ox and his boy. Minwa has the great, grey shape of the ox moving across the division from left to right; the eye is carried straight up to the boy, sitting on the ox, who looks back left and immediately carries the viewer's eye over to some flowers growing by a winding stream, which meanders back and forth down the division, finally bringing us back to the rear of the ox. The apparent simplicity of the individual elements, which are such a feature of the style of Kōrin, is thus belied by the rather complicated construction. What looks a rather artless picture is in fact a very sophisticated one.

Simple movement from one side to another was not only a means of unifying the composition; it was also a way of adding dynamism and excitement, and this is a very noticeable virtue of Japanese books. Even a rather starkly drawn fish like the one by Ryōtai in his *Kenshi Gaen* of 1775 (no. 32) seems to be swimming out of the book's margin, and the carp ridden by the Chinese Immortal Kinkō in no. 118, Hatta Kōshū's picture-book *Kōshū Gafu* (1812), seems about to rush out of the left-hand frame altogether. Gentler and more natural movements were well-used by many artists. Bunchō designs narcissi bending leftwards in a breeze in one of his most successful book illustrations in no. 124, *Shazanrō Gahon* (1816). He has realised that the thicker, more lively lines of the plants will eclipse the straight lines of the frames.

A flowering or fruiting bough will trail effortlessly across and down a page, but nearly always coming from the right, that is, from the direction in which the viewer is turning the pages. Fine examples reproduced in the Catalogue include what may be regarded as the Chinese prototype, one of the openings from the first Japanese edition of no. 29, the influential 'Mustard Seed arden Painting Manual' (in Japanese, *Kaishien Gaden*) of 1748. This was published in parts in album form between 1679 and 1701 (apart from a nineteenth-century additional volume) and was intended as a guide to painting for middle-class amateurs. It was colour-printed, and was perhaps the most important stimulus to the development of Japanese multi-colour block-printing when it became widely available after a ban on foreign books was lifted in 1720. It is full of flowering and fruiting boughs, which ever afterwards the Japanese made their own. The illustration reproduced in colour on p. 17 is of a magnolia, and one is immediately struck by the fact that the Japanese publisher has decided to insert frames round each half of the page, where the original was a folding album without them. Later examples of this type include two interpretations of a bough weighed down by ripe persimmon fruits (in colour on p. 111): one by Chinnen in no. 134, *Sonan Gafu* (1834), and one right at the end of the tradition by Seitei in his *Seitei Kachō Gafu* (no. 148), published in 1890–1.

A subtler design of a cherry bough hanging down over a stream with fish drifting in the opposite direction is found in no. 129, *Sansai Hana Hyakushū* (1828), by Hokkei, one of Hokusai's best pupils. Here the accompanying poetry of spring itself runs downwards in the direction of the stream and becomes unified with the curve of the whole composition. Water also provides effortless visual movement in no. 31, *Kanyōsai Gafu* (1762), on

which the duck and drake, happening to cross the central lines which divide them, appear to be merely floating momentarily across our vision. This design by Ryōtai is one of the most successful of many wonderfully effective pages by this little-known artist in the Chinese-inspired *Nanga* style.

Occasionally artists seem to have become momentarily exasperated by the limitations of the frame and to have burst right out of it, as in the opening illustrated from no. 146, Gyōsai's *Kyōsai Gafu* (1880).

The books of Gesshō

It is impossible to leave this long discussion of the two-frame illustration without discussing Chō Gesshō. He must rank with Ryōtai, Bumpō, Hokusai, Masayoshi and Utamaro (most of whose best work was in the album form, see p. 31) as the greatest of Japanese book artists, and he has considerable claims to be the most natural talent of them all. Gesshō was a master of *haiga*, which were abbreviated, allusive pictures of a rather sketchy nature drawn to accompany a specific *haiku* poem. The poems were themselves very short (only seventeen syllables) and full of meaning, and they could therefore be complemented by the illustration without over-loading it with too much text. *Haiga*, originating in the seventeenth century as brush paintings, usually with calligraphy by the same person, became natural subjects for books in the eighteenth century. One of the very best is the *Koya Bunkō* of 1768 (no. 78), in three volumes illustrated by Tōhō and others and published in Nagoya. The illustration of a dragon-fly on a wind-bell (p. 97) shows the virtues of sheer simplicity, perfect placing on the page and complete balance with the calligraphy, which are the essential characteristics of these books.

Gesshō did most of the designs for a sequel to *Koya Bunkō* called *Zoku* ('continuation') *Koya Bunkō* (no. 79), which appeared also in Nagoya in five volumes in 1798 and transcended even that fine original. To leaf through them one after the other is to experience the full gamut of Japanese inventiveness in design. Page after page puts perfectly standard subjects, done a thousand times before in books, prints or paintings, in a new and startling, but never vulgar, way. All are in ink only, and all are in the two-frame format. Gesshō's use of space never fails, and his placing on the page is immaculate even by the highest Japanese standards. The illustration reproduced on p. 98 is of the fox-god Inari with stooks of rice at harvest time, an allusion to the god's association with the harvest. It is an image both sinister, amusing and compelling.

Gesshō's talent for sheer pictorial verve extended beyond the *haiga*. His *Fukei Gasō* of 1817 (no. 80) is a one-volume colour-printed picture-book which can be recommended to every student of Japanese design. The scene of a *sumō* wrestling tournament (p. 98) uses one of the pillars which supported the canopy over the ring in a shrine for two purposes: one to conceal the central division with a distractingly bold oblique shape; the other to 'squeeze' the huge wrestlers up against the straw edge of the ring, out of which they have to push each other to win, and thus to increase the sense of strain; and incidentally to let the little referee expand on the right so that his authority can somehow balance the mass of flesh on the left. All this is done with no apparent effort. In a simpler and most charming vein

Gesshō shows how to balance three chicks and a rake in space in no. 81, *Gesshō Sōga* (c. 1828).

The lack of alignment between the two halves of the rake shows that this particular copy-book has been too tightly resewn. The wider gap intended by the publisher would have allowed the rake to extend in a natural-looking curve. It is crucial to understand the importance of the gap. People who dismember these books, cut out the two halves and butt them together on a mount do more than destroy a book: they destroy a design by disturbing its balance and reducing its carefully calculated scale.

Books for connoisseurs – the album format

The preceding account of how artists of very different schools and over a long period of time dealt with the problems of the standard *hon* format has been rather exhaustive. This is because it is so central to the understanding of why book design was different from design for sheet prints or paintings, and also because it explains some of the attitudes of Japanese artists to two-dimensional art. In addition, the great majority of books were in that format. However, we must now turn to the main alternative type of book which, though produced in smaller numbers, tended to attract the top-quality publishers, artists and connoisseurs.

The album (*chō*) was put together very differently from the *hon*. It consisted of a number of usually oblong horizontal sheets, each of which formed a complete opening of the album. Each sheet was first printed complete in itself before being folded inwards down the middle. The sheets were then joined together in the following way: the back of each left-hand edge was pasted to the back of the right-hand edge of the next sheet. When all were attached, they all folded together into a standard book shape half the width of a sheet. The outside covers were not much stiffer than those of ordinary books, and were often expensively but quietly decorated with gold or mica designs, though these have often been replaced in Japan by hard covers of the sort used on the similarly constructed *gajō* (albums of paintings).

Those few millimetres of paste were clearly easy to apply, and judging by the results the work was not done by highly trained people. The sheets were held together just enough to stop them from opening out in one continuous sheet which could lie flat, but they were still easily pulled apart by careless handling or deliberately dismantled. To make the sheets fold out flat involved the skilled application of paper backings and hence time and money. There is one full example of this technique illustrated in this book, a continuous map-like panorama, designed by Moronobu, of the route from Edo to Kyoto known as the Tōkaidō ('the East Sea Road'). This, the *Tōkaidō Buken Ezu* (no. 10) was published in five volumes in 1690. The illustration shows the advantages this format gave in broadness of scope; the viewer could open and lay out as much or as little as he wished. The panorama round Mount Fuji is a particularly expansive one (this copy was hand-coloured). In one other example, an unnamed poetry album with illustrations by Hokusai published in 1796 (no. 99), one of the scenes is a long view of the Sumida River in Edo, which opens out flat over two double sheets. The rest of the album, however, is of normal construction and opens one sheet at a time.

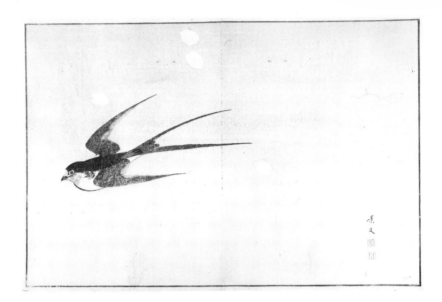

120 Matsumura Keibun (1779–1843). Swallow; from *Keijō Gaen*, 1814.

The album produced a rather different approach to design. Firstly, each sheet was a unity, and no special devices had to be used to make it work visually. The album sheet was therefore much closer to a sheet of a painted album in design, and this produced a tendency on the part of the cutters and publishers to try to reproduce the feeling of a painting in texture and pigment. The beautifully cut and printed scene of ducks by Tetsuzan in no. 112, the mixed album *Rampō Jō* (1806), is surprisingly close to the feeling of a soft *Shijō* School naturalistic painting. The freedom from other constraints of the *hon* format allowed artists to use space much more imaginatively, and it is the use of space which is one of the great and original features of Japanese painting and design. Keibun's lone swallow in a sky subtly laced with falling petals (no. 120) is a remarkable example. It is taken from *Keijō Gaen* (1814), an anthology by Kyoto artists, and seems to consist very largely of beautifully placed space. Another example is a quirky view of women enjoying the air near Kyoto by Nangaku (no. 69), which is from an untitled anthology by *Shijō* School artists published in 1793. Even more refined is a scene by Soken of a watch-tower by the shore in yet another untitled album (no. 84) datable between 1804 and 1817. The relative frequency of untitled works reinforces their similarity to painted albums, and perhaps their pretensions to that status.

Secondly, the paper used in albums was of high quality and usually of the very thick but soft sort known as *torinoko* (bird's egg – a reference to its smooth, slightly granulated surface). The reason is obvious: a thin *kōzō* paper simply could not stand up to the strains of being pasted together. The delicate *Chikudō Gafu* of 1800 (no. 86) certainly proves this, for copies which have survived have always become buckled or have fallen apart. There is no doubt that the exceptional refinement of the woodblock prints of Chikudō's painting gains from the thin, almost transparent paper, but the experiment was a technical failure.

The thick, white paper needed more pressure from the woodblocks, which therefore had to remain sharper to make a good impression. Consequently, editions were much smaller, and there was a delicate clarity

about the line and the colours which glowed more brightly on the white paper. Many of the most beautiful of all Japanese prints (for the sheets were indeed separate prints) appeared in these albums. Most of them were books of *kyōka* (comic verses) among which the plates, sometimes only slightly relevant to the verses, were interspersed.

The *Ukiyoe* artists Shumman and Utamaro excelled in this format, taking their scenes of the beautiful courtesans of Edo into the realms of pure dream. Shumman's view of girls boarding a pleasure-boat in no. 73, *Momo Saezuri* (1796), is a masterpiece of refined understatement, while Utamaro in his *Ginsekai* of 1790 (no. 57) exploits to the full the blind printing made possible by the thick paper and depicts a snow-lion among the bright colours and applied metal leaf (see illustrations in colour on pp. 83 and 71). Both produce idealised fantasies of impossibly elegant young women – Shumman in no. 72 (and cover), *Ehon Uta Yomidori* (1795), and Utamaro in no. 58, *Shioi no Tsuto* (1790). We have chosen to reproduce the print of women playing the Shell Game from the latter (see illustration in colour, p. 72). For all its brilliance it cannot compare in technique with the other sheets of shells in the water, but they are so very exquisite in execution that no photograph can convey the subtle refinement of their printing.

Undivided album sheets allowed expansiveness as well as detail, pre-eminently so in no. 88, the bold and powerful *Taigadō Gafu* (1804). In this most relaxed yet dynamic of printed albums the eccentric brushwork and composition of the *Nanga* artist Ike no Taiga, who had died a generation earlier, is re-created in graphic form by his pupil Geppō. The splendidly isolated mountain in the reproduction has a feeling of space round it, lacking in most books. This sense of expanding space is present in other large albums, for example, in no. 91, *Shōkadō Gafu* (1804–5), which goes back much further to the laconic brushwork of the early seventeenth-century calligrapher and painter Nakanuma Shōkadō. This already very large book, by Japanese standards, has been turned on its side to give the

86 Ki Chikudō (*d.* 1825). Bamboo and crescent moon; from *Chikudō Gafu*, 1800.

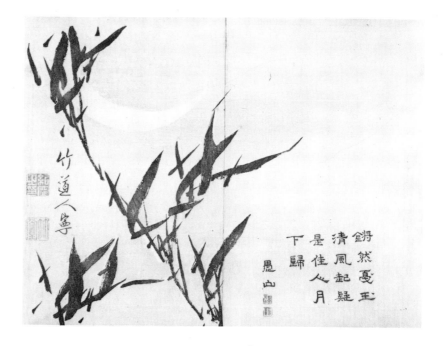

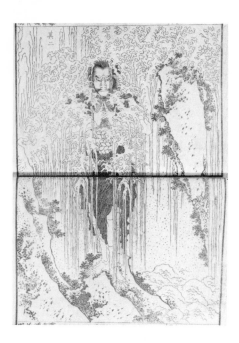

109 Katsushika Hokusai (1769–1849). Endō Morito doing penance under the waterfall; from *Ehon Sakigake*, 1836.

illustration an even bigger vertical canvas. This may have inspired that great innovator, as well as copier, Hokusai to turn some of his figures in the *hon* format sideways, as in the scene of a penitent under a waterfall from no. 109, *Ehon Sakigake* (1836), illustrated here and on p. 6.

Ishizuri albums and books and their influence

Two of the albums illustrated (nos. 38 and 39) are technically quite exceptional. These are printed in the *ishizuri* style, which means 'stone-printing'. These albums reproduced for a very sophisticated public the appearance of stone-rubbings, which for over 1,000 years in China had been a recognised method of recording and distributing examples of engraved calligraphy from monuments to scholars interested in ancient writing forms. These Japanese imitations were made by pasting the sheets of designs into a blank album of thick paper. The actual sheets are not prints at all but woodblock-rubbings, done on the same principle as stone-rubbings: the thin paper was pressed into the depressions of a carved woodblock and inked over leaving the pressed areas white.

Jakuchū's *Soken Sekisatsu* of 1768 (no. 38) uses the simple monumental style of ink-rubbings to produce an album of designs of considerable power, in which the flowers and the text are carefully balanced. The woodblock surfaces have been treated to give a stone-like effect. No. 39, the mixed album *Shōshun Hō* (1777), is slighter and prettier, with a jet-black lustrous ink surface. In 1793 Hatta Koshū did the pictures for a memorial volume of poetry in which all the poems were in stone-rubbing style – *Chūko Sanjū-rokkasen* (no. 40). His designs are very abbreviated and full of emotional intensity, like the moon shining on bamboo which is reproduced here. This is a *hon*, not an album; the sheets have been woodblock-printed with the designs and calligraphy being cut *into* the block rather than left in relief, which was the more usual practice.

The influence of stone-rubbings after 1720, when Chinese books were again allowed into Japan, extended to ordinary design, and black on white became one way of achieving eye-catching printed patterns. It is obviously there, in an unusually long horizontal format, in no. 25, *Ramma Zushiki* (1734), the curious book of *ramma* designs by the Osaka artist Shumboku. *Ramma* were the horizontal transoms above the level of the sliding doors in a Japanese house, and they were often cut in wood in fine open-work designs which gave the impression of white on black. It is there, too, in no. 85, Soken's compelling *Soken Gafu* (1806): his water plantain, from the flowers and grasses volume of his work, could almost be a rubbing from a stone monument. A predecessor which combined normal line with the use of black reminiscent of rubbings was no. 27, the five-volume botanical work *Ehon Noyamagusa* by Yasukuni (1755), a little-known yet most brilliantly illustrated book.

Woodblock printing and calligraphy

This account has mentioned in passing the fact that almost all traditional printing was done by the woodblock process. Clearly this was the other major constraint on the sort of art which could be achieved in books; but so accomplished was the long tradition of technical skill in the Far East that to

Hatta Koshū. Moon and bamboo, illustrating poem by Dainagon Michitomo with calligraphy by Shōwa; from *Chūko Sanjū-rokkasen*, 1793.

talk of constraints at all seems carping. It would be hard, for example, to find a painted album sheet contemporary with the landscape by Sōseki in no. 143, *Tama Hiroi* (1861), which could excel it in sensitivity of design or finesse of execution.

Like many of the prints illustrated in this book, Sōseki's view of Mitsugamine near Kyoto is accompanied by much text, in this case poetry. It is the textual connection which is crucial to the understanding of woodblock printing. The taking of ink-rubbings in China to record calligraphic inscriptions carved on stone was almost certainly one of the ways in which the idea of printing arose. Another was the development of the personal seal, since they were often carved leaving *in relief* the lines of the written characters which were used to write the name of the seal's owner. Artists' seals do not appear on book pages very often, but there is a good example of one of Hokusai's large seals below his signature in the print reproduced from no. 100, *Hatsu Wakana* (1798). In a monumental inscription, on the other hand, the characters were carved *into* the stone, and the rubbing produced a negative. In both cases the written characters of the Chinese language provided the starting-point.

These characters were always uniquely prestigious in China. To know them (and there were many thousands) and above all to write them elegantly were essential attributes of the superior man. This prestige was carried over to Japan with the writing system and was transferred to the much simpler Japanese *hiragana* syllabary, with its graceful flowing forms,

which was developed to be used either with the Chinese characters or on its own. The text of no. 5, *Honchō Kokon Retsujo Den* (1668) shows the characters at their squarest and most Chinese, while the popular novel *Banshū Sone no Matsu* (no. 28), published in the 1750s, has a running text in modern 'cartoon' style written mostly in the syllabary. Neither of these is on a high level, but the more normal mixture of characters and syllabary in the calligraphic book *Nyohitsu Shinan Shū* (no. 21), published in the 1730s for the edification of ladies, shows a sense of movement, balance and strong characterisation which are the marks of a fine brush.

Because a command of brush and ink was taught to every educated child and standards were high, a very poor printed substitute was unacceptable. This was equally true from the early days of printing in China, in Korea and in Japan, where it was practised from at least the eighth century AD. On the other hand, the development and use of a fount of standard movable type presented formidable difficulties. There were over 5,000 characters in common educational use, and to carve or cast them, arrange and set them proved too complicated and inefficient in the long term, although movable type was used in all three countries at certain periods. No. 1 of this selection, the *Ise Monogatari* of 1608, was set in this way. The late sixteenth and early seventeenth centuries were a time of enthusiasm in Japan for movable type techniques learned from the West and from Korea. Given the high numbers of skilled craftsmen always available in the populous lands of East Asia, it made much more sense to carve the entire page of a text on to one block, which could then be used until it wore out or stored for future editions. The owner or storer of the blocks thus became in effect the copyright holder, who was sometimes not the same man as the publisher. This seems to have been the case with no. 38, Jakuchū's splendid *Soken Sekisatsu* (1768), whose blocks were owned by a Kyoto temple, long after the temples had lost their earlier central role in publishing.

To cut a densely packed page of the multitudinous and varied forms of Chinese characters and Japanese syllabary into hard catalpa or cherry-wood blocks required the most delicate skills; but, in addition, to interpret the nuances of brush calligraphy to the satisfaction of people to whom those niceties were of very high importance a special sensitivity was required. It was not surprising, then, that skills in woodblock cutting proved very easily equal to the demands of graphic art when they were needed.

For many centuries woodblock prints in black line had occasionally accompanied Buddhist texts, which were printed solely in monasteries. Although sometimes very fine, they were more often of a very simple type, with a rather unexpressive line and primitive pictorial organisation. As the seventeenth century progressed, secular literature was for the first time widely published for the popular markets in the developing large cities, and by 1650 more and more publishers were beginning to add line illustrations, especially to novels. These early examples, which were the predecessors of the *Ukiyoe* School of art mentioned earlier, have the same primitive feeling and rather square-cut line and composition as many of the Buddhist prints – for example, the anonymously illustrated *Yoshiwara Hayari Ko-uta Sō Makuri* of c. 1659 (no. 4). But as demand and therefore competition and experience grew, so the block-cutters, who were until the twentieth century never the same people as artists, were able to use their skill in carving blocks

36 *opposite* Katsuma Ryūsui (1711–96). Gourd vine; from *Yama no Sachi*, 1765, part 2.

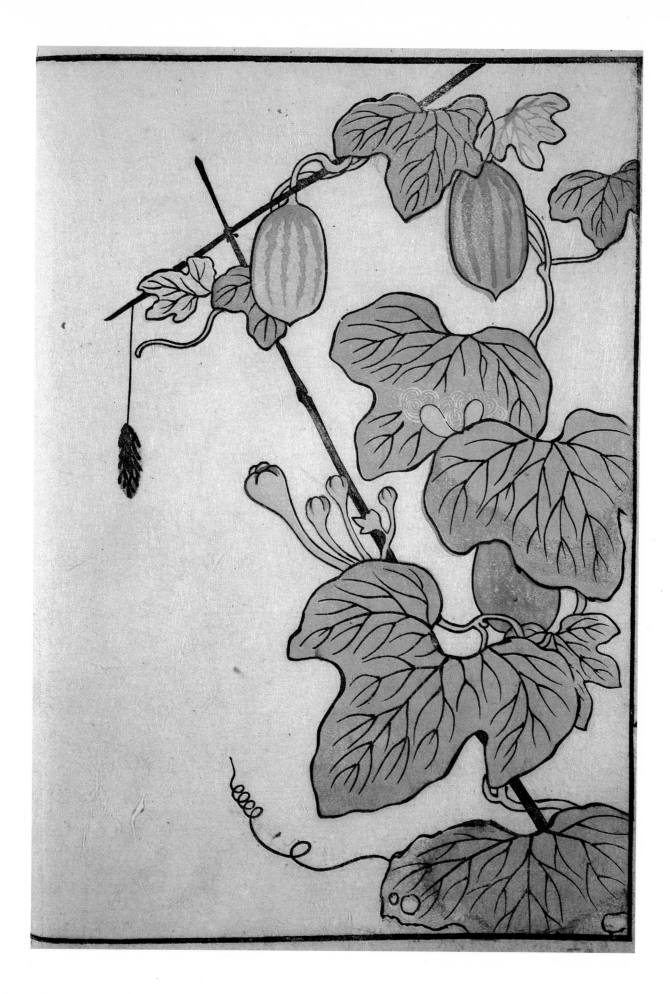

小ひ町

志ゝ鶴

のづはな

秋 二十

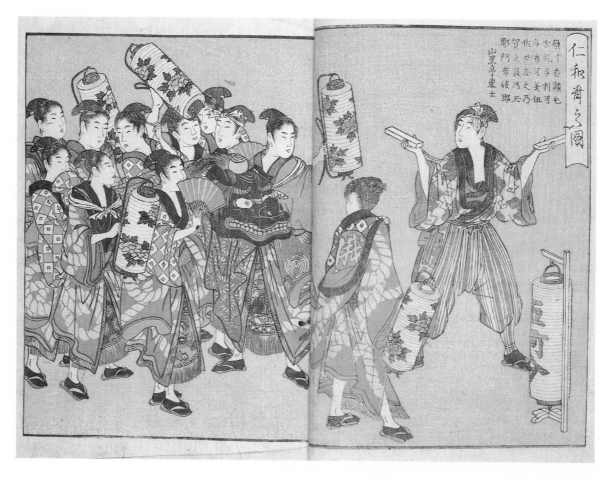

仁和香之図

領子香頷毛
他与古利乱可与
市世志可之美割可
宇段之毛乃玉
賀布佐伎乃
耶阿布枝耶
山里亭東士

of complicated calligraphy to produce a fine and expressive graphic line.

Thus a lively and sensitive line eventually became a standard feature, even in the most popular *kurobon* such as no. 28, Kiyomasu II's *Banshū Sone no Matsu*, published in the early 1750s; while as early as 1672 the cutters could acquire the much more advanced skills needed to reproduce fairly adequately Chinese calligraphy and ink painting, as in *Hasshū Gafu* (1672). As popular awareness of the subtleties of brush and ink painting increased, so the cutters' technique expanded from pure line into the many other possibilities open to artists in ink. By very refined cutting the hair-lines and nuances visible in a living artist's brush style could be very convincingly reproduced, as, for example, in no. 26, Shumboku's *Gakō Senran* (1740); no. 49, Ransai's *Ransai Gafu* (1778); or Utamaro's noble landscape in no. 56, *Kyogetsubō* (1789). As techniques advanced, the painting and calligraphy of long-dead masters were reproduced with an accuracy which began to have an almost facsimile-like quality. Such books were devoted to the work of the Zen saint Hakuin (no. 37, *Kobiki Uta*, 1760); the poet-painter Buson (no. 68, *Shin Hanazumi*, c. 1798 – this even reproducing the format of an MS book, as well as the transparent texture of colour washes); the early seventeenth-century calligrapher and ink painter Shōkadō (no. 91, *Shōkadō Gafu*, 1804–5); and the *Nanga* School artist Watanabe Kazan (no. 149, *Kamigata Fūzoku Seso Hyakutei*, c. 1900). This album is so close to photographic reproduction that woodblock printing could progress no further in that direction. Artists began to look back to the natural constraints of the medium and in fact became more self-conscious. At this time and in this atmosphere was born the *Sōsaku hanga* movement in which artists for the first time cut their own blocks. Kōshirō Onchi (see no. 150) was one of its founders.

Not that these twentieth-century artists had to work in a new pictorial mode; for ever since the 1740s there had been a separate and powerful tradition which accepted that the subject matter of woodblock prints could be expressed in different ways from paintings. Because of their boldness, apparent simplicity and basic understanding of form, books with these tendencies have been increasingly appreciated in the West in the twentieth century. Fine examples illustrated in this book include no. 34, *Kokon Gasō* (1769–71); the untitled album of 1793 (no. 69); no. 126, the superb, but little-known, *Bitchū Meisho Kō*, illustrated by Tsuji Hōzan (1822); and no. 119, *Meika Gafu* (1814), with its delightfully simple frog by Hoji.

Colour printing

Many of the examples referred to so far are printed in colour. It is true that by about 1740 graphic printing in ink was reaching a sophisticated level. Blocks could be inked up to give varied washes ranging from deepest black to palest grey. The first part of no. 49, *Ransai Gafu* (1778) is perhaps the most accomplished of them all. Alternatively, blocks could be 'lowered' by being scraped away very lightly in parts, which gave a varied surface similar to that found in certain ink painting (no. 24, *Umpitsu Sōga*, 1749). But it was inevitable that colour printing should be wanted by the more ordinary public as soon as it became profitable.

Of course, the idea of printing in colour must have arisen almost as early

44 *opposite (above)* Kitao Shigemasa (1739–1820) and Katsukawa Shunshō (1726–92). Icy morning at the house of Maruya; from *Seirō Bijin Awase Sugata Kagami*, 1776, vol. 2.

60 *opposite (below)* Kitagawa Utamaro (1753–1806). Apprentice courtesans with lanterns at the Niwaka Festival; from *Seirō Ehon Nenjū Gyōji*, 1804, vol.1.

as printing itself, and we know that it was being done for simple decorative papers as early as the eighth century in Japan. The only problems were registration of the colours and expense. In general a different block had to be cut for each colour, except when two widely separated patches of different colour could be accommodated on the same block and printed together. Registration ensured that the impressions from the separate colour blocks fitted exactly with each other and with the line block. Each new block added to the expense of materials, craftsmanship and storage. The relative costs were not unlike those of the black and white plates and the colour plates in this book. The demand therefore had to cover the costs, and it was not until the late fifteenth century in China that a suitable public existed and multi-block colour printing first began to develop fast. Obviously the problem of registering the different blocks had to be solved in order to offer the buying public a professional-looking product, and the Chinese had methods which were not widely adopted in Japan.

Chinese examples existed, therefore, for well over 200 years before the Japanese began to want to print in colour themselves on any scale. They had already in the seventeenth century developed their own simple method of registration called the *kentō*. This consisted of a right-angled depression cut in one corner of each block to be used in that print, and a raised line on an adjacent side. When the paper was cut carefully to size, it would then drop into the same place on each block and good registration would result. One or two early attempts, like nos. 29 and 30, *Kaishien Gaden* (1748 and 1753), are less well registered and seem to have tried with only moderate success to follow Chinese techniques; but by the mid-1760s, when demand, skill and prosperity had reached the right levels, the *kentō* came to be used for nearly all colour printing. The old fabric art of stencil-printing, which dispensed with the need for registration, was used in a few fine books, such as no. 41, Sekkōsai's *Saishiki Gasen* (1767), but they soon gave way to the sharper and more polished woodblock medium.

So quickly did the new vogue develop that the last thirty years of the eighteenth century saw the publication of many beautiful and accomplished colour-printed books which can stand comparison with any in the world. The colour reproductions in this book have been chosen to give an idea of that achievement. Two main traditions can easily be followed in them. One is of black and white outline filled in with colour, derived from both Chinese popular printing and Japanese *Yamatoe* painting (see Glossary). It had its greatest flowering in the books and prints of the *Ukiyoe* School, which took as its subject matter the life of the men and women of the towns and especially their leisure and entertainments. The outline tended to be thin and rather unvaried, the colour brilliant and harmonious, as, for example, in no. 44, *Seirō Bijin Awase Jihitsu Kagami* (1776). The other tradition is of colour without outline, derived originally from Chinese printed manuals designed to teach painting techniques, such as *Kaishien Gaden*; or of line which closely follows the movements of the painter's brush. No. 123, Bōsai's *Kyōchūzan* (1816), is a fine example. The colours are quieter and subtler, the line expressive. Such books were for a known market of connoisseurs, painters, calligraphers and poets.

The subject of colour cannot be left without making one final and vital point. The pigments used in painting in the Far East were not mixed, as

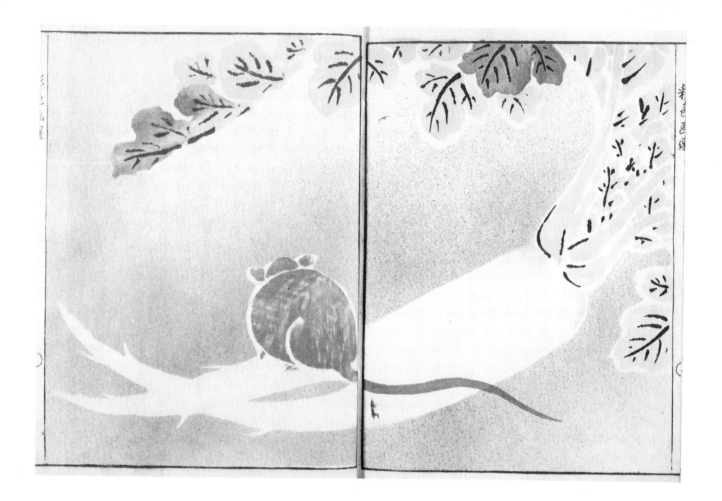

41 Kitao Sekkōsai (Torinobu) (*fl.* 1750s–60s).
Rat on *daikon* (both symbols of the god Daikoku);
from *Saishiki Gasen*, 1767.

Western pigments were, to form an almost infinite variety of shades but stood clear and separate. They could be made stronger or darker by regulating the amount of water or white pigment, and they could also, in skilful hands, be laid over each other so that one would shine through the other. All these techniques could be simulated in printing, and prints therefore became an acceptable popular substitute for paintings. In the West the subtleties of painting were not approached by the print techniques, and the relationship with graphic art was a more distant one.

Conclusion

Japanese illustrated albums and books are a significant element in the history of the world's graphic art; but they flourished according to wide public demand and responded to the interests and needs of that public. They therefore reflect, compactly and yet clearly, a specific civilisation: illustrated novels; books of poetry; manuals of painting, calligraphy, manners, or of any sort of skill; maps and gazetteers; accounts and critiques of Kabuki actors, entertainers and prostitutes; works on zoology, botany, physics and all the knowledge from the mysterious, forbidden world outside Japan; and books which are simply volumes of fine pictures by fine artists. In this strong and confident social setting the arts of the book flourished.

List of works referred to in abbreviated form

Less frequently quoted books are given fuller citations under individual entries.

BINYON AND SEXTON Laurence Binyon and J. J. O'Brien Sexton, *Japanese Colour Prints* (new edn.), London, 1963.

BROWN Louise Norton Brown, *Block Printing and Book Illustration in Japan*, London and New York, 1924.

DAWES Leonard G. Dawes, *Victoria and Albert Museum Catalogue of Japanese Illustrated Books*, London, 1972.

DURET *Livres et Albums Illustrés du Japon Réunis et Catalogués par Théodore Duret*, Paris, 1900.

GONSE (I) *Collection Louis Gonse. Première Vente*, Catalogue by Charles Vignier, Paris, 1924.

GONSE (III) *Collection Louis Gonse. Troisième Vente*, Catalogue by Charles Vignier, Paris, 1926.

HAVILAND (10) *Collection Ch. Haviland. Estampes Japonaises, Albums illustrés des Maîtres de l'Ukiyoyé*, Paris, 1923.

HAYASHI *Collection Hayashi. Dessins, Estampes, Livres illustrés du Japon réunis par T. Hayashi*, Paris, 1902.

HILLIER (1) J. Hillier, *Utamaro. Colour Prints and Paintings*, London, 1961 and 1979.

HILLIER (2) J. Hillier, *The Uninhibited Brush. Japanese Art in the Shijō Style*, London, 1974.

HILLIER (3) J. Hillier, *The Art of Hokusai in Book Illustration*, London, 1980.

HOLLOWAY Owen E. Holloway, *Graphic Art of Japan: The Classical School*, London, 1957.

ISAAC *Collection de Monsieur P. A. Isaac. Objets d'Art du Japon Estampes et Livres des Principaux Maîtres de l'Ukiyoyé . . .*, Paris, 1925.

JAVAL (I) *Catalogue de la Bibliothèque de Livres Japonais Illustrés Appartenant a Émile Javal. Première Partie*, Catalogue by Charles Vignier in collaboration with M. Densmore, Paris, 1927.

JAVAL (II) *Catalogue de la Bibliothèque de Livres Japonais Illustrés. Appartenant a Émile Javal. Deuxième Partie*, Catalogue by Charles Vignier in collaboration with M. Densmore, Paris, 1928.

KS *Kokusho Sōmokuroku*, 9 vols., Tokyo, 1970–7.

MITCHELL C. H. Mitchell with the assistance of Osamu Ueda, *The Illustrated Books of the Nanga, Maruyama, Shijo and Other Related Schools of Japan. A Biobibliography*, Los Angeles, 1972.

NAKATA Katsunosuke Nakata, *Ehon no Kenkyū*, Tokyo, 1950.

NFZ *Nihon Fūzoku Zue*, 12 vols., Tokyo, 1914.

ODAKA Sennosuke Odaka, *Utamaro Ehon Kō* (A Study of Utamaro's Illustrated Books), Ukiyoye no Kenkyū, 20, vol. 5, no. 4, Tokyo, 1928.

ODIN *Catalogue de la Bibliothèque de Livres Japonais Illustrés Appartenant à Ulrich Odin*, Catalogue by Charles Vignier in collaboration with M. Densmore, Paris, 1928.

DE ROOS *Catalogue of the de Roos Collection of Japanese Illustrated Books*, Sotheby & Co., London, 17 May 1972.

RYERSON Kenji Toda, *Descriptive Catalogue of the Japanese and Chinese Illustrated Books in the Ryerson Library of the Art Institute of Chicago*, Chicago, 1931.

SORIMACHI Shigeo Sorimachi, *Catalogue of Japanese Illustrated Books in the Spenser Collection of the New York Public Library*, New York, 1968.

VEVER CATALOGUE Jack Hillier, *Japanese Prints and Drawings from the Vever Collection*, 3 vols., London, 1976.

WATERHOUSE D. B. Waterhouse, *Harunobu and his age*, London, 1964.

CATALOGUE

One hundred and fifty books and albums have been chosen from the Hillier Collection to represent as comprehensively as possible the history and achievements of Japanese graphic woodblock printing in book form. One opening, or detail of an opening, is reproduced from each one. The Catalogue gives basic details, but many of the books are mentioned in the Introduction, where they are put in their art-historical and technical context.

Because this is an art-historical selection, the books are listed under artists, although in some cases the literary interest may be as great or considerably greater than the aesthetic. The Catalogue is basically chronological; but books by one artist are for convenience placed together, again chronologically, and for convenience of reference, obvious groupings have been kept together, such as the *de luxe kyōka* albums in nos. 70–5. The full name and dates of each artist are given only on their first appearance.

Books are assumed to be in the standard stitched format (see Introduction), unless otherwise stated, and to be printed in ink (*sumi*). Colour-printing, gauffrage (blind printing) and other techniques are mentioned specifically.

There is a separate concordance of catalogue numbers and Hillier Collection numbers, as well as an index of artists and an index of album and book titles. Individual Japanese words set in italics are explained in the Glossary.

Warning on titles

It is important for Westerners to understand that there is sometimes no correct title for a Japanese book. As explained in the Introduction there may be more than one title used; in other books there may be only a manuscript title which may or may not approximate to the title(s) intended. The titles quoted here are those which seem to be the most established, but the reader should bear in mind that the book may go under a completely different name or variant in other reference works. Where we have known this to be the case, we have given the necessary references.

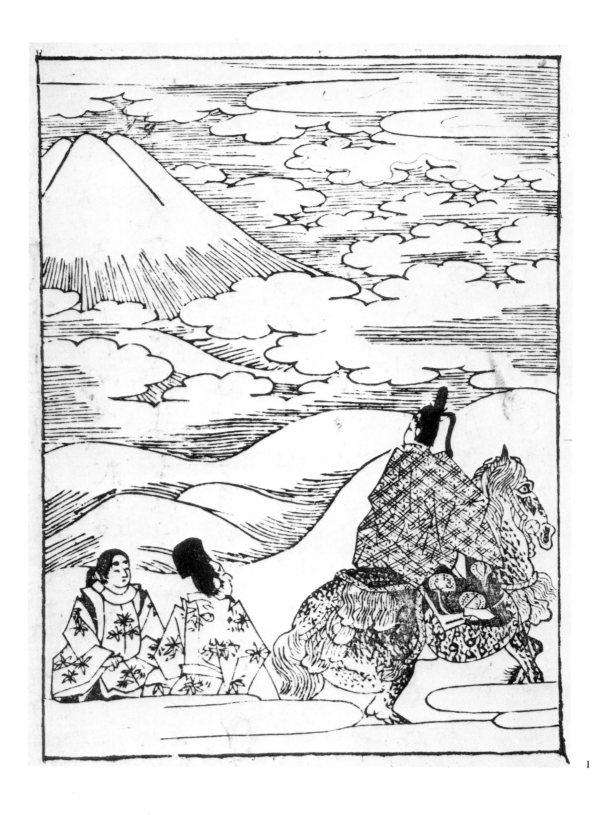

1

1 Anon

Ise Monogatari Tales of Ise

1608

Publisher: No colophon, but known to be published by Suminokura Soan, joint founder with Kōetsu of the press at Saga, near Kyoto. 2 vols. 272 × 194 mm. Printed on five different-coloured papers. From the Kurth Collection, and with his bookplate.

Literature: D. Chibbett, *The History of Japanese Printing and Book Illustration*, Tokyo, 1977, pp. 75–6; Brown, p. 25; *Duret*, no. 2; *Ryerson*, pp. 14–26; Koreshirō Wada, *Saga-bon Kō*, Tokyo, 1916.

Closing note by Yasoku-sō, dated Keichō 13 (AD 1608). The first secular illustrated book of importance in Japan; the text by Nakanoin Michikatsu (Yasoku-sō) is a series of amorous episodes based on the writings and escapades of Ariwara no Narihira, the ninth-century poet, and is the only one in this catalogue set in movable type rather than printed by woodblock. The artist, working in a simplified, classical *Yamatoe* style, is not known.

Illustrated: The poet Narihira stops to admire Mount Fuji on his way to exile; vol. 1.

2 Anon

Sanjū-rokkasen The Thirty-six Immortals of Poetry

c. 1610

No preface or colophon.

1 vol. 328 × 258 mm.

Literature: Brown, p. 25; *Ryerson*, p. 18; Wada, *op. cit.*

Imaginary portraits of the thirty-six poets selected by Fujiwara no Kintō, *c.* AD 1000, each with a poem above. The illustrations have been attributed to Tosa Mitsushige, and the calligraphy to Kōetsu. This copy is a recut version closely following the original of *c.* 1610 and probably of seventeenth-century date. One of the first true masterpieces of Japanese black and white graphic printing.

Illustrated: The poets Yoshinobu (left) and Ko no Ogimi (right).

2

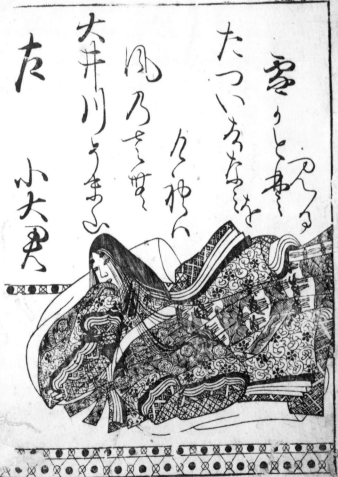

4

3 Anon

Shinkoku Kō Retsujo Den Lives of Ancient Heroines,
Newly Cut

1653
Publisher: Shōtō (or Kojima) Mosaemon, Edo.
8 vols. 270 × 170 mm.

A translation of the Chinese (Han dynasty) work by Liu Hsiang
whose name figures in the cover title, *Ryūkyō (Liu Hsiang)
Retsujo Den*.

In the 1650s there was a vogue for illustrations in Chinese
style, and the rather simple illustrations of this book have the
appearance of being based on Chinese originals.

Illustrated (p. 15): The Lady Lu Qiujie; vol. 5.

4 Anon

Yoshiwara Hayari Ko-uta Sō Makuri Collection of Short
Songs in the Yoshiwara Vein

c. 1659
Publisher: Nakajimaya Isaemon, Edo.
1 vol. 174 × 130 mm. Printed on thick grey paper.
Literature: KS, vol. 7, p. 921.

The illustrations are among the earliest in Edo *Ukiyoe* style.

(Gillet, the former owner, dated it to 1659; *KS* to the Kambun
period, 1661–72.)

Illustrated: Clients viewing prostitutes in Edo (Tokyo).

5 Anon

Honchō Kokon Retsujo Den Lives of our National
Heroines in Ancient and Modern Times

1668
Publisher: Katsumura Jiemon.
6 vols. 249 × 181 mm.
Literature: Brown, p. 40 ('an unusually fine example of block-printing
in every way, and the pages of text in Chinese characters, instead of
the usual flowing *hiragana*, give it a very distinctive appearance');
KS, vol. 7, p. 412; *Ryerson*, p. 59 *et seq*.

Based on the book of Chinese heroines by Liu Hsiang (see no. 3),
this book, by Kurosawa Hirotada, recounts the lives of Japanese
female paragons. The illustrations amount virtually to printed
Narae.

Illustrated: Ubatama pines for her husband; vol. 5.

6 Various Chinese artists

Hasshū Gafu The Drawing-book of Eight Varieties
(a collective title not in the books themselves)
Meikō Senfu Album of Famous Fan Paintings
Tōshi Shichigon Tang Seven-verse Poems
Tōshi Rokugon Tang Six-verse Poems
Tōshi Gogon Tang Five-verse Poems

First edition of *Meikō Senfu* dated 1672
Publishers: Tōhonya Seibei and Kichizaemon, Kyoto; Tōhonya Tahei,
Edo.
4 vols. (of 8) as listed above. 284 × 203 mm.
Literature: Brown, p. 40; Mitchell, pp. 289–90; *Ryerson*, p. 71.

The illustrations are woodblock paraphrases of Chinese
paintings and are important in Japan for their influence on
eighteenth-century *Nanga* and *Kanō* artists who, because of the
scarcity of original Chinese paintings, turned to these woodcut
versions for inspiration.

Illustrated: Epidendrum, illustrating a poem in the calligraphy of
Shen Wenxian; vol. 2.

7 Hishikawa Moronobu *c.* 1618–1694

Ise Monogatari Tales of Ise

1679
Publisher: Matsue, Edo.
2 parts (in 1 vol.). 268 × 189 mm.
Literature: Javal (1), no. 10; *Ryerson*, p. 95. The copy in the Museum of
Fine Arts, Boston, has a portrait of the poet Narihira inside the front
cover (lacking in BM copy).

See no. 1 for the Saga edition.

Illustrated: The poet Narihira sends his poems and a present of
seaweed to a lady; part 1.

烏玉女

佐爲王婢

佐爲王有近習婢也于時宿直不遇夫君難遇感情
馳結係戀實深於是當宿之夜夢裡相見覺寤探抱
曾無觸乃哽咽歔欷高聲吟詠此歌曰飲喫騰
味毋不在雖行往安父毛不有赤根佐須君之情志
忘可稱津藻因王聞之哀慟未免待宿也

頌曰

昔爲佐王　有近習婢　糖辣思伯　意念徹髓
王爲圓夢　夫末共祓　至誠薫人　獨豈骨副

西堂晩室　朱の久
自喬を静示毛気唯生
松陰高晩室寓泊高山
作懦香ふ志辨一旦上
宋子
諸彥老人沈文寔

あるなかにとりあげて
ときよむとうくあそびける
きとくとみえてあそびける
いとりほかにけるほどさに
ふりてゆくいくくあそびける
かへりてたえておやのまへ
なにはよのなかそひある
男とをりていくくくわばり
なくよいてあそびける
いとりほかにけりなくれ
たへくくいろうすなくすもろ
なへちてあそひくく
あかくけにれてあそびける
かきりなくすゆのためしけん
いまをくけにくけるためしける
かくれありくくるなくれたかう
かくれ雅俊羽にん
よりてくくたんのれる
くにわまる心くくいる
ためしへきとくそおあそびける
いまくほとさになけし

九

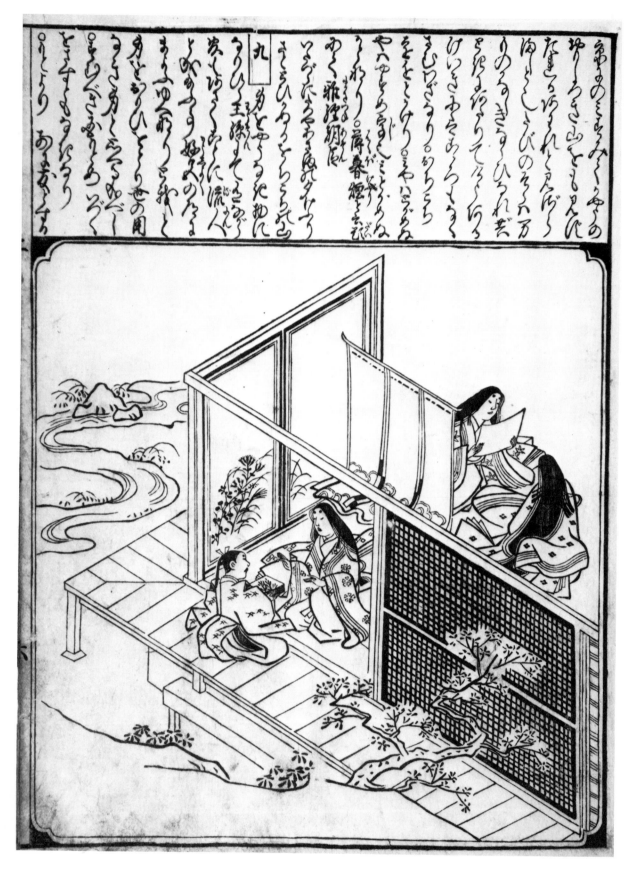

8 Moronobu

Ukiyo Hyakunin Onna One Hundred Women of the
Floating World

1681
Publisher: Kashiwaya Yoichi, Edo.
1 vol. (incomplete, as is another copy in the BM). 260 × 190 mm.
Literature: Binyon and Sexton, pl. 2; *Collection Ch. Gillot, Deuxième
Partie*, Paris, 1904, no. 13.

Illustrated (p. 20): Court ladies watching the composing of a
poem.

9 Moronobu

(*Shimpan*) *Bijin Ezukushi* A (Newly Published) Series of
Pictures of Beautiful Women

1683
Publisher: Urokogataya, Edo.
3 vols. 273 × 185 mm.
Literature: Brown, pp. 45–7; *Gonse* (III), no. 394 (vols. 1 and 3); *Javal*
(II), no. 13 (vol. 2); the three volumes united by Henri Vever.
Reproduced in facsimile in *NFZ*, vol. 1.

Illustrated: Verandah scene from the *Tale of Genji*; vol. 1.

10 Moronobu

Tōkaidō Buken Ezu A Measured Pictorial Map of the
Tōkaidō

1690
Publisher: Hangiya Shichirōbei, Edo.
5 folding albums. 260 × 130 mm. Hand-coloured.
Literature: *KS*, vol. 6, p. 14; *Ryerson*, pp. 109–10.

A famous early pictorial map of Japan's principal highway,
running between Edo and Kyoto. The hand-colouring appears to
be contemporary. The colophon of this set is lacking, but the
standard of the impression suggests an early issue. The albums
fold out continually so that it is possible to look at a complete
panorama.

Illustrated: Panorama round Mount Fuji; vol. 2.

9

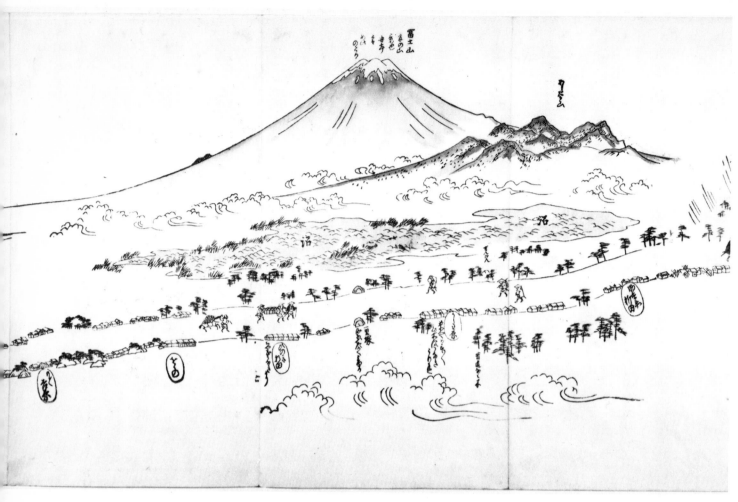

10

11 Moronobu

Kedamono Ehon Zukushi Complete Picture-book of Animals

1694
Publisher: Urokogataya, Edo.
1 vol. 252 × 191 mm.
Literature: Brown, p. 48, has a corrupt title, *Kimono Ehon Edzukushi*.
Few copies are recorded: e.g., *Haviland* (10), no. 453; Nakata, p. 42.

The naïve and charming illustrations contrast surprisingly with Moronobu's sophisticated work on women and their attractions.

Illustrated: Bears and monkeys.

12 Furuyama Moroshige *fl. c.* 1678–1698

Kōshoku Edo Murasaki The Sensual 'Violets' of Edo

c. 1686
Publisher and date not given (but clearly from Edo).
1 vol. 223 × 156 mm. Some hand-colouring in *tan*.
From the Vever Collection, but not catalogued.
Literature: Brown, p. 49, gives date as 1684; Kiyoshi Shibui, *Shōki Hanga*, Tokyo, 1954, p. 103, as 1686.

A notorious seventeenth-century novel by Ishikawa Ryūsen. The illustration reproduced is signed Furuyama Moroshige.

Illustrated: Chitsune Kudoku watches Gennosuke reading a letter.

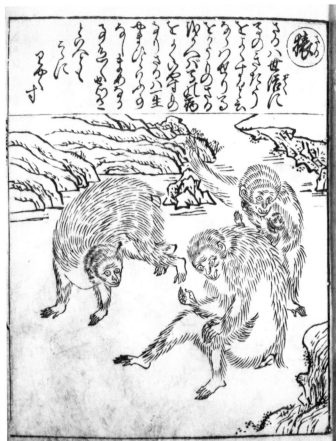

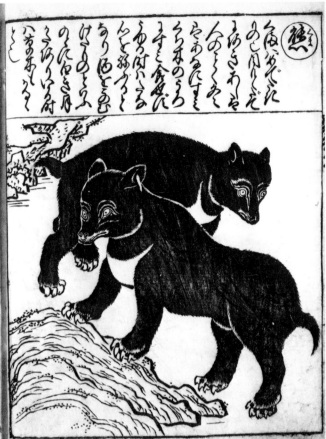

11

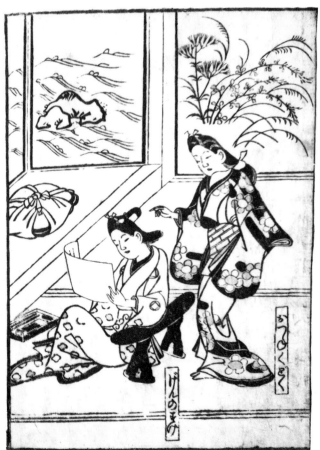

12

49

13 Sugimura Jihei *fl. c.* 1680–1698

Yamato Fūryū Ekagami Japan mirrored in Elegant Pictures

(MS title)
1684
Publisher: Yamagata Ichirōemon, probably Edo.
1 vol. 250 × 188 mm. Nineteenth-century hand-colouring.
Literature: J. Hillier, 'Sugimura Jihei's *Yamato Fūryū Ekagami*' in *Ukiyoe Art*, no. 45, Tokyo, 1975; Chimyō Horioka, 'Sugimura Jihei's *Yamato Fūryū Ekagami*' in *Ukiyoe Art*, no. 40, 1973.

The finest of Sugimura's non-erotic *ehon*, its black and white brilliance unhappily lessened by crude hand-colouring. One other copy is known, in the Museum of Fine Arts, Boston. It is in scroll form with a similar MS title. Like this copy it is incomplete, but the two together appear to make a complete book, less any preface there may have been.

Illustrated (p. 20): Townsman viewing waterfall, supported by entertainers.

14 Attributed to Sugimura

E-iri Shin Onna Imagawa A New *Onna Imagawa* with Illustrations

(MS title *Meijin Fumi no Minamoto* Famous hands of the Minamoto)
1700
Publishers: Iseya Seibei and Hammotoya Shinsuke, Edo.
1 vol. 267 × 182 mm.

This is primarily a book of calligraphy, and both the original and the MS title relate to the subject. (*Onna Imagawa*, admonitions for young girls, was written by Sawada Kichi; her classic text was used as a practice-piece for calligraphy; the MS title refers to famous calligraphers of the ancient Minamoto family.)
 The style of the prints is not irrefutably that of Sugimura, but it is difficult to suggest any other contemporary artist to whom they could more plausibly be ascribed. The book is later than any dated work by the artist. Its real interest lies in the dashing and brilliantly cut pages of calligraphy, a tribute to a tradition of non-graphic woodblock printing going back nearly a thousand years in Japan.

Illustrated (p. 15): Page of fine calligraphy.

15 Ishikawa Ryūsen *fl. c.* 1687–1713

Tsubo no Ishibumi The Stone Monument of Ishibumi

1698
Publisher: Shōkai Sanshirō, Hasegawa-machi (Edo).
13 vols. 227 × 161 mm.
Literature: Brown, p. 49 (ascribing it to Morofusa); *KS*, vol. 5, p. 764; *Ryerson*, p. 86.

A well-known book of ethical and practical instruction for women. The title comes from a stone monument at one time believed to have been raised at Tsubo by an eighth-century general when subjugating the indigenous natives of northern Japan (ancestors of the Ainu). Toda suggests in *Ryerson* (p. 86) that it was adopted by the author 'as the symbol of the constancy

of women's virtues'. This beautifully produced work amply proves the rising standards of the top end of the popular market in Japanese publishing. Each cover is decorated with a pattern in mica, and the title slips are printed with a pattern of shells in green.

Illustrated: Ladies playing a *koto*, a *biwa* and a zither, with a singer; vol. 2.

16 Yoshida Hambei *fl. c.* 1664–1689

Nihon Etai-gura Japan's Treasury for the Ages

1688
Publishers: Kaneya, Kyoto; Morita Shotarō, Osaka.
2 vols. 265 × 180 mm.
Literature: *KS*, vol. 6, p. 373; Futō Mizutani, *Kohen Shōgetsu Soga Shi*, Tokyo, 1936, p. 125.

First edition of one of the best known of Saikaku's *ukiyo-zōshi*, many times reprinted in modern times. Although unsigned, the illustrations are typical Hambei. Saikaku was the best-known novelist of the Edo period.

Illustrated: The Battle of Fans; vol. 1.

17 Hambei

Amayo no Sambai Kigen A Merry Cup of *Sake* with Actors on a Rainy Evening

Preface dated 1693
Publisher: Yugao no Yadohotori (a fanciful name).
Vol. 1 (of 2). 266 × 183 mm.
Literature: *KS*, vol. 1, p. 89.

An actor critique (*yakusha hyōbanki*) by Bokuteki-an Sōgyū, of value to Kabuki students for its commentary on late seventeenth-century actors. Such books reflect the growing importance of the Kabuki theatre in middle-class entertainment.

Illustrated: The actor Katsurayama Shikibu.

18 Take Hiratsugi *fl. c.* 1690

Gozen Hinagata Patterns for Noble Ladies

(MS title *Ehon Kimono no Moyō* Picture-book of Kimono Designs)
c. 1690
Publishers: Yamaguchiya of Kawase Ishimachi and Tsugifuji Kembei, Edo.
1 vol. 230 × 162 mm.

The two opening illustrations are very much in Moronobu's style. The last of the *kimono* designs is signed Eshi (artist) Hiratsugi. There are two variant, later editions in the Museum of Fine Arts, Boston, one with MS title dated 1697, the other with printed title *Gozen Hinagata* dated 1729. Needless to say, the reference to the nobility is designed to appeal to the social pretensions of the townsmen who bought the book, which is a masterpiece of design and black and white printing.

Illustrated: Stencil-dyeing *kimono* material.

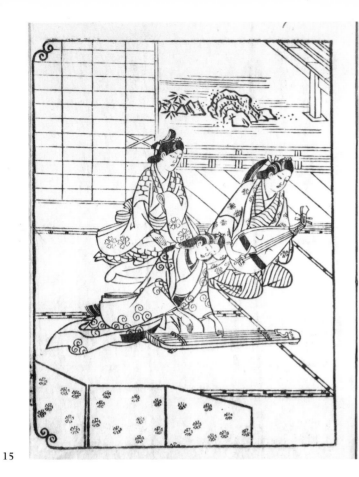

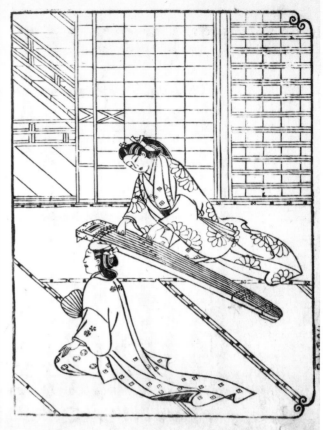

15

16

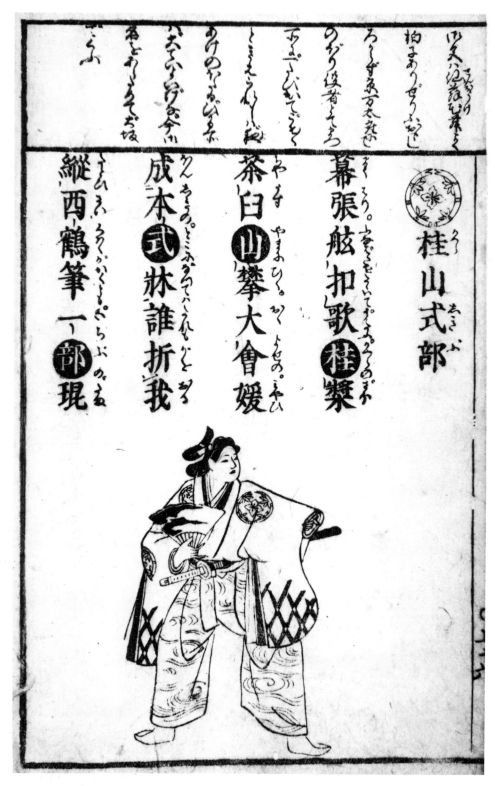

17

54 *opposite* Kitagawa Utamaro (1753–1806). Balloon-flower with other
plants, and cicada; from *Ehon Mushi Erabi*, 1788, vol. 2.

52

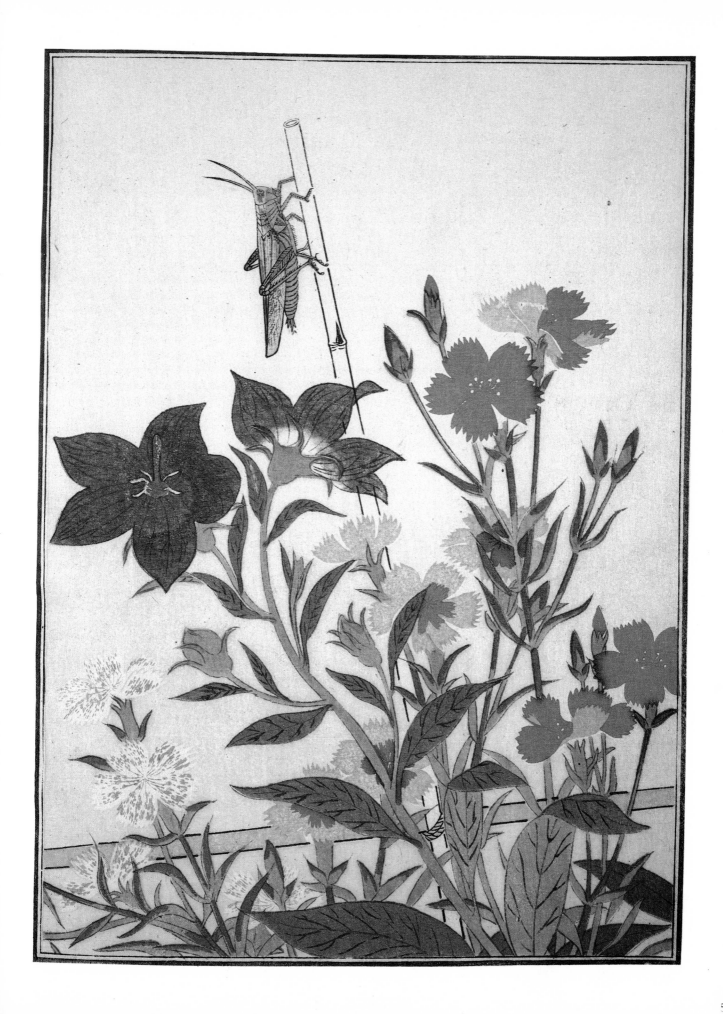

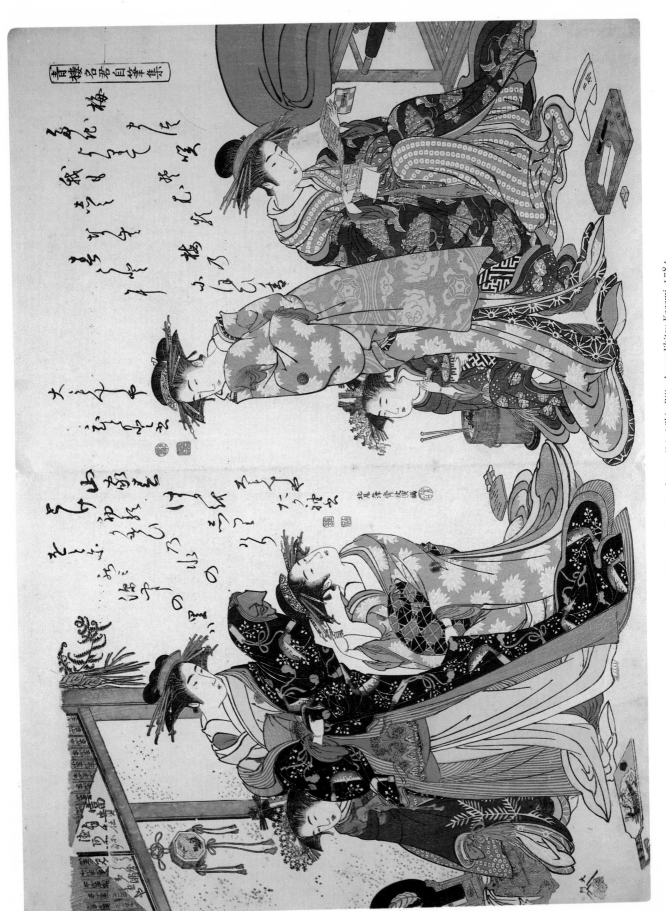

53 Kitao Masanobu (1761–1816). The literary courtesans Tagasode and Hitomoto: from *Yoshiwara Keisei Shin Bijin Awase Jihitsu Kagami*. 1784.

19

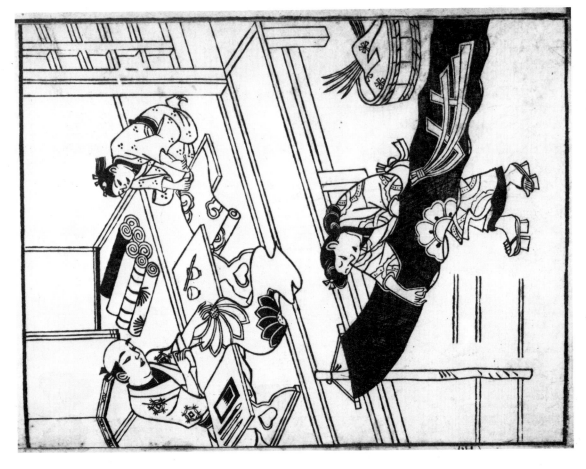

18

19 Nishikawa Sukenobu 1671–1750

Chinsoku Hinagata Miyako Fūzoku Rare *Kimono* Patterns of the Capital

(MS title)
1716
Publishers: Kobayashi Kiemon, Nishimura Rieimon and Tanimura Seibei, Kyoto.
Folding album (incomplete). 243 × 165 mm.

Kimono designs interspersed with full-length figures of girls and *wakashū* in the latest fashions.

Illustrated: *Kimono* design of chrysanthemums by a stream.

20 Sukenobu

Hyakunin Jorō Shinasadame Critical Studies of One Hundred Women

1723
Publisher: Hachimonjiya Hachizaemon, Kyoto.
2 vols. 285 × 195 mm.
Literature: Brown, p. 130, 132; *NFZ*, vol. 3; facsimile, Rinsen Book Co. Ltd., Kyoto, 1979; *Ryerson*, pp. 129–30.

Volume 1 portrays women of all vocations and classes; volume 2, courtesans of high and low degree. This is one of the masterpieces of *Ukiyoe* art.

Illustrated (p. 22): Maidservants going out; vol. 1.

21 Sukenobu

Nyohitsu Shinan Shū A Collected Guide to Women's Calligraphy

c. 1730s
Publisher not given, but Kyoto.
3 vols. 235 × 190 mm.
Not recorded in Japanese or Western literature.

The *hiragana* phonetic script was favoured by women and known as *nyohitsu*, 'women's calligraphy'. In this book the guide offers some extravagant and eccentric forms of exciting virtuosity. Each volume has a frontispiece by Sukenobu, one of them the model on which Harunobu based a well-known colour print. The calligrapher is not named.

Illustrated: Anon. Cursive calligraphy; vol. 3.

22 Sukenobu

Ehon Tokiwagusa Picture-book of Evergreens

1731
Publisher: Morita Shōtarō, Osaka.
Vols. 2 and 3 (of 3). 270 × 190 mm.
Literature: Brown, p. 131; *Duret*, no. 79; *NFZ*, vol. 3; *Ryerson*, pp. 131–3; Waterhouse, no. 140.

In his preface Sukenobu says that the book is intended to help beginners in painting. For depicting court ladies he advocates the style of Tosa Mitsunobu, for the common people, a more realistic style; but in practice he follows his own brand of *Kamigata Ukiyoe* throughout. 'Evergreens' refer to young and beautiful women.

Illustrated: Young mother with attendants and waitress at a riverside tea-stall; vol. 2.

23 Sukenobu

Ehon Asakayama Picture-book of Mount Asaka

1739
Publisher: Kikuya Kihei, Kyoto.
1 vol. 260 × 180 mm.
Literature: Brown, p. 131; *Duret*, no. 81; J. Michener, *The Floating World*, New York, 1954, ch. 6; *NFZ*, vol. 3.

Despite the title, this is another book of pictures of beautiful women, and by general agreement represents Sukenobu's art at its most ingratiating. The connection of the beauty-spot of Mount Asaka with the subject of the book is uncertain.

Two editions are known, both with the same date, one (thought to be the later) prefaced by three double-page designs, lacking in this one.

Illustrated: Mother and child.

24 Tachibana Morikuni 1679–1748

Umpitsu Sōga The Moving Brush in 'Rough' Painting

1749
Publishers: Nishimura Genroku, Edo; Shibukawa Seiemon and Shibukawa Yozaemon, Osaka.
3 vols. 257 × 182 mm.
Literature: Brown, pp. 64–5; *Ryerson*, p. 319.

Morikuni's preface deals with the technique of the *sō*, or quick, cursive brush style. The woodblock technique is an early example of the method of securing gradated tonal effects by 'lowering' or scraping certain areas of the blocks and thus approaching the appearance of real brushwork more closely.

Illustrated: Lakeside landscape in *sō* style; vol. 1.

25 Ōoka Shumboku 1680–1763

Ramma Zushiki Designs for Ramma

1734
Publishers: Suhara Mohei, Edo; Ōnogi Ichibei, Osaka.
3 vols. 191 × 257 mm.
Literature: Brown, pp. 71–2; *Ryerson*, p. 320.

Ramma, in the Japanese house, were the transoms above the *fusuma* and often of carved, or carved and pierced, wood. These volumes are, unusually, in landscape format in response to the shape of *ramma*. They are among the first Japanese books to exploit the 'white on black' technique.

Illustrated: Transom design of *origami* models; vol. 3.

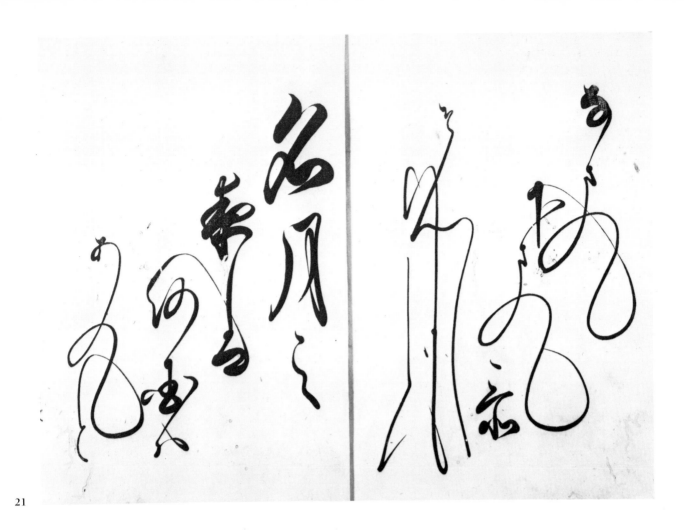

21

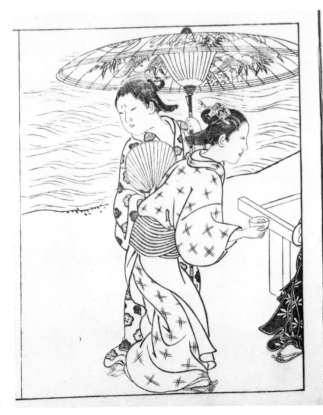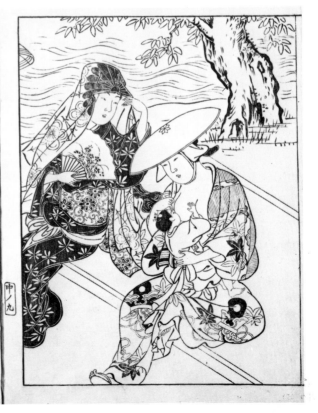

22

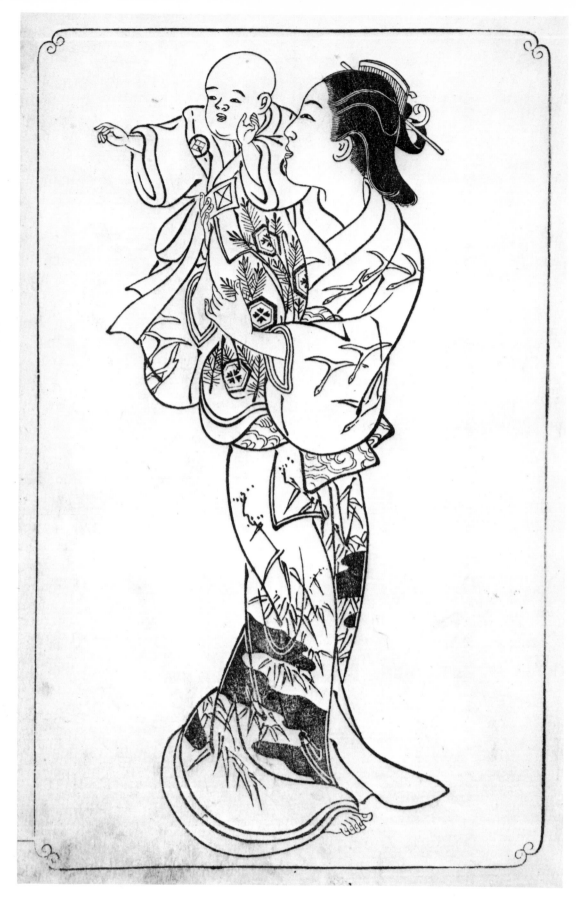

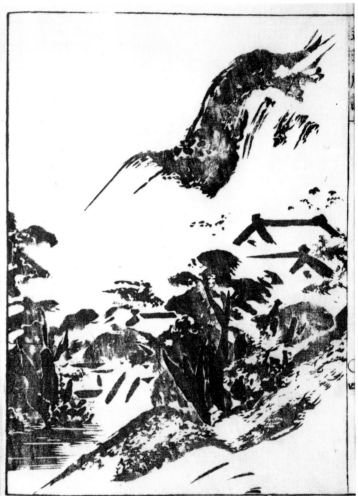

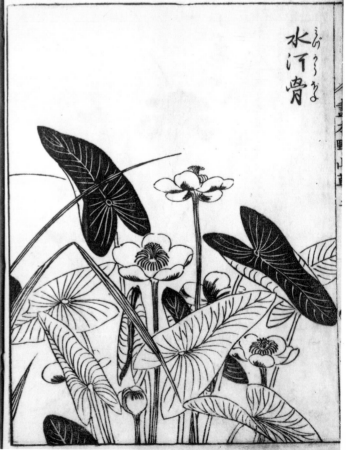

水汀骨
かうほね

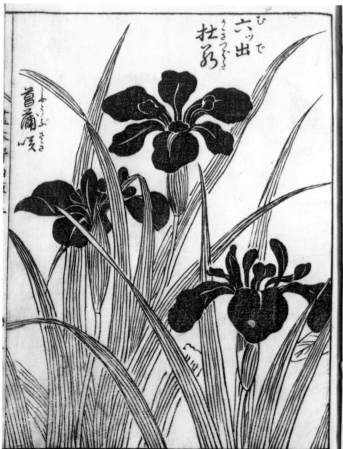

ひで 六ッ出
うきつばた 杜若
あやめさき 菖蒲咲

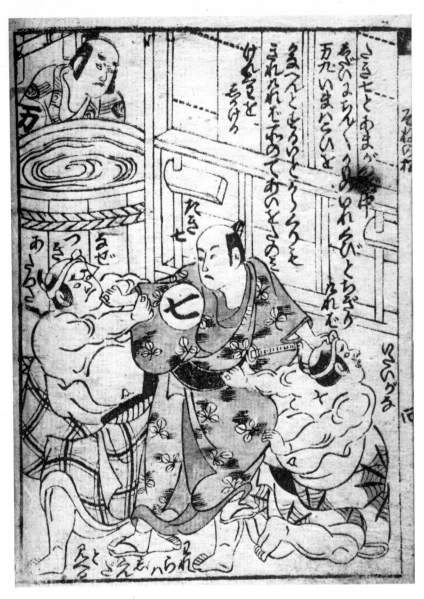

28

26 Shumboku

Gakō Senran Aspects of the Hidden Skills of Painting

1740
Publisher: Tongaya Kyuhei, Osaka.
6 vols. 272 × 178 mm.
Literature: KS, vol. 2, p. 104.

A typical compendium of reproductions of Chinese and Japanese paintings, ancient and modern, intended for the lay public as well as artists.

Illustrated: Wader on willow; vol. 3.

27 Tachibana Yasukuni 1717–1792

Ehon Noyamagusa Picture-book of Wild Flowers

1755
Publisher: Shibukawa Seiemon, Osaka.
5 vols. 223 × 158 mm.
Literature: KS, vol. 1, p. 499; *Ryerson*, p. 319.

A botanical compendium which maintains on each page the highest standards of design and of effective use of the black and white medium.

Illustrated: Irises and water plantains; vol. 2.

28 Attributed to Torii Kiyomasu II *fl. c.* 1720s–1760s

Banshū Sone no Matsu The Pine-trees of Sone in Harima Province

c. 1750–5
Publisher: Urokogataya, Edo.
2 vols (of 3). 183 × 132 mm.

A *kurobon*, 'black-covered' book; light fiction of the *kusazōshi* type with copious illustrations, popular between 1740 and 1780, and designed for the less literate book-buying public.

Illustrated: Cartoon-like illustration of a brawl at night; vol. 1.

29 Anon

Kaishien Gaden The Mustard Seed Garden Painting Manual

(Original Chinese title *Jie Zi Yuan Shu Hua Pu*)
1748
Publisher: Kananrō, Kyoto.
4 vols. (of 6). 284 × 181 mm. Colour-printed.
Literature: A K'ai-ming Ch'iu, 'The Chieh Tzu Yuan Hua Chuan (Mustard Seed Garden Painting Manual)' in *Archives of the Chinese Art Society in America*. Mitchell does not mention this edition.

This is the first Japanese edition (in part) of the Chinese work first published, with colour-printed illustrations, in 1679, whose popularity both in China and Japan is attested by the many editions in both countries. In China it aimed to introduce 'scholarly' painting to the townsmen of Nanking; in Japan it was taken as the gateway to Chinese painting itself and to the art of full-colour printing.

Illustrated in colour (p. 17): Magnolia; vol. 4.

30 Anon

Kaishien Gaden The Mustard Seed Garden Painting Manual

1753
Publisher: Kananrō, Kyoto.
5 vols. 285 × 182 mm. Partly colour-printed.
Literature: Brown, p. 111; A K'ai-ming Ch'iu, *op. cit.*; Tadashige Ono, *Shina Hanga Sōkō*, Tokyo, 1944; de Roos, no. 76. Mitchell does not mention this edition.

This book completed the publication of the Japanese edition of part of the Chinese original. Like the *Hasshū Gafu* (no. 6), the book had an immense influence on the development of *Nanga* in Japan.

Illustrated in colour (p. 17): Chinese lakeside landscape; vol. 5.

31 Tatebe Ryōtai 1719–1774

Kanyōsai Gafu Kanyōsai's Picture-album

1762
Publisher: Suwaraya Ichibei, Edo.
3 vols. 271 × 175 mm.
Literature: Brown, p. 115; Mitchell, pp. 341–2; *Ryerson*, pp. 412–13; Waterhouse, no. 133.

Kanyōsai was one of Ryōtai's art-names. This was one of the more influential manuals conveying implicit instruction on Chinese-style painting but it included many pages of great power in a thoroughly graphic and non-Chinese style. The three-volume edition was followed by editions in four and five volumes. In the last volume of the five-volume edition (of the same year) Ryōtai gives his version of a scroll by Shen Nanpin, the Chinese artist whose presence in Nagasaki in the 1730s had led to the founding of the Nagasaki school of painting in Japan.

Illustrated: Ducks; vol. 1.

32 Ryōtai

Kenshi Gaen Mr Tatebe's Garden of Pictures

1775
Publishers: A number of publishers and booksellers in Kyoto, Edo and Osaka.
3 vols. 260 × 186 mm. Partly colour-printed.
Literature: Brown, p. 115; Holloway, no. 28; Mitchell, pp. 358–9; Waterhouse, no. 132.

Consists principally of copies by Ryōtai of Chinese paintings in the collection of Kimura Kenkadō (1736–1812). Bibliographically there are problems owing to the fact that there were separate issues in two, in three and in four volumes, and it is as yet unclear in which order they appeared.

Illustrated: Fish called 'bingyō'; vol. 3.

33 Sō Shiseki 1712–1786

Sō Shiseki Gafu Sō Shiseki's Picture-album

1765
Publishers: Suwaraya Mohei and Suwaraya Shirōemon, Edo.
3 vols. 268 × 180 mm. Partly colour-printed.
Literature: Brown, p. 114; Holloway, no. 49; Mitchell, p. 502.

The colour prints are experimental, with some affinity to the prints in the 'Mustard Seed Garden Painting Manual' (nos. 29 and 30).

Illustrated: Landscape with pines in *Nanga* style; after Jung Chu.

34 Shiseki

Kokon Gasō: Kohen Thicket of Ancient and Modern Pictures: Sequel

1769–71
Publishers: Suwaraya Mohei, Edo, and others in Edo and Kyoto.
8 vols. 267 × 170 mm. Partly colour-printed.
Literature: J. Hillier, *Highly Important Japanese Prints, Illustrated Books and Drawings from the Henri Vever Collection*, part 1, London, 1974, no. 167; Mitchell, pp. 373–4; de Roos, no. 88; *Ryerson*, p. 415; Waterhouse, no. 138. This set, from the first Vever sale (ex Odin), is fully described in the Sotheby catalogue, 26 March 1974, no. 167.

No two sets of this multi-volumed work coincide, and it is accepted as an unsolvable bibliographical problem. The contents of these volumes vary from the driest ink outline after academic Chinese woodblock versions of classic paintings to the most starkly graphic designs in which several colours are merged into each other on one block.

Illustrated: Evening over the mountain village; vol. 5.

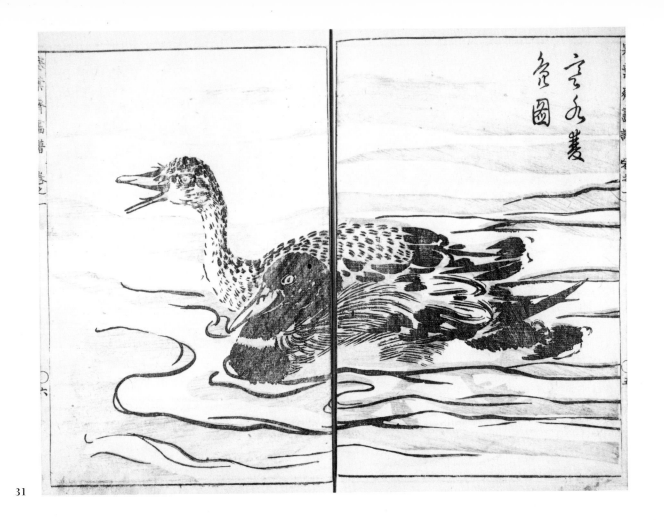

31

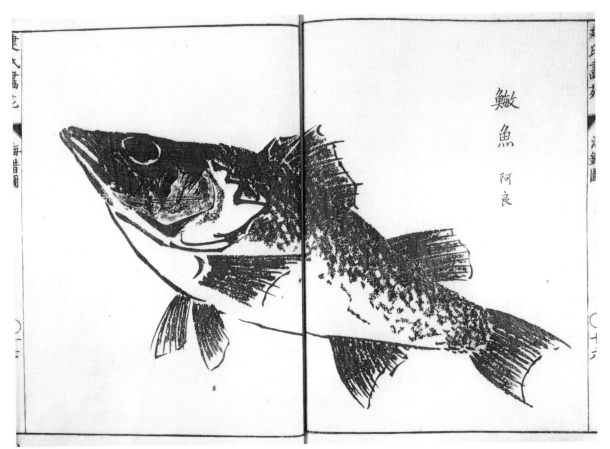

32

33

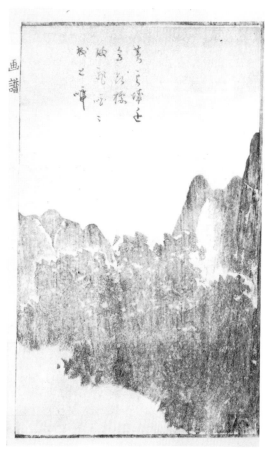

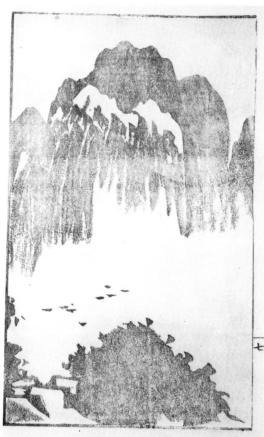

34

35 Katsuma Ryūsui 1711–1796 and Hanabusa Ippō
1691–1760

Wakana Fresh Shoots

Preface dated 1756
Publisher not given.
1 vol. 274 × 181 mm. Partly colour-printed.
Literature: Brown, p. 57; Dawes, p. 62 (under title *Hokkei Chō*); *Ryerson*, p. 350.

Memorial volume for the poet and teacher Doku-an Chōha (1705–40). The illustrations by Ippō, including a portrait of Chōha, are in *sumi*; those by Ryūsui are colour-printed and remarkable for anticipating the *nishikie* of 1765 and later.

Illustrated in colour (p. 18): Autumn landscape.

36 Ryūsui

Yama no Sachi Boon of the Mountains

1765
Publishers: Ōsakaya Heisaburō and Matsumoto Zembei, Edo.

2 parts (in 1 vol.). 275 × 194 mm.
Literature: Dawes, p. 121 (under title *Kyōka Hana Dzukushi*); KS, vol. 7, p. 814; Sorimachi, no. 421.

An exceptional book of flower designs colour-printed with unusual subtlety and accompanied by calligraphic pages of *haiku*.

Illustrated in colour (p. 35): Gourd vine; part 2.

37 Nagasawa Hakuin 1685–1768

Kobiku Uta Ballad of Bravado

1760
Publisher: ? Kinoshita.
Folding album. 310 × 231 mm.

From an MS of Hakuin with two typical illustrations. The block-cutter has contrived to convey the powerful individual quality of Hakuin's brush not only in the illustrations but also in the calligraphy.

Illustrated: The popular goddess Okame preparing tea.

38

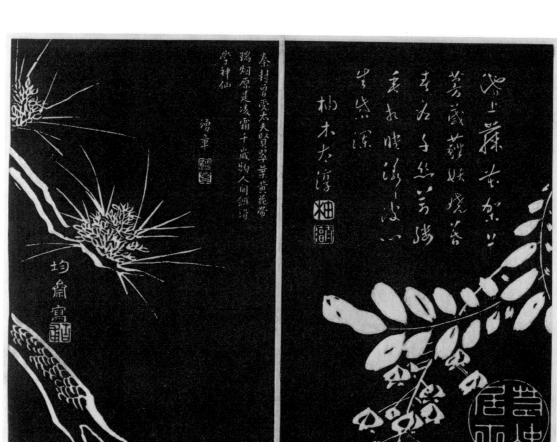

39

38 Itō Jakuchū 1716–1800

Soken Sekisatsu

1768
Blocks owned by Eishōbō, Junshōji, Kyoto.
Folding album. 298 × 178 mm. *Ishizuri.*
Literature: Mitchell, p. 499; Sorimachi, no. 426.

Ishizuri, so-called 'stone prints' (the Japanese term for this sort of book is *takuhon*, 'folio of rubbings'). The designs are by one of the greatest of Japanese individualistic artists. The prints are related to those produced by the Chinese stone-rubbing process. The title, which may yet prove incorrect, seems to refer to the process but has never been satisfactorily translated. See also nos. 39 and 40 for other examples of this technique.

Illustrated: Tree peony, with calligraphic Chinese poem, in style of a stone-rubbing.

39 Various artists

Shōshun Hō Admiring the Fragrance of Spring

1777
Publisher: Emi Nagatoshi, Kyoto.
Folding album. 250 × 165 mm. *Ishizuri.*
Literature: Mitchell, pp. 487–8; *Ryerson*, p. 368; Sorimachi, no. 441.

Ishizuri illustrations to *haiku*. Jakuchū, Taiga and Ōkyo are among the many artists who contributed designs.

Illustrated: Kinsai (left) and Jakuchū (right). Wisteria and pine, in style of stone-rubbings.

40 Hatta Koshū

Chūko Sanjū-rokkasen The Thirty-six Poetic Immortals of the Middle Ages

1793
Publisher not given, but possibly the block-cutter Omori Ichibei.
1 vol. 310 × 212 mm. *Ishizuri.*
Literature: Hillier (2), pp. 157–8.

The works of the thirty-six poets with an allusive and powerful illustration opposite each, all imitating ink-rubbings. This is a memorial volume to a calligraphy master named Ryūchi, compiled by his pupils, each poem in the hand of a different pupil.

There seems to be nothing to connect this Koshū with the artist of *Koshū Gafu* (no. 118), and in fact their names are composed of different characters.

Illustrated (p. 33): Moon and bamboo, illustrating a poem by Dainagon Michitomo with calligraphy by Shōwa.

41 Kitao Sekkōsai (Tokinobu) *fl.* 1750s–1760s

Saishiki Gasen A Selection of Coloured Drawings

1767
Publishers: Shibukawa Daizō, Osaka; Kawakami Shirōemon, Kyoto; Suwaraya Heisuke, Edo.
2 vols. (of 3). 270 × 175 mm. Colour-printed in various techniques.
Literature: KS, vol. 3, p. 642; *Vever Catalogue*, vol. 1, no. 206.

The pages of this rare work were produced by a combination of block-printing, brush painting through stencil, and *fukie* or *fukibotan*, a technique of blowing and atomising colour, also through stencil. Mica was also applied.

Illustrated (p. 39): Rat on *daikon* (both symbols of the god Daikoku).

42 Tachibana Minkō *fl.* 1760s–1770s

Saiga Shokunin Burui Various Classes of Artisans in Coloured Pictures

1770
Publishers: Nemura Tosaburō and Sawa Isuke, Edo.
2 vols. (complete). 285 × 190 mm. Stencil-printed.
Literature: Binyon and Sexton, p. 212; Brown, p. 66; *Ryerson*, p. 178 for second (1784) edition; *Vever Catalogue*, vol. 1, no. 207; Waterhouse, no. 129.

Probably the finest *kappazuri* (stencil) work ever produced in Japan and a deeply interesting account of contemporary craftsmanship. Ex Morrison Collection.

Illustrated in colour (p. 18): Woman and child awaiting a quiver-salesman (detail); vol. 1.

43 Kitao Shigemasa 1739–1820

(Gekijō Fūzoku) Ehon Sakae no Gusa Theatre Life: a Picture-book of the Flowers of Prosperity

1771
Publishers: Nakamura Tadatsugi and one other, Edo.
3 vols. 220 × 158 mm.
Literature: Brown, p. 148.

Includes a section of seven pages of *mon* (crests) with the actors' names below, which is of value to Kabuki students.

Illustrated: Dressing and making-up female impersonators (*onnagata*) for the Kabuki stage; vol. 3.

44 Shigemasa and Katsukawa Shunshō 1726–1792

Seirō Bijin Awase Sugata Kagami A Mirror of Beautiful Women of the Green Houses Compared

1776
Publishers: Yamazaki Kimbei and Tsutaya Jūsaburō, Edo.
3 vols. 280 × 185 mm. Colour-printed.
Literature: Brown, pp. 148, 161; *Ryerson*, pp. 180–1; Sorimachi, no. 439.

Acknowledged as one of the outstanding illustrated books of the world. The 'Green Houses' were the great establishments of courtesans in Edo. The seasons are represented by flowers at the beginning of each volume – spring and summer in volume 1, autumn and winter in volume 2. Volume 3 has verses on the four seasons written by the courtesans depicted in the prints. Although some have seen Shigemasa's hand in the spring and autumn pictures and Shunshō's in the remainder, the two artists, as was often the case in collaborative works of this nature, contrived to give a surprising uniformity to the style throughout, and there is far from universal agreement on the division mentioned.

Illustrated in colour (p. 36): Icy morning at the house of Maruya; vol. 2.

43

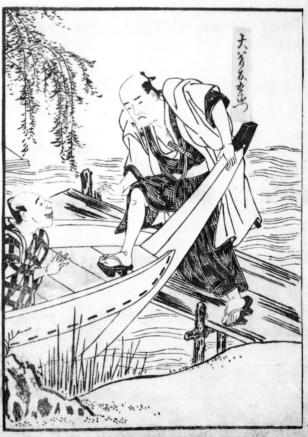

45

68

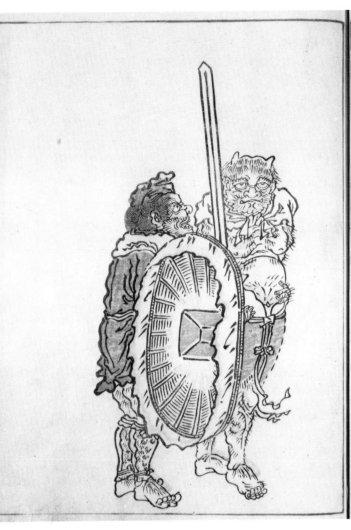 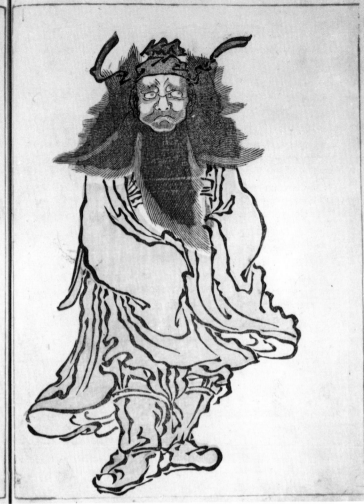

46

45 Shunshō

Yakusha Natsu no Fuji Actors like Fuji in Summer

1780
Publishers: Okumura Genroku and Matsumura Yahei, Edo.
1 vol. 215 × 150 mm.
Literature: *KS*, vol. 7, p. 754; facsimile, *NFZ*, vol. II; *Odin*, no. 85;
Ryerson, pp. 181–2.

'Fuji in Summer' means 'Fuji without snow', which is a droll
circumlocution for 'Actors without their wigs', that is, 'off-
stage'. There are two editions of this book, distinguished by
differences in the figures in the last illustration (discussed in both
Odin and *Ryerson*). In this copy the actors are identified by MS
slips neatly stuck to the pages.

Illustrated: Kabuki actors on a Sumida River pleasure-boat.

46 Toriyama Sekien 1712–1788

Sekien Gafu Sekien's Picture-album

1774
Publisher: Yūrien Toshū, Edo.
2 vols. 318 × 215 mm. Partly colour-printed.
Literature: Binyon and Sexton, p. 213; Brown, p. 167; Waterhouse, no.
135.

Sekien runs the gamut from *Kanō* landscape to *Ukiyoe* genre, and
the print-makers give a virtuoso interpretation from the
extremely delicate to the vigorously bold.

Illustrated: Shoki the Demon Queller with two subdued demons,
in *Kanō* style.

47 Isoda Koryūsai *fl. c.* 1766–1788

Azuma Nishiki Matsu-no-kurai Courtesans in Brocades of the East

Preface dated 1777
Publisher: Urokagataya, Edo.
1 vol. (incomplete). 218 × 162 mm. Colour-printed.
Literature: Brown, p. 145.

The title needs explanation: 'Brocades of the East' was a way of describing Edo (*Azuma*, or East) colour prints. According to tradition, the title *Matsu-no-kurai*, 'The High Steward of the Pine', was conferred by the first Chin Emperor of China on a pine-tree under which he sheltered during a rainstorm. In the Edo period it was one of the numerous nicknames for courtesans.

A book of exceptional rarity (no complete copy is known) owing to the fact that most copies have been divided up. Single pages are fairly common. Although quite charming, it is difficult to justify Mrs Brown's extravagant praise of it as 'Perhaps the most beautiful of all Japanese colour-printed books'. It certainly cannot compare in design, interest or quality of printing with, for example, no. 44.

Illustrated: Courtesans of Matsuganeya looking at the latest colour-printed fans.

48 Koryūsai

Konzatsu Yamato Sōga A Miscellany of Native Pictures in Cursive Style

1781
Publishers (of first edition): Takekawa Tōsuke and Izumiya Kōjirō, Edo. This copy lacks a colophon.
3 vols. 275 × 185 mm.
Literature: Brown, p. 146; *Ryerson*, pp. 174–5.

A follower of Harunobu, Koryūsai first worked in true *Ukiyoe* style, but in the latter part of his career returned to something closer to the *Kanō*, as in this book. The 'cursive' or 'rough' style was cultivated by artists claiming to understand Chinese art.

Illustrated: Street-tradesmen brawling; vol. 1.

49 Mori Ransai 1740–1801

Ransai Gafu: Ran no Bu Ransai's Picture-album: Epidendrum Section

Preface dated 1778
No colophon.
4 vols. 285 × 183 mm. Printed on thin Chinese-style paper.
Literature: Sorimachi, no. 500.

The narrow-leaved epidendrum, an orchidaceous plant, was used by artists as they used the bamboo, as a basis for what were virtually calligraphic exercises, beginning with simple forms and developing into complex compositions demanding the utmost virtuosity. In this book, and succeeding works by the artist based on bamboo, prunus and chrysanthemum (see no. 50), the *sumi* printing is exceptionally subtle and sensitive, reflecting a true sense of a brush in movement.

Illustrated: Epidendrums by a stream; vol. 4.

50 Ransai

Ransai Gafu: Kiku no Bu, Ume no Bu, Kiseki Sōsui no Bu, Tori no Bu Ransai's Picture-album: Chrysanthemum, Plum, Trees, Rocks, Grasses, Water and Bird Sections

1801
Publishers: Owada Yasubei and Suwaraya Mohei, Edo.
4 vols. 280 × 188 mm.
Literature: Isaac, no. 415; Sorimachi, no. 500; *Vever Catalogue*, vol. 3, p. 677.

The *hashira* ('pillar' or outer margin) title is *Nampin Sensei Gaden*, 'Record of the Painting of the Master Nampin' (the Chinese master Shen Nanpin, who resided in Nagasaki in the 1730s and had a pronounced influence on a number of Japanese artists). The chrysanthemum section uses grey blocks to produce luminously atmospheric effects.

Illustrated: White pheasants in the snow; vol. 4.

51 Kunitaka Suifutei *fl.* 1780s

Suifutei Gigafu An Album of Humorous Pictures by Suifutei

1782
Publisher: Seikōdō, probably Osaka.
1 vol. 260 × 160 mm.
Literature: Yoshida, 'Suifutei Gigafu no Sonzai', in *Ukiyoe Art*, no. 39, Tokyo, 1969.

Highly individual portraits of actors, remarkable not only for the characterisation but in many instances for the extreme asymmetry of placement on the page. They seem to have had a profound influence on the *Kamigata* school of actor portraitists, especially Ryūkōsai and Shōkōsai.

Illustrated: The Kabuki actors Arashi Sanzaemon (left) and Otowa Jirōzō (right).

52 Torii Kiyonaga 1752–1815

Ehon Monomi ga Oka Picture-book of Hills of Fair Views

1785
Publishers: Nishimura Genroku and Iseya Kichijirō, Edo.
2 parts (in 1 vol.). 222 × 163 mm.
Literature: Chie Hirano, *Kiyonaga, A Study of His Life and Work*, Boston (Mass.), 1939, pp. 495–6.

Life in Edo throughout the year by one of the foremost *Ukiyoe* artists. About 1850 a new edition was published in colour, with the heads recut to bring the style of hairdressing up to date.

Illustrated: Samurai and their ladies enjoying the breeze by the Sumida River in Edo; part 1.

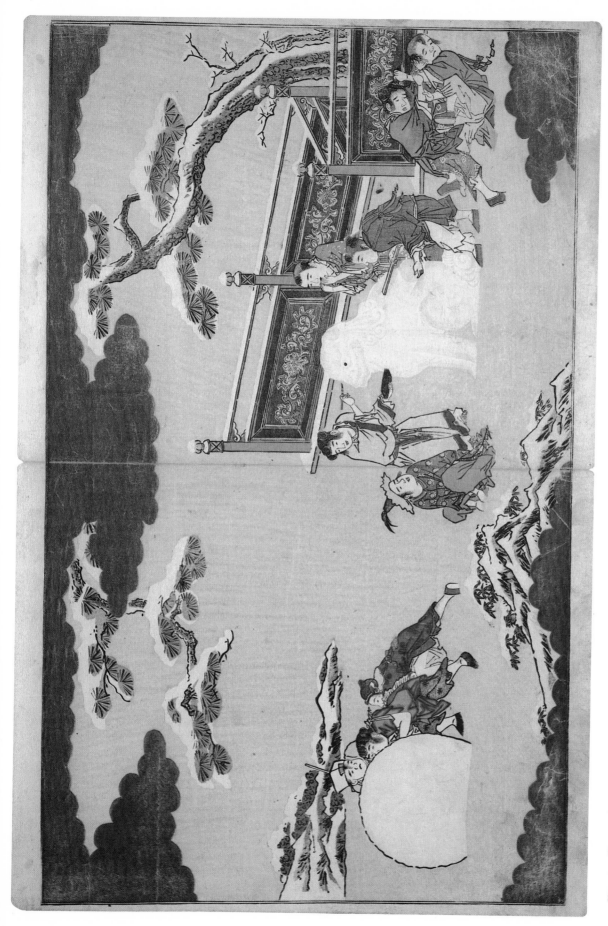

57 Kitagawa Utamaro (1753–1806). Building a snow-lion: from *Ginsekai*, 1790.

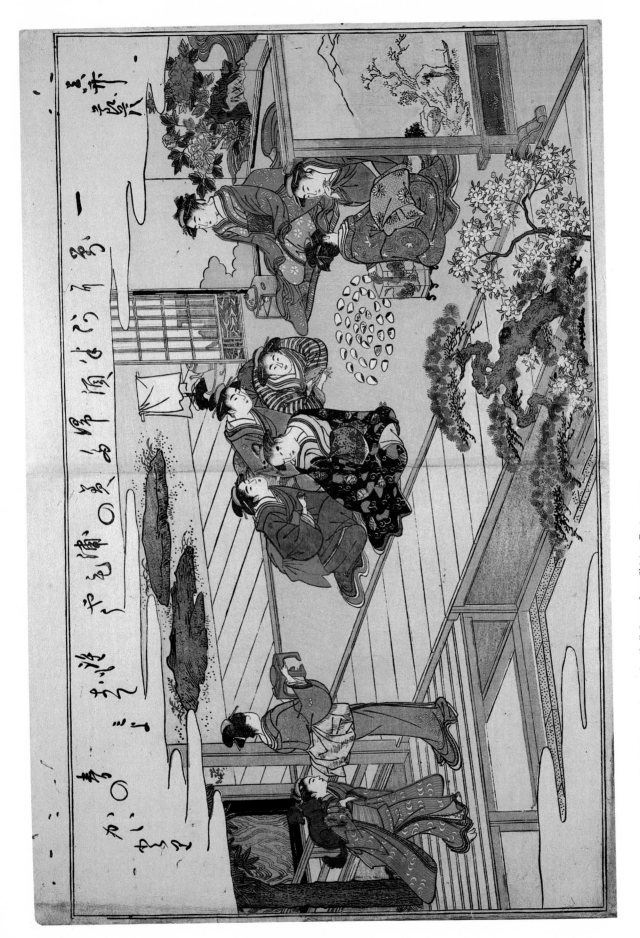

58 Kitagawa Utamaro (1753–1806). Women playing the Shell Game; from *Shioi no Tsuto*, c. 1790.

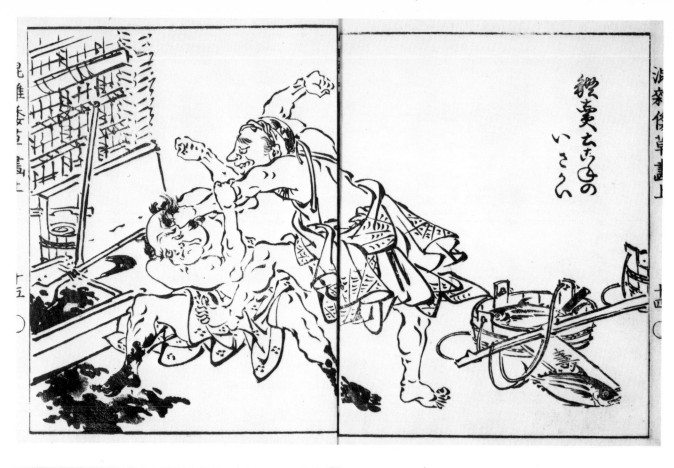

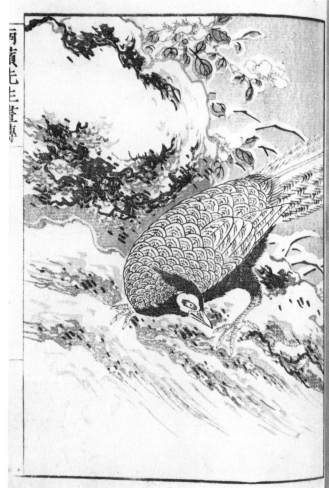

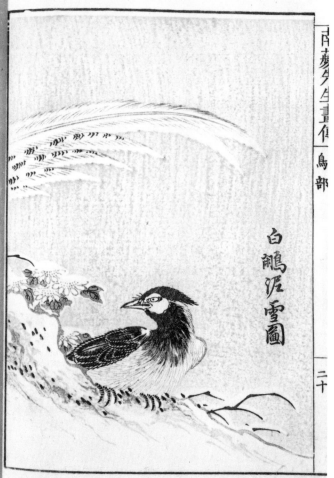

音羽治郎三

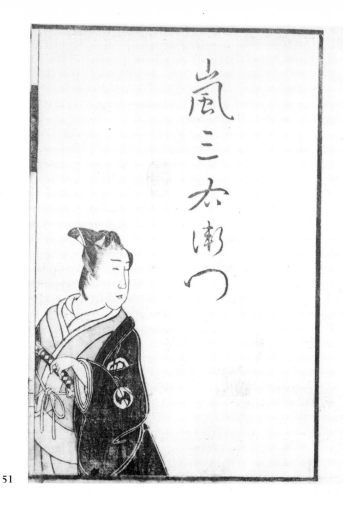

嵐三太郎つ

51

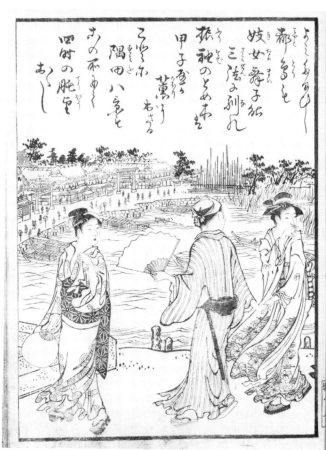

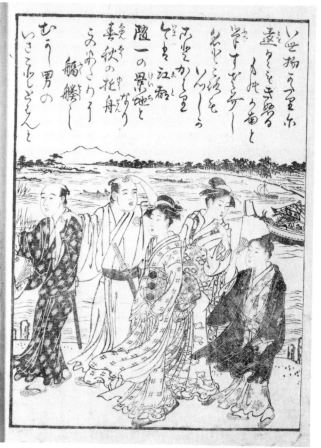

52

53 Kitao Masanobu 1761–1816

Yoshiwara Keisei Shin Bijin Awase Jihitsu Kagami
A Mirror Comparing the Handwriting of New and
Beautiful Courtesans of the Yoshiwara

1784
Publisher: Tsutaya Jūsaburō, Edo.
Folding album. 382 × 255 mm. Colour-printed.
Literature: Binyon and Sexton, pp. 214–15; Brown, p. 150.

One of the most sumptuously printed of all Japanese colour-
printed albums. The seven unusually large prints depict leading
courtesans of the day in their finery, with verses inscribed above
in their own calligraphy. They are usually found detached and
as a result faded, but this fine copy gives full credit to one of the
masterpieces of *Ukiyoe* art.

Illustrated in colour (p. 54): The literary courtesans Tagasode and
Hitomoto.

54 Kitagawa Utamaro 1753–1806

Ehon Mushi Erabi Picture-book of Selected Insects

1788
Publisher: Tsutaya Jūsaburō, Edo.
2 vols. 271 × 185 mm. Colour-printed, with mica and gauffrage.
Literature: Brown, p. 169; Hillier (1), ch. VI; Odaka, no. 5; *Ryerson*,
pp. 220–2; J. J. O'Brien Sexton, 'Illustrated Books of Japan II:
Utamaro's Books of Natural History', in the *Burlington Magazine*,
no. CLXXX, vol. XXXII, March, 1918.

In the year 1788 Utamaro's reputation was established by the
publication of masterpieces in two entirely different spheres, the
Uta Makura, an album of unsurpassable erotic prints (not in the
Hillier Collection) and the *Ehon Mushi Erabi*, a book of *kyōka*
(lightweight verses) and of supremely beautiful prints of flowers,
insects and other creatures.

Illustrated in colour (p. 53): Balloon-flower with other plants, and
cicada; vol. 2.

55 Utamaro

Ehon Waka Ebisu Picture-book of Young Ebisu

1789
Publisher: Tsutaya Jūsaburō, Edo.
Folding album. 259 × 189 mm. Colour-printed with gauffrage and
gold and silver leaf.
Literature: Binyon and Sexton, pp. 218–19; Brown, p. 169; Roger
Keyes, 'Envisioning the Past: Utamaro's Album *Waka Ebisu*' in *A Sheaf
of Japanese Papers*, The Hague, 1979; Odaka, no. 1.

This is one of a series of New Year albums, each of five colour
prints, to which *Kyogetsubō* and *Ginsekai* (nos. 56 and 57) also
belong. The title is not easily translatable because of a play, or
plays, on words: *Ebisu* is the popular god most associated with
the New Year, but *Waka* can be 'young' or 'thirty-one syllable
poem'. Broadly, the meaning can be taken as 'An Anthology of

New Year Verse'. The contents are varied, with two prints
simulating the courtly *Tosa* style, a third, Moronobu period
genre, the remaining two being contemporary *Ukiyoe*.

Illustrated: New Year snow on the outskirts of Edo.

56 Utamaro

Kyogetsubō The Full Mad Moon

1789
Publisher: Tsutaya Jūsaburō, Edo.
Folding album. 254 × 190 mm. Colour-printed with gauffrage and
gold and silver leaf.
Literature: Binyon and Sexton, p. 220; Hillier (1), ch. VII; Odaka, no. 8;
Ryerson, p. 451.

As in *Waka Ebisu*, several of the five prints adopt the style of
earlier masters of other schools – *Tosa* in the Yukihira episode,
Itchō in a rustic scene, and, most remarkably, *Kanō* in a classical
landscape. The full moon figures in all five prints.

Illustrated: Moonlit landscape in *Kanō* style.

57 Utamaro

Ginsekai The Silver World

1790
Publisher: Tsutaya Jūsaburō, Edo.
Folding album. 255 × 190 mm. Colour-printed with gauffrage.
Literature: Binyon and Sexton, pp. 220–1; Brown, p. 169; Hillier (1),
ch. VII; Odaka, no. 9.

This album, with five snow scenes in a variety of styles, may be
thought of as part of a traditional trilogy of 'Snow, Moon and
Flowers' (*setsugekka*), *Kyogetsubō* (no. 56) representing the
Moon, and *Fugenzō* (not in the Hillier Collection), the Flowers.

Illustrated in colour (p. 71): Building a snow-lion.

58 Utamaro

Shioi no Tsuto Gifts of the Ebb-tide

c. 1790
Publisher: Tsutaya Jūsaburō, Edo.
Folding album. 260 × 190 mm. Colour-printed, with gauffrage, brass
dust, mica, gold and silver leaf.
Literature: Binyon and Sexton, pp. 222–3; Brown, p. 169; Hillier (1),
ch. X, pls. 37–9; Odaka, no. 7.

There are eight colour prints: an opening view of shell-gathering
at Shinagawa Bay; six prints of shells, seaweed and other sea
wrack; and a fine interior scene of women playing the Shell
Game (*kai-awase*). This is the first issue, with wave lines decora-
ting the upper part of each page of shells, and scattered brass dust
simulating the sand of the beach. Acknowledged as one of the
technical masterpieces of Japanese woodblock printing.

Illustrated in colour (p. 72): Women playing the Shell Game.

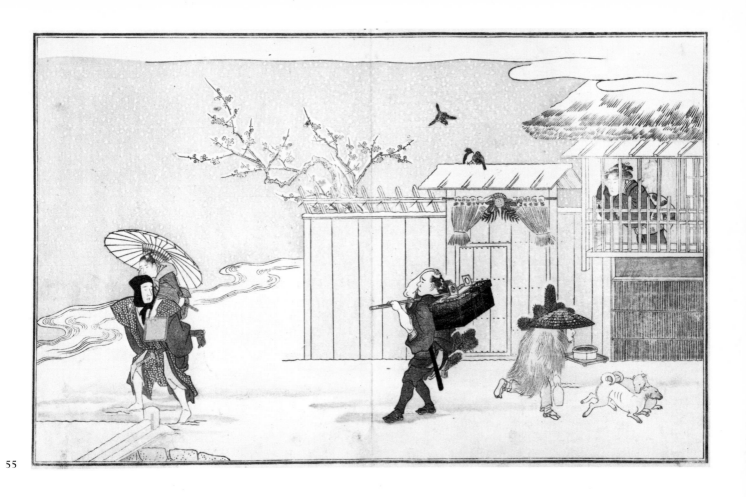

55

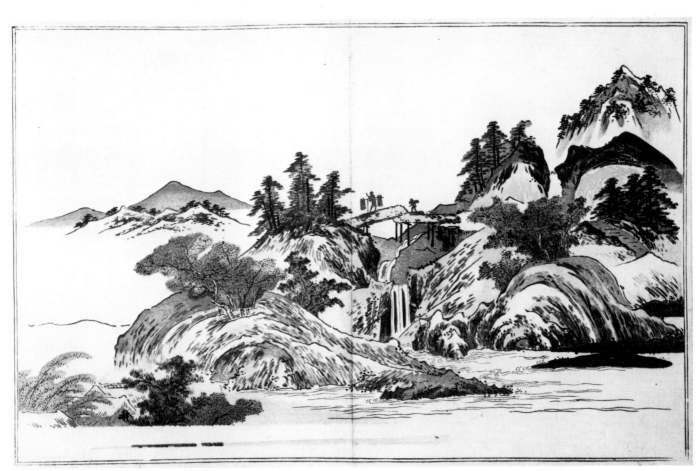

56

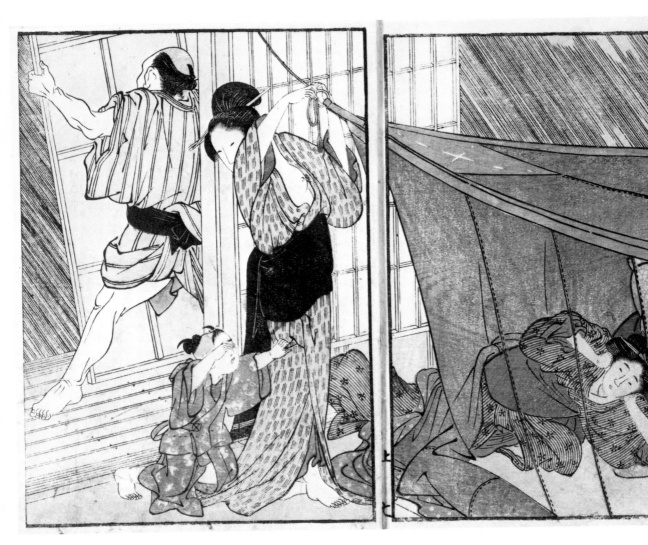

59

59 Utamaro

Ehon Shiki no Hana Picture-book of the Flowers of the
Four Seasons

1801
Publisher: Izumiya Ichibei, Edo.
2 vols. 217 × 152 mm. Colour-printed.
Literature: Brown, p. 170; *Duret*, no. 144; Hillier (1), pp. 139–40;
Odaka, no. 23.

Pictures of courtesans, the seasons introduced by single-page
prints of flowers. In this and no. 60 Utamaro displays both his
intimacy with the Edo licensed quarters and his sympathy for
and understanding of its denizens.

Illustrated: Women and child retiring for the night under a
mosquito net (with a servant fitting the shutters); vol. 1.

60 Utamaro

Seirō Ehon Nenjū Gyōji Picture-book of Events of the
Year in the Green Houses

1804
Publisher: Kazusaya Chūsuke, Edo.
2 vols. 225 × 158 mm. Colour-printed.
Literature: Brown, p. 170; *Duret*, no. 146; Goncourt, *op. cit.*, pp. 64–95;
Hillier (1), ch. XIX; Odaka, no. 24.

The most widely known of Utamaro's books, partly because a
translation of the lively text, by the comic writer Jippensha Ikku
(1765–1831), figured in Edmond de Goncourt's *Outamaro: Le
Peintre des Maisons Vertes* (Paris, 1896). The most celebrated
page shows a rather idealised Utamaro decorating the interior of
one of the Houses with a painting of a *hō-ō* bird, watched by
admiring courtesans.

Illustrated in colour (p. 36): Apprentice courtesans with lanterns
at the Niwaka Festival; vol. 1.

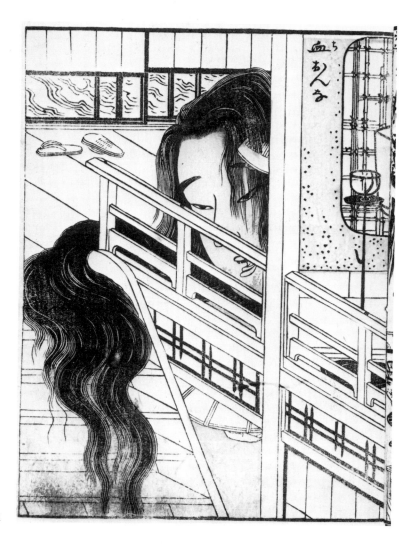

61

61 Katsukawa Shun'ei 1762–1819 with Shunshō

Imawa-mukashi Once upon a time . . .

1790
Publishers: Suwaraya Ichibei, Enshōya Bishichi and Sankiya Seikichi, Edo.
3 vols. 207 × 148 mm. Partly colour-printed.
Literature: Incorrectly named *Kwaidan Hyaku Zue* in Brown, p. 164, and in *Collection Ch. Gillot, Deuxième Partie*, Paris, 1904, no. 391.

A book of ghost stories. The colophon indicates that Shun'ei was assisted by his master, Shunshō. This is the most imaginative and the best designed and printed of all Japanese books of *diablerie*. The title is an elaborate play on written characters; the first three can mean 'stories of strange demons' as well as 'once upon a time'.

Illustrated: 'Blood Woman', vol. 3.

62 Yushidō Shunchō *fl. c.* 1780–1800

Ehon Sakaegusa Picture-book of a Prosperous Household

1790
Publisher: Izumiya Ichibei, Edo.
2 vols. 217 × 154 mm. Colour-printed.
Literature: Brown, p. 163 (colour pl. 31); *Ryerson*, p. 183.

A woman's life, her schooldays, and wedding in volume 1, her life after marriage, the birth of a child, and the first visit to a temple with the child in volume 2. The books are a form of guide to accepted middle-class usage for those aspiring to that status.

Illustrated: Wedding ceremony; vol. 1.

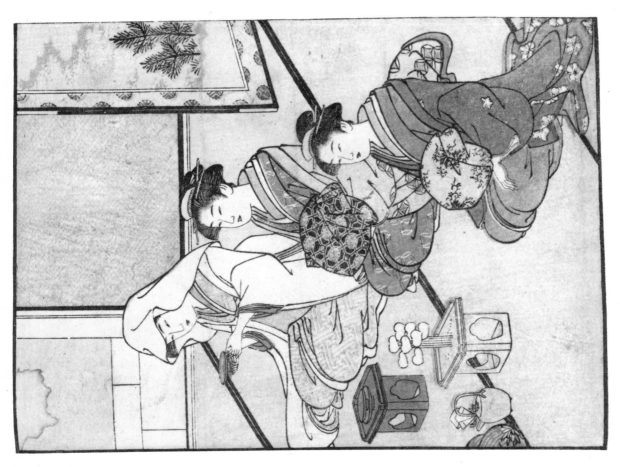

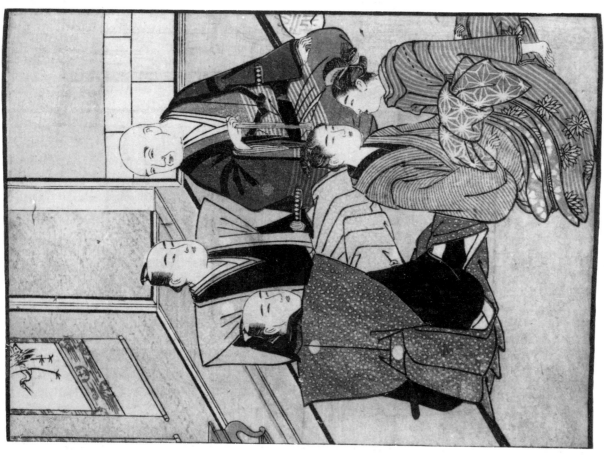

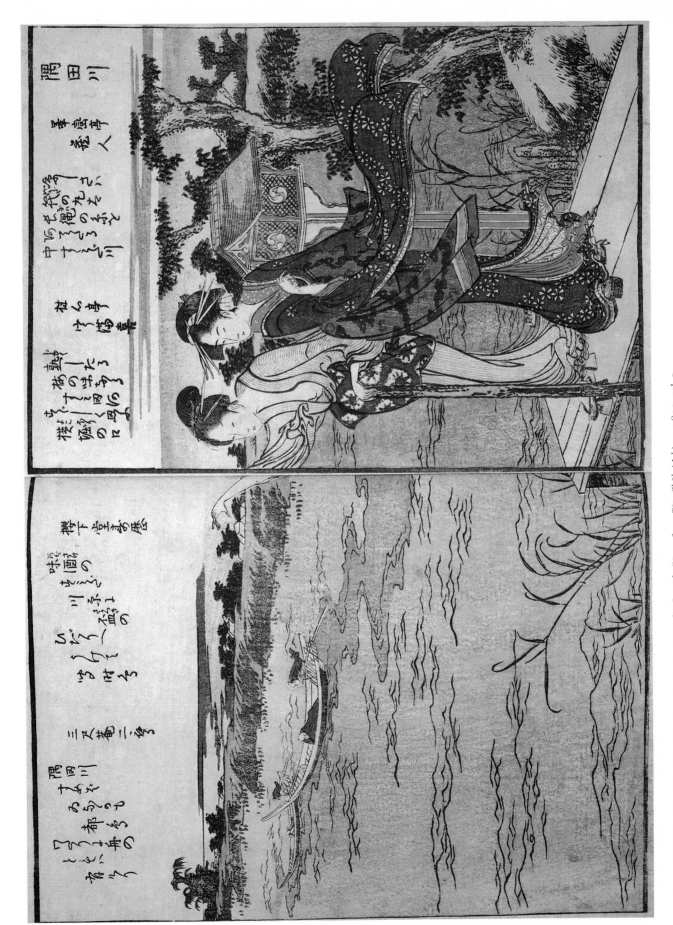

103 Katsushika Hokusai (1760–1849). Landing at a teahouse on the Sumida River; from *Tōto Shōkei Ichiran*. 1800. vol. 1.

金閣寺ハ七年所井乾名笠山の
ふりとてもあり禅宗ふ一て
鹿花寺ともい一應永四年
将軍義蒲公高閣と
院殿也高閣とかりて
花多八ば一一金泊を
名そこ一面ま一まかひ
一て九山八海と
るげけつてる
寄そそ其ぐ
あり金閣
三重と
して

衣笠山

金閣

金閣
三重ふ一て
第一法水院
第二潮音洞
第三究竟項
しよ

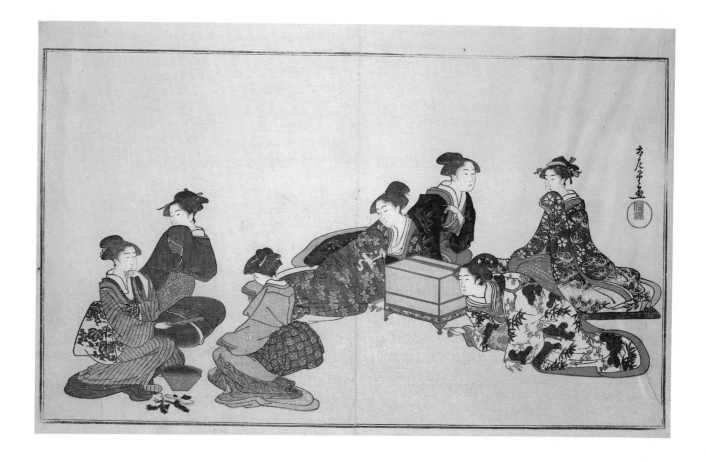

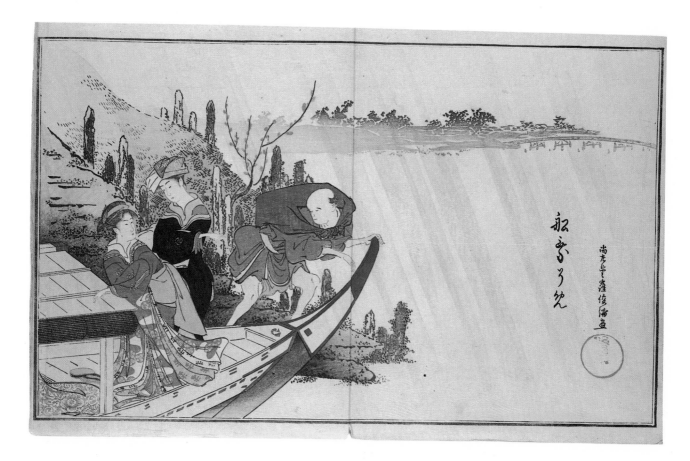

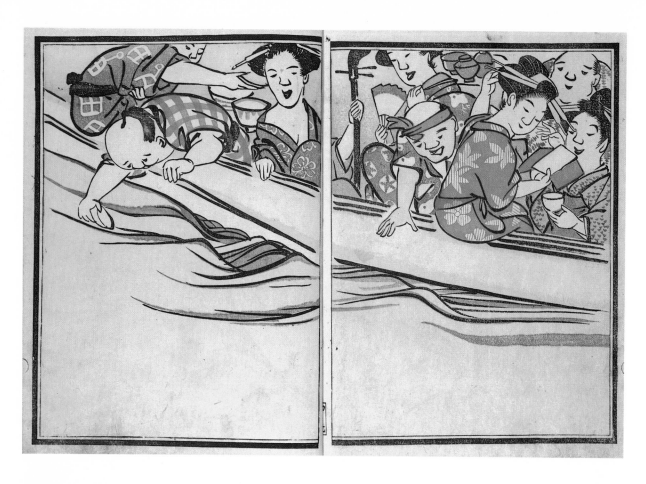

63

63 Keisai Masayoshi 1764–1824, Shiba Kōkan 1737–1818 and others

Kōmō Zatsuwa A Miscellany of Dutch Studies

1787
Publisher not given, but Edo.
5 vols. 223 × 157 mm.
Literature: C. R. Boxer, *Jan Compagnie in Japan, 1600–1850*, new edn., Oxford, 1969, pp. 113–15; Calvin L. French, *Shiba Kōkan*, New York, 1974.

Kōmō (red-haired) was the term used by the Japanese during the Isolation for describing Dutchmen, in the belief that, like demons, they all had red hair. Kōkan's illustrations include a microscope, and insects, flowers and seeds viewed through the lens. The text is edited by Morishima Chūryo.

Illustrated: Electric generator; vol. 5.

64 Masayoshi

Ehon Miyako no Nishiki Picture-book of Brocades of the Capital (Kyoto)

1787
Publisher: Yoshinoya Tamehachi, Kyoto.
1 vol. 300 × 220 mm. Colour-printed.
Literature: Brown, p. 123; *Ryerson*, p. 208.

Landscape prints of this amplitude and complexity had rarely been accomplished before in Japan. 'Brocades' refer to the coloured woodblock process, which reproduces in printed and expanded form the characteristics of *Yamatoe* landscape. *Miyako* was a name for Kyoto, which remained the formal capital until 1867.

Illustrated in colour (p. 82): The Golden Pavilion in Kyoto.

90 *opposite (above)* Aoi Sōkyū (*fl.* early 1800s). Evening river party; from *Kishi Empu*, 1803, vol. 2.

130 *opposite (below)* Nakamura Hōchū (*fl.* early 1800s). Nobleman with attendant crossing a bridge; after Kōrin; from *Kōrin Gafu*, 1826, vol. 1.

65 Masayoshi

Ryakuga-shiki Abbreviated Picture Style

1799 (first edition 1795)
Publisher: Suwaraya Ichibei, Edo.
1 vol. 260 × 180 mm. Colour-printed.
Literature: Brown, pp. 122–4.

Ryakuga, which has been variously translated as 'cursive', 'rough', 'shorthand' or 'simplified' drawings, is best explained by looking at a page of one of Masayoshi's books. The term literally means 'abbreviated', and the essential feature of the style is to use the absolute minimum of brush strokes. Masayoshi was probably, next to Hokusai, the most versatile of all the artists devoted to the book, but the *ryakuga* was his unique contribution, unprecedented and never equalled by later copyists. A whole series of books of witty, decorative colour prints of this kind were published from the *Ryakuga-shiki* of 1795 onwards.

Illustrated: Martial arts.

66 Masayoshi

Sansui Ryakuga-shiki Landscapes in the Abbreviated Picture Style

1800
Publisher: Suwaraya Ichibei, Edo.
1 vol. 265 × 180 mm. Colour-printed.
Literature: Brown, p. 124; Duret, no. 182; Ryerson, p. 213.

This superb book includes some of the most beautiful and fresh of all Japanese landscape prints. It is surprising that it is so little known.

Illustrated (p. 25): The town of Yoshiwara, near Mount Fuji.

67 Masayoshi

Tenarai Hyakunin Isshu The Hundred Poems for Handwriting Practice

1815
No publisher given. Printed by Umiya Ihei, Edo.
1 vol. 227 × 161 mm. Colour-printed.
Literature: Odin, no. 117, appears to be the only other copy recorded, and it contained hand-written poems up to the twenty-eighth page.

The poets are depicted in 'abbreviated style' with space enough above each for the owner to inscribe the appropriate poem. This copy was never used for the purpose. The *Hyakunin Isshu* is a traditional collection of 100 famous poems, each by a different poet, first put together in 1235 by Fujiwara Sadaie.

Illustrated: Poetess from the 'Hundred Poets' anthology.

68 Matsumura Goshun 1752–1811

Shin Hanazumi New Flower Picking

c. 1798
Publisher: Kashima Chūbei, Osaka.
1 vol. 268 × 191 mm. Printed in pink and grey.
Literature: Brown, p. 91; Holloway, no. 22; Mitchell, pp. 475–6; Ryerson, pp. 376–8.

The book consists of poems and notes by the *haiku* poet and *Nanga* painter Yosa Buson (1716–83) in his own calligraphy, interspersed with a few illustrations by his pupil Goshun, who is thought to have acquired the manuscript and tried to preserve it as a scroll. As Toda remarks in *Ryerson*, 'the illustrations do not look as if they were made to be reproduced in book form'. Nevertheless, the printing is astonishingly close to the feeling of *haiga*.

The last date appearing in the book, a note by Goshun, is 1784, but there is evidence that the publication date must have been nearer to 1798.

Illustrated: Monk with gong (entry for 19 May); after Buson.

69 Various artists

Untitled album

1793
Publisher: Kikunoya Tahei, Kyoto.
Folding album. 278 × 211 mm. Colour-printed with gauffrage.
Literature: Hillier (2), pp. 53–4; Mitchell, p. 522.

This is an anthology of *haiku* by various verse-writers, interspersed with five prints, one each designed by Goshun, Kaidō, Genki, Nangaku and Yūjo. The artists seem to be associated with Goshun (though Kaidō and Yūjo are practically unknown), and the album is looked upon as the first *Shijō* anthology.

Three copies of the work are known (the other two are in the New York Public Library (ex Mitchell) and the Museum of Fine Arts, Boston), and all are without a title label.

Illustrated: Nangaku. Lady from the *Kansai* with servant enjoying a walk.

70 Kubo Shumman 1757–1820

Yomo no Hana Flowers of the Four Quarters

1794
Private publication by Matsuyama Haruki, Edo.
Folding album. 187 × 256 mm.

This is a New Year *kyōka* book (the artist also appears as one of the poets), illustrated by a single *surimono*-style print of two girls seated beside a standing screen (a *tsuitate*) on which a scene is depicted from the *Nō* play on the subject of Urashima, the *Rip Van Winkle* scene of his return to his native land.

Illustrated: Two women looking round a wooden *tsuitate* screen painted with a scene from the *Nō* play about Urashima.

十九日

引ひをそちひ月や
秋の花佛は化る狸うる

狸ノ戸ニ オトツル、ハ尾ヲモテ抑クト
人云メレト九ニハアラス戸ニ肯サキツクル
音ナり

68

71 Various artists

Haru no Iro The Colours of Spring

1794
Publisher: Tsutaya Jūsaburō, Edo.
Folding album. 245 × 187 mm. Colour-printed.
Literature: Odaka, no. 18.

This is the earliest of a series of New Year annuals, published by
Tsutaya, consisting of numerous *kyōka* supplied by writers of one
or other of the leading clubs, accompanied by five or six colour
prints by leading artists of the day. Kubo Shumman figures
prominently as the designer of a number of the prints and, as
a leader of the verse-clubs, he seems to have been something
of a guiding spirit in the publication of these anthologies.

In this album the artists are Unzan and Tōrin (of the Tsutsumi
school), Rinshō (a follower of Hanabusa Itchō and a frequent
collaborator with Shumman), and Utamaro, Shumman and
Shigemasa of the *Ukiyoe* school.

Illustrated: Shumman. Country pilgrims visiting a Shintō shrine.

72 Various artists

Ehon Uta Yomidori Picture-book: Poems of Birds of the
Four Quarters

1795
Publisher: Tsutaya Jūsaburō, Edo.
Folding album. 255 × 190 mm. Colour-printed.

Of the six prints in this *kyōka* album one is a joint work by Tōrin,
Shumman and Rinshō; the others are by Tōrin, Shumman (2),
Shōhō, and Rinshō. The print by Shumman (illustrated) is a
masterpiece of *Ukiyoe* displaying sumptuous and dazzling colour
printing.

Illustrated in colour (p. 83 and cover): Shumman. Women at the
New Year.

69

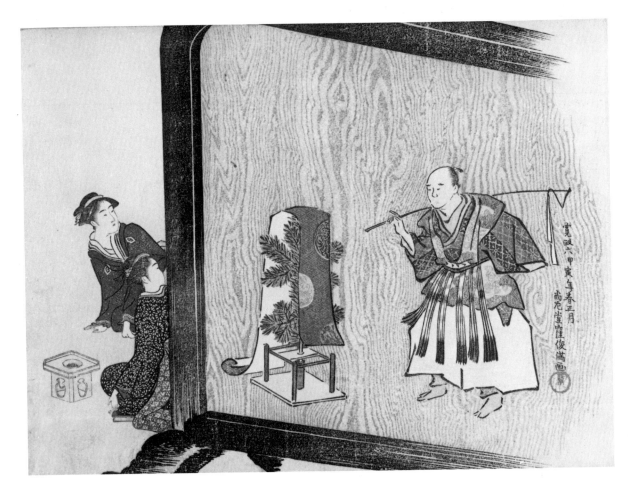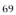

70

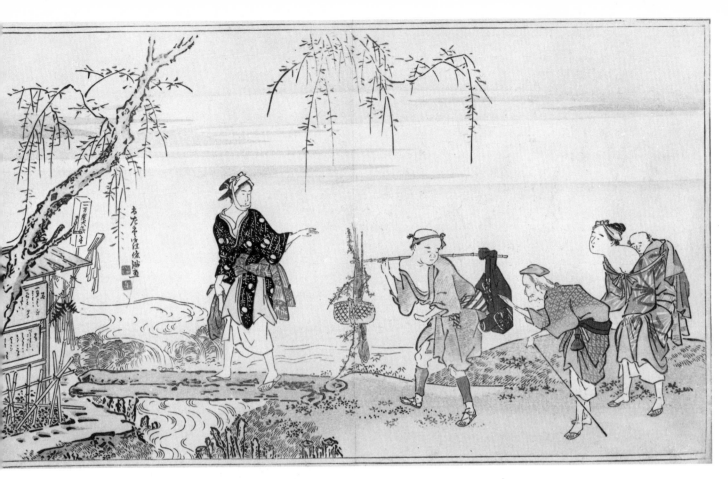

71

73 Various artists

Momo Saezuri A Hundred Twitterings

1796
Publisher: Tsutaya Jūsaburō, Edo.
Folding album. 258 × 190 mm. Colour-printed.

The six prints are by Shōhō, Tōrin (2), Kaho Sambei, and
Shumman (2).

Illustrated in colour (p. 83): Shumman. Boarding a pleasure-boat
on the Sumida River.

74 Various artists

Yanagi no Ito Willow-silk

1797
Publisher: Tsutaya Jūsaburō, Edo.
Folding album. 254 × 190 mm. Colour-printed.

This is another of the *kyōka* annuals, with six prints, in this
instance designed by Tōrin (2), Rinshō, Eishi, Shigemasa and
Hokusai.

Illustrated: Eishi. Courtesans of the Yoshiwara parading at New
Year.

75 Various artists

Otoko-dōka The Stamping Song of Men

1798
Publisher: Tsutaya Jūsaburō, Edo.
Folding album. 255 × 185 mm. Colour-printed.
Literature: Binyon and Sexton, p. 223; Brown, pp. 170, 172, 175;
Odaka, no. 21; *Ryerson*, pp. 452–4.

The title is the name of a men's dance performed on the fifteenth
day of the first month, and hence implies the New Year.

This was the last of the series of splendid *kyōka* albums
published under the imprint of Tsutaya, who died in 1797.
The artists were Shigemasa, Ekiji, Eishi, Hokusai, Tōrin and
Utamaro, whose print of women on the verandah of a house has
been frequently reproduced in Western literature on the artist.
Here the print illustrated is by the comparatively unknown artist
Ekiji.

Illustrated: Ekiji. Court lady admiring the plum blossom at the
New Year.

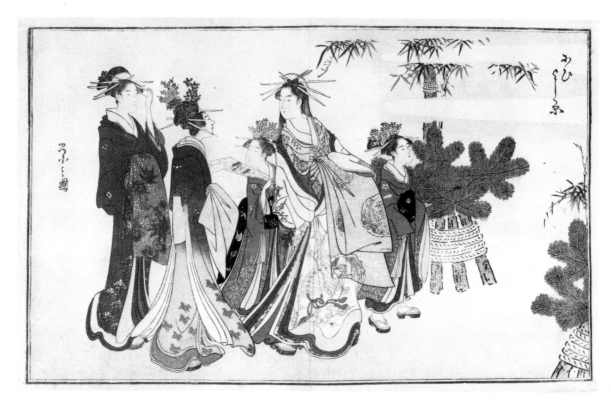

74

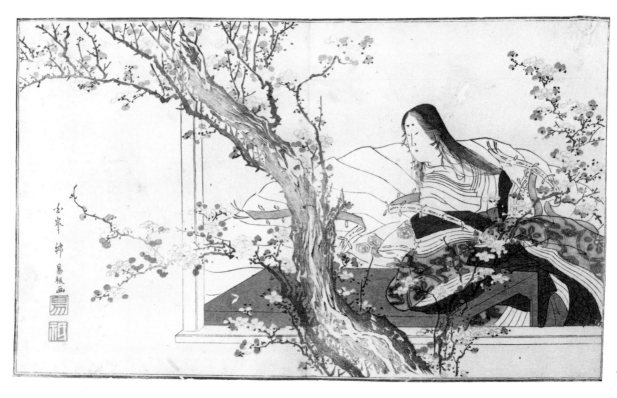

75

102 *opposite (above)* Katsushika Hokusai (1760–1849). Kyōgen dancers; from *Tarōtsuki, c.* 1797·

122 *opposite (below)* Satō Suiseki (*fl. c.* 1806–40). Flock of birds; from *Suiseki Gafu Nihen,* 1820.

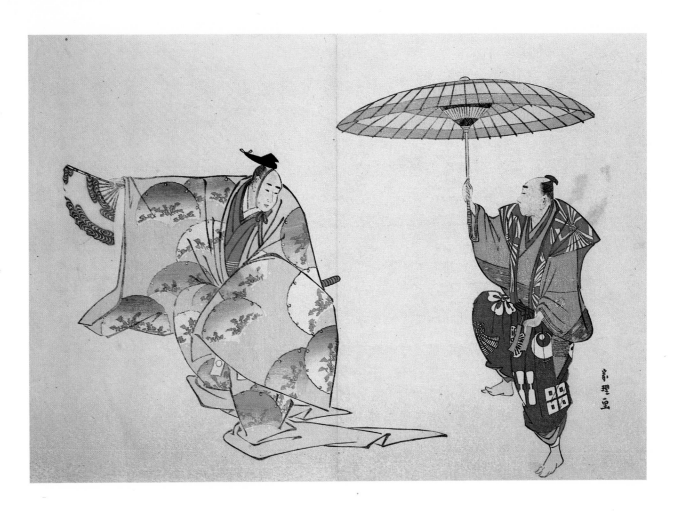

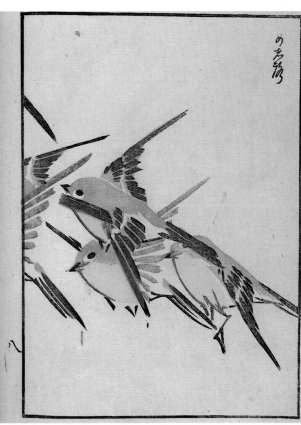

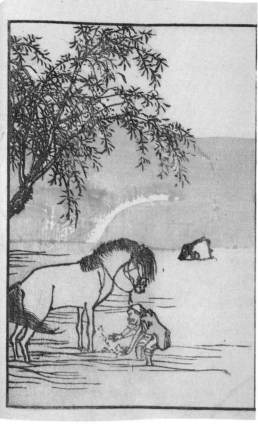
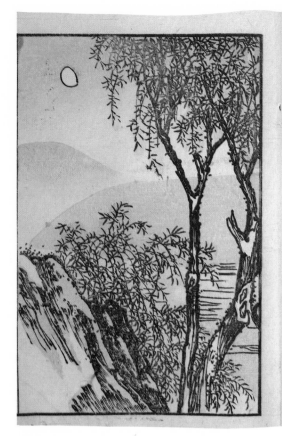

115 Kawamura Bumpō (1779–1821). Watering-place in moonlight: from *Bumpō Sansui Gafu*, 1824.

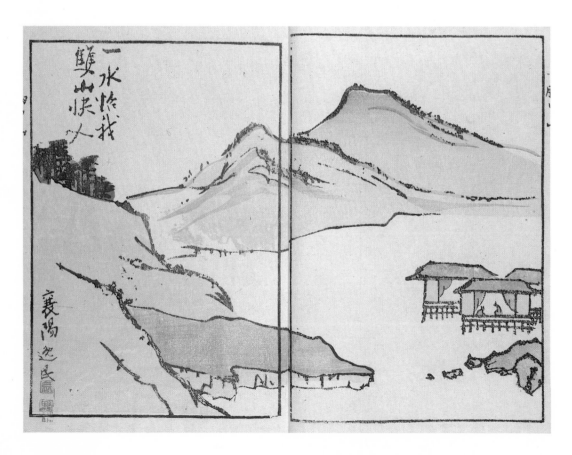

123 Kameda Bōsai (1754–1826). Chinese lakeside landscape; from *Kyōchūzan*, 1816.

76 (?) Eishōsai Chōki (*fl.* late 1700s–early 1800s)

Ehon Matsu no Shirabe Picture-book of the Music of the Pine-trees

Preface dated 1795
Publisher: Tsutaya Jūsaburō, Edo.
1 vol. 240 × 170 mm.
Literature: *Ryerson*, pp. 199–200. This seems to be the same as the 1795 edition, although it is implied that the pages are not numbered in *Iroha* order as in the Hillier copy.

The pictures illustrate songs for *koto* music, and the title comes from the comparison of the sounds of this instrument to the wind passing through pine-trees.

Controversy over the identity of the artist of a book is rare but it exists here. Most copies lack a colophon, and in fact the only instance where a name is reported as being shown is in the copy in the Hayashi sale catalogue of 1902, where, under no. 1590, Hayashi gives 'Signatures – Dessinateur: Shiko; Auteur: Tsoutano Karamarou' as if they appeared in a colophon. A case has been made for Shigemasa, Masayoshi and even Utamaro, but Chōki is perhaps the strongest contender, though the use of the *gō* Shikō in 1795 would then be hard to account for, since he had by then apparently abandoned that name.

Illustrated: Courtesan in early spring.

77 Various artists

Tōkaidō Meisho Zue Pictorial Guide to Famous Places on the Tōkaidō

1797
Publishers: 11 publishers or booksellers are listed, in Kyoto, Osaka and Edo, the principal being Yanagihara Kihei, Osaka.
6 vols. 260 × 185 mm.

Meishoki, or guides to important places, were published for a great many localities and do not normally rise above a sort of humdrum topography in ink outline. This book, although still without colour, was rather more ambitiously planned, and a number of prominent Maruyama-Shijō artists were enlisted as illustrators, including Goshun, Soken, Ōzui, Bummei, Naokata and others. The Tōkaidō was the main highway between Edo and Kyoto.

Illustrated: Goshun. Enticements on the road; vol. 2.

78 Naitō Tōho d. 1788 and others

Koya Bunkō The Koya Library

1768
Publishers: Tachibanaya Jihei, Kyoto; Fūgetsudō Magosuke, Nagoya.
3 vols. 260 × 170 mm.
Literature: Hillier (2), p. 170.

Books of *haiku*, epigrammatic seventeen-syllable verses linked to the seasons, were a major publishing activity of the Edo period (1603–1867). Quite often the verses were accompanied by pictorial motifs, occasionally elaborate (as in the case of Ryūsui's *Yama no Sachi*, no. 36) or, more often, very abbreviated, complementing the calligraphy of the verse to form what were

known as *haiga*. Many of the *haiga* books, issued as New Year annuals by societies of amateur verse-writers, were ephemeral, but the *Koya Bunkō* was an imposing production, though little is known of the artists. The use of black and white is outstanding in this powerful production. No satisfactory explanation of the *Koya* of the title has been found.

Illustrated: Shihōen. Dragon-fly on wind-bell with poem slip attached (illustrating a *haiku*); vol. 2.

79 Chō Gesshō 1772–1832 and Kazaore Yūjō (d. before 1798)

Zoku Koya Bunkō The Sequel to the Koya Library

1798
Publishers: Fūgetsudō Magosuke, Nagoya, and other booksellers and publishers in Edo, Osaka and Kyoto.
5 vols. 270 × 180 mm.
Literature: Hillier (2), ch. VIII; Holloway, no. 18; *Ryerson*, p. 389.

In this book, purporting to be a sequel to the first *Koya Bunkō* described above, the main artist is Gesshō who took over from Yūjō on the death of that artist. It is the most comprehensive exposition of the *haiga* ever produced, with designs of startling simplicity by an artistic genius matching the allusiveness of the verses and the asymmetry of the calligraphy.

Illustrated: Gesshō. Fox and rice stook, illustrating a *haiku*; vol. 4.

80 Gesshō

Fukei Gasō A Thicket of Pictures without Shapes

1817
Publishers: Eirakuya Toshirō and Keiundō Tōbei, Nagoya.
1 vol. 278 × 186 mm. Colour-printed.
Literature: Brown, p. 109; Holloway, no. 19; Mitchell, pp. 253–4; *Ryerson*, p. 390.

This is a picture-book of more general designs by Gesshō. The title is sometimes read as *Fugyō Gasō*, and refers to the style of painting without outline used in many of the designs.

Illustrated: *Sumō* tournament at a Shintō shrine.

81 Gesshō

Gesshō Sōga Sketches of Gesshō

c. 1828
Publisher: Minoya Seishichi (Bunkadō), Nagoya.
1 vol. (others planned). 228 × 160 mm. Colour-printed.
Literature: Brown, p. 108; Holloway, no. 21; Mitchell, pp. 269–70; *Ryerson*, p. 390.

The designs in this book were adapted from Gesshō's *Shin Koya Bunkō* (1818), the poems being omitted. The colour printing is effected from a single block, as in *Keisai Sōga* (no. 137), where the technique is described.

Illustrated: Chicks and rake.

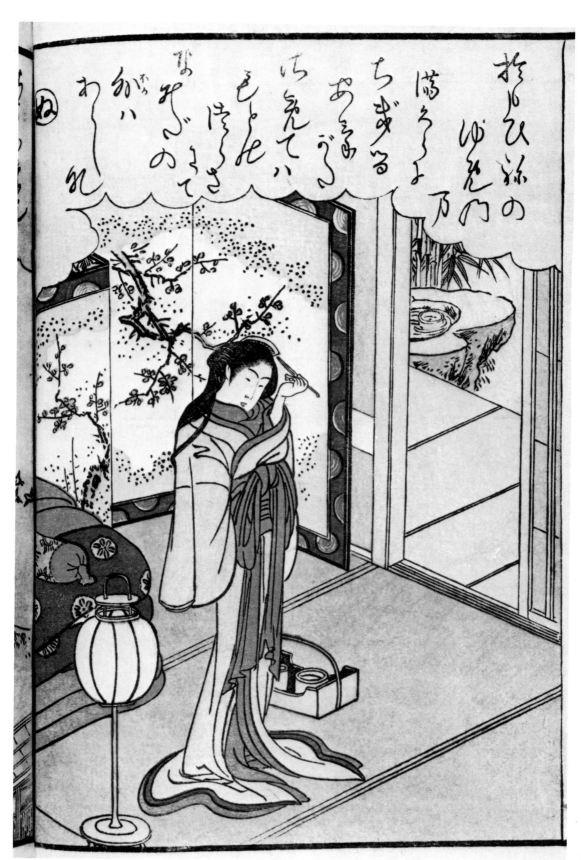

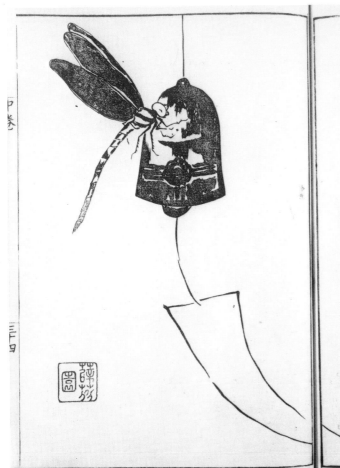

情於此
おなつり
なり
若中坊

別客

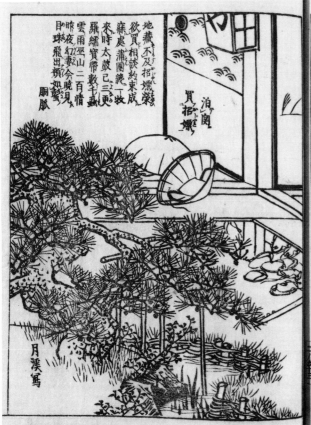

地藏不及招媛灘
欲貝相談約束成
麻處蒲團總一枚
來時太歲己三更
羅繡寶帶數千蟲
雲雨巫山二百情
晚夜幻棄今曉見
珠飛出頻知製
剛脈

浪裏
貝招孃

月溪寫

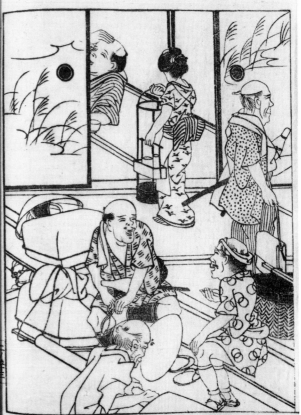

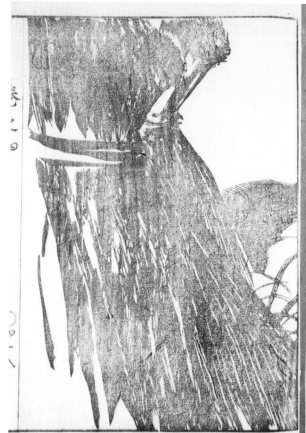
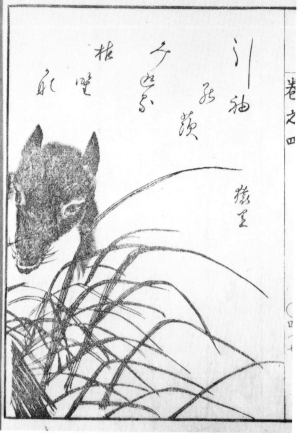

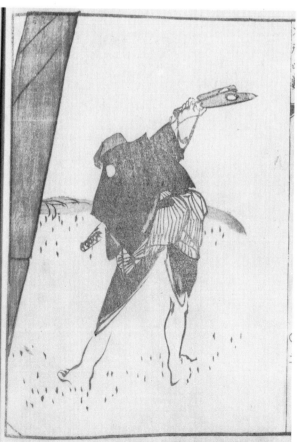

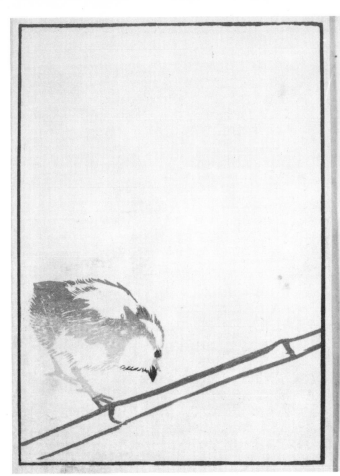

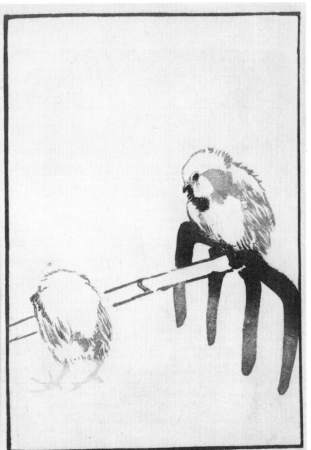

81

83

82

82 Ki Baitei 1774–1810

Kyūrō Gafu Kyūrō's Picture-album

Preface dated 1797
Colophon lacking. Mitchell's example 'B' names two Kyoto publishers.
1 vol. 261 × 186 mm.
Literature: Brown, p. 93; Holloway, no. 2; Mitchell, pp. 15–16, 402–4;
Ryerson, p. 419.

Kyūrō is one of the art-names of Baitei, a *Nanga* painter in the Buson manner. The strength of the stark woodcut line in this book is impressive.

An earlier edition, c. 1795, is known, in which the prints are accompanied by *haiku*.

Illustrated: Woman taking food to her husband in the rice fields.

83 Yamaguchi Soken 1759–1818

Yamato Jimbutsu Gafu Picture-album of the Natives of Yamato

1800
Publishers: Nagamura Tasuke, Kyoto, and others in Osaka and Kyoto.
3 vols. 260 × 182 mm.
Literature: Hillier (2), pp. 109, 114, 116, 154; Holloway, no. 45;
Mitchell, pp. 552–3; *Ryerson*, pp. 371–2.

One of the most admired of black and white books. A second similar series was published in 1804. Yamato here refers to the area of Kyoto and Osaka as contrasted with Edo. The genre style of the former is racier and nearer to reality than the fantasies of the newer city.

Illustrated: Traveller on a donkey, with driver; vol. 1.

84 Soken

Title defaced and illegible

c. 1804–17
No place or date of publication given.
Folding album. 230 × 164 mm. Colour-printed.
Literature: Odin, no. 150.

This is a *kyōka* book with two double-page colour prints, both by Soken.

Illustrated: A watch-tower by the sea.

85 Soken

Soken Gafu: Sōka no Bu Soken's Picture-album: Plant Section

1806
Publishers: Noda Dembei and others in Kyoto.
3 vols. 261 × 182 mm.
Literature: Hillier (2), pp. 111–15; Holloway, no. 47; Mitchell, pp. 498–9.

Gradated *sumi*-printing is here used with real virtuosity.

Illustrated: Water plantain; vol. 3.

86 Ki Chikudō d. 1825

Chikudō Gafu Chikudō's Picture-album

1800
Publishers: Fukiya Gihei, Kikuya Tahei and Fukiya Jinsuke, Kyoto.
Folding album. 272 × 174 mm. Colour-printed.
Literature: Brown, p. 103; Holloway, nos. 56–7.

The colour printing of these essentially *Nanga* pictures has been aided by a subtly textured greyish-white paper and by pigments that produced a crayon-like effect. A second series was published in 1815.

Illustrated (p. 31): Bamboo and crescent moon.

87 Ike no Taiga 1723–1776 **and Ifukyū**

Ifukyū Ike no Taiga Sansui Gafu Picture-album of Landscapes by Ifukyū and Ike no Taiga

1803
Publishers: Shōshūen (main) with Maruya Gempachirō, Kyoto;
Suwaraya Mohei, Edo.
2 vols. 255 × 178 mm.
Literature: Brown, pp. 88, 111; Holloway, no. 54; Mitchell, p. 307.

Ifukyū (I Fu-chiu) was a very minor Chinese painter who visited Nagasaki at various times between 1726 and 1750, and whose influence can be seen in the work of the eighteenth-century Japanese *Nanga* artists. In the present book Taiga comes over as an immeasurably more forceful, though less orthodox, artist. The adaptations of the artists' work are by Kan Dainen (1747–95).

Illustrated (p. 10): Lakeside village; vol. 2.

88 Taiga

Taigadō Gafu The Taigadō Picture-album

1804
Publishers: Hayashi Kichibei and Kikuya Taibei, Kyoto.
Folding album. 295 × 193 mm. Colour-printed.
Literature: Brown, p. 88; Holloway, no 55; Mitchell, pp. 509–10.

One of the masterpieces of *Nanga* art in printed form. The adaptations are by Taiga's most important pupil, Sō Geppō (1760–1839), and the book is associated with the founding of the Taigadō, a sort of Taiga memorial hall, at Maruyama in Kyoto.

Illustrated: Chinese landscape.

89 Taiga

Taiga Gahō Taiga's Pictorial Methods

1804
Publishers: Shinshosai, Kyoto (main), with eleven others in Kyoto, Osaka and Edo.
3 vols. 315 × 191 mm. Partly colour-printed, on very soft paper.
Literature: Brown, p. 88; Holloway, no. 55.

Illustrated: 'Mountain barrier'; vol. 2.

84

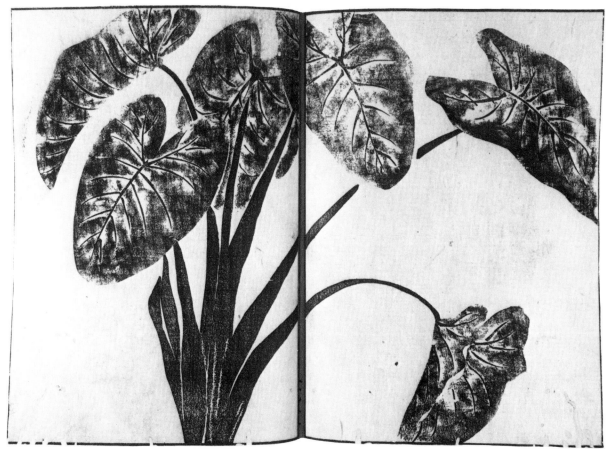

85

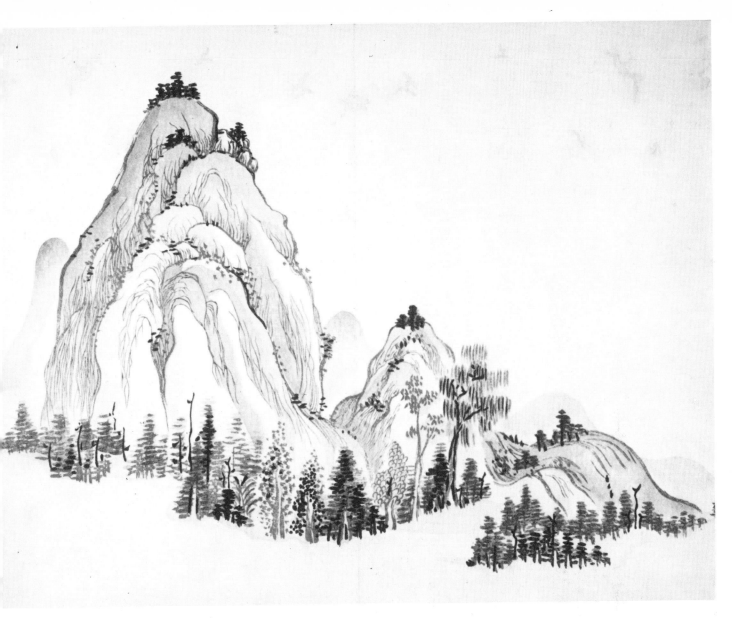

88

90 Aoi Sōkyū (*fl. early* 1800s)

Kishi Empu Mr Aoi's Album of Charm

1803
Publishers: Ueda Uhei and Murakami Sakichi, Osaka.
3 vols. 258 × 181 mm. Colour-printed.
Literature: Hillier (2), pp. 116–19; Mitchell, pp. 367–8.

Nothing is known of the artist of this dashing book, in which the superbly designed pictures, affectionately satirising life in the Osaka brothels and entertainment quarters, are given added force by delightful colour printing.

Illustrated in colour (p. 84): Evening river party; vol. 2.

91 Nakanuma Shōkadō 1584–1639

Shōkadō Gafu Shōkadō's Picture-album

1804–5
Publisher: Shōhakudō.
2 folding albums. 319 × 225 mm. Partly colour-printed.
Literature: Javal (1), no. 107; *de Roos*, no. 193.

In the first decade of the nineteenth century a number of books were published honouring great artists of the past – the works of Tan'yū, Shōkadō, Kōrin (no. 130) and Taiga (nos. 87–9), for example, were presented in woodblock prints of exceptional quality. Louis Gonse described these exceptionally big volumes of *Shōkadō Gafu* as the 'chef d'oeuvre de la chromoxylographie japonaise'. It reproduces remarkably the great calligrapher's brush style in both written characters and ink sketches.

Illustrated: Michizane, an Immortal of literature; vol. 1.

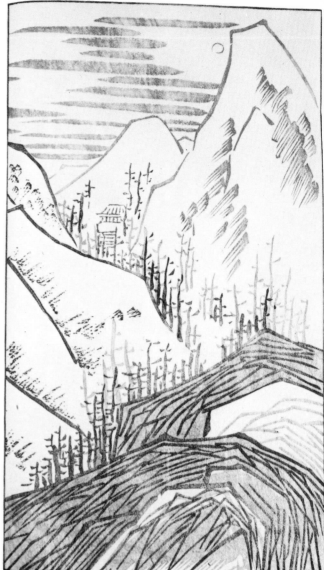

89

92 Hosoda Eishi 1756–1829

Ehon Kasen Shū Picture-book of Immortal Poets

1799
Publisher: Eijusai Nishimuraya Yohachi (Eijudō), Edo.
1 vol. 253 × 218 mm. Printed in very light colours.
Literature: Brown, p. 172, obviously copies *Hayashi*, no. 1678. The Hayashi copy had only thirty-four prints.

Inside the front cover is a print of an *uguisu* (nightingale) on a flowering plum; then follow thirty-six single-page prints, each depicting one of the classic 'Thirty-six Poets', accompanied by two, usually female, attendants in contemporary *Ukiyoe* style, with a verse of the poet above a conventional cloud line. The style and the restrained colour have much in common with the *Genji à la mode* triptychs designed a few years earlier by Eishi. Very few copies have been recorded.

Illustrated: The poet Yorimoto with ladies in modern style.

93 Utagawa Toyokuni 1769–1825 and Utagawa Kunimasa 1773–1810

(Nigao Ehon) Yakusha Gakuya Tsū (Portrait Picture-book) Actors in their Dressing-rooms

Preface dated 1799
Publisher: Kazusaya Chūsuke, Edo.
1 vol. 182 × 128 mm. Colour-printed.
Literature: Brown, p. 154.

There is a double-page frontispiece of theatre-goers in the foyer of a theatre by Utamaro, a single-page print of theatrical mask-costume for the *sambasō* dance, unsigned, and thirty-six half-length portraits of actors by Toyokuni and Kunimasa, each with a *kyōka* inscribed in the background.

Illustrated (p. 10): Toyokuni (left). The actor Ōtani Hirotsugi. Kunimasa (right). The actor Ichikawa Omezō.

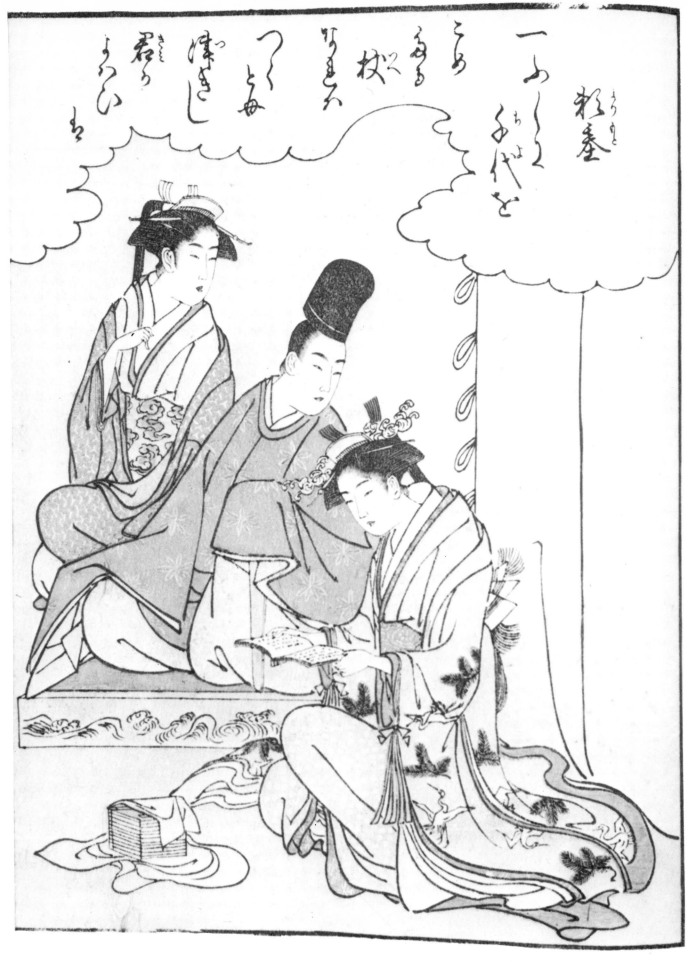

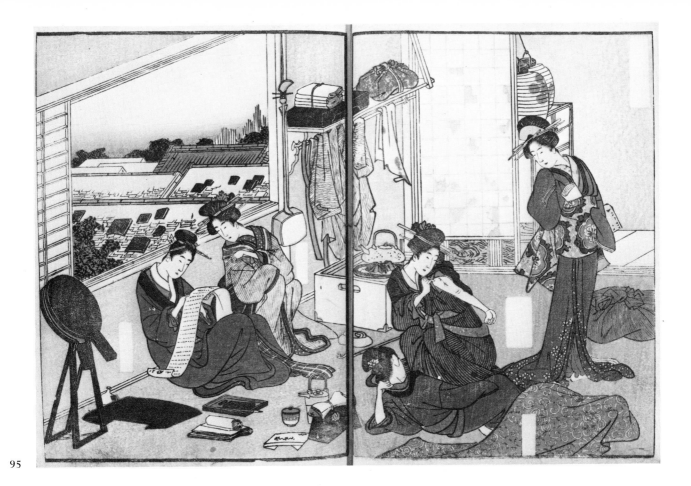

95

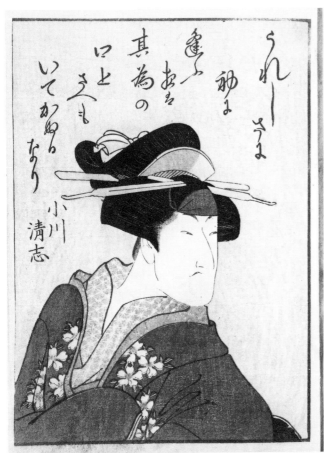
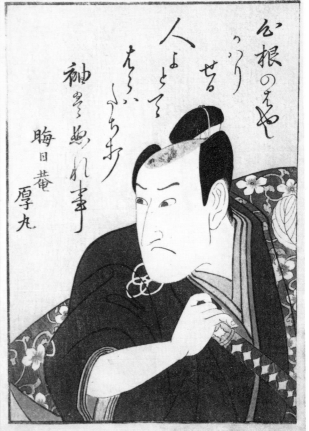

96

107

94 Toyokuni

Yakusha Sangaikyō Amusements of Actors on the Third Floor

1801
Publishers: Shunshōken Nishimiya Shinroku and Yorozuya Tajiemon, Edo.
2 vols. 218 × 156 mm. Colour-printed.
Literature: Ryerson, pp. 287–8.

The private lives of entertainers were of deep interest to the public, and this very finely printed work, its designs often appropriately dramatic, served as a superior sort of gossip-sheet. The 'third floor' housed the actors' dressing-rooms.

Illustrated (p. 22): Kabuki actors in the dressing-rooms. The central figure is Arashi Zōhachi; vol. 1.

95 Toyokuni

Ehon Imayō Sugata Picture-book of Modern Figures of Fashion

1802
Publisher: Kansendō Izumiya Ichibei, Edo.
2 vols. 217 × 145 mm. Colour-printed.
Literature: facsimile, Rinsen Book Co. Ltd., Kyoto, 1979; Ryerson, pp. 289–90 (but lacking the last print of vol. 2); F. Succo: *Utagawa Toyokuni und Seine Zeit*, Munich, 1913, vol. 1, pp. 57–69.

The first volume depicts women in general, from court ladies to farmers' wives; the second centres on women of the licensed quarters. In the first edition the cartouches alongside each figure gave their names, but soon after the first issue, for reasons that have never been established, the names were removed, leaving blanks (as in the page illustrated). This work is distinguished for its lively and detailed view of contemporary life and for its covers, beautifully embossed with the artist's seals.

Illustrated: Courtesans comparing notes on the morning after; vol. 2.

96 Toyokuni

Yakusha Awase Kagami A Mirror of Actors Compared

1804
Publishers: Banshundō and Yamadaya Sanshirō, Edo.
2 vols. 267 × 181 mm. Colour-printed.
Literature: Brown, p. 155.

One of the outstanding books devoted to Kabuki actors, here depicted half-length in the style in which Toyokuni scored some of his most striking successes in single-sheet form. The preservation of the colours in this copy is remarkable.

Illustrated: Kabuki actors with *kyōka* poems by Kogawa Seishi (left) and Mizoka-an Atsumaru (right); vol. 2.

97 Shōkōsai Hokushū *fl. c.* 1795–1809

Santo Yakusha Masukagami A Clear Mirror of Actors of the Three Cities

1806
Publisher: Shioiya Chōbei, Osaka.
2 vols. 219 × 153 mm. Colour-printed.

Hokushū, a major Osaka designer of actor prints, shows in this book how much he owed to Toyokuni (especially *Yakusha Awase Kagami*, no. 96, published two years earlier). The 'three cities' are Edo, Osaka and Kyoto.

Illustrated: The Kabuki actor Arashi Sangorō, with a poem by Tōun Akiyasu; vol. 2.

98 Utagawa Toyohiro 1773–1828

(Fukushū) Banshū Maikohama (Revenge) Maiko Beach in Harima Province

1804
Publishers: Ōmiya and Yamadaya, Edo.
2 vols. 219 × 154 mm. Colour-printed.
Literature: KS, vol. 6, p. 700, citing editions of 1808 and 1838 as well as 1804.

This is a story by the comic writer Jippensha Ikku (1765–1831) with his own preface. The illustrations are in an exceptional state of preservation, and the pristine colours of 1804 come with something of a shock. The original printed wrapper with a design of clouds and cranes is, most rarely, preserved in this copy.

Illustrated: Hida Gorō leaves the scene of his murders watched by the concealed Heitayū; vol. 1.

99 Katsushika Hokusai 1760–1849

Untitled album

1796
No publisher given, but probably Edo.
Folding album. 205 × 140 mm. Colour-printed.
Literature: Hillier (3), no. 64; Javal (1), no. 131.

A rare, perhaps unique, *kyōka* book with a four-page *surimono*-style print, which rather unusually folds out flat, of peasants on the bank of the Sumida River with great pine-trees in the foreground; and two single-sheet prints, one of peonies, the other of a *hototogisu* flying above herbage. The cover is embossed and colour-printed with chrysanthemums.

Illustrated: View of the Sumida River in Edo.

100 Hokusai

(Kyōka) Hatsu Wakana First Green Shoots

Preface dated 1798
No publisher given.
Folding album. 223 × 162 mm.
Literature: Hayashi, no. 1710; Hillier (3), no. 75; Javal (1), no. 152.

A *kyōka* book, embellished with one delightful print only.

Illustrated: Woman and young boy observing the New Year sunrise.

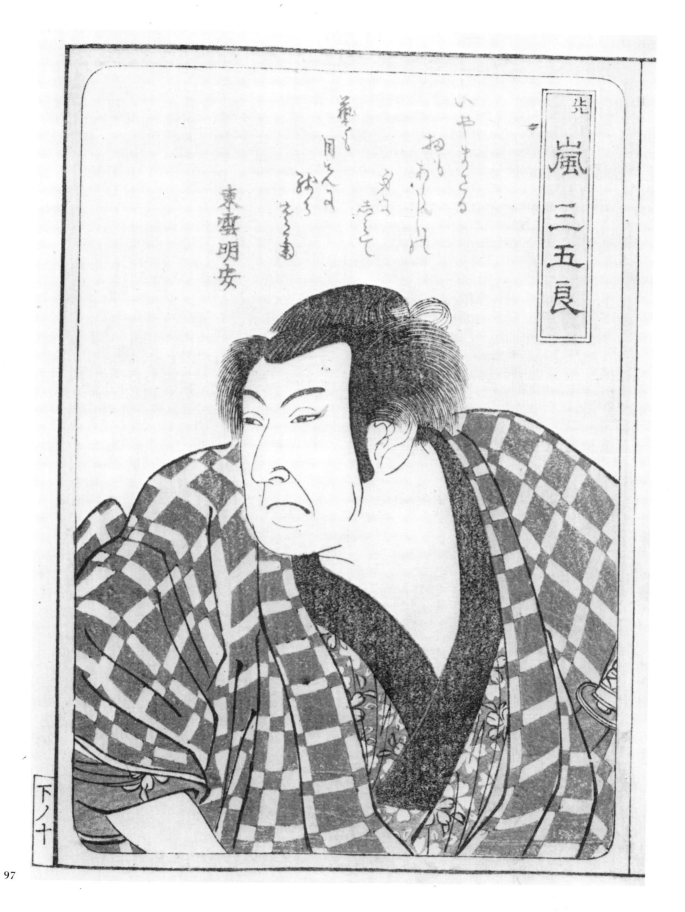

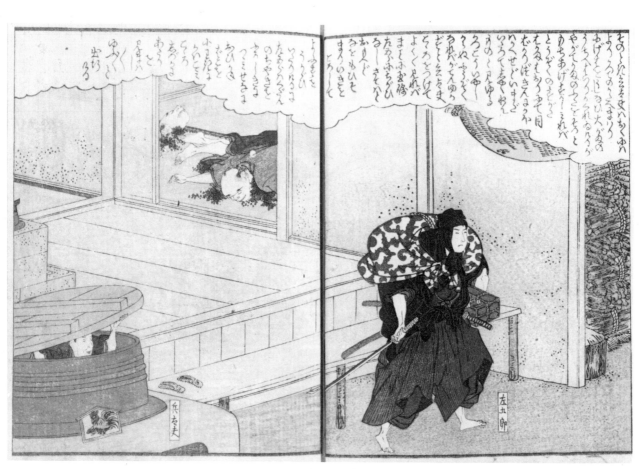

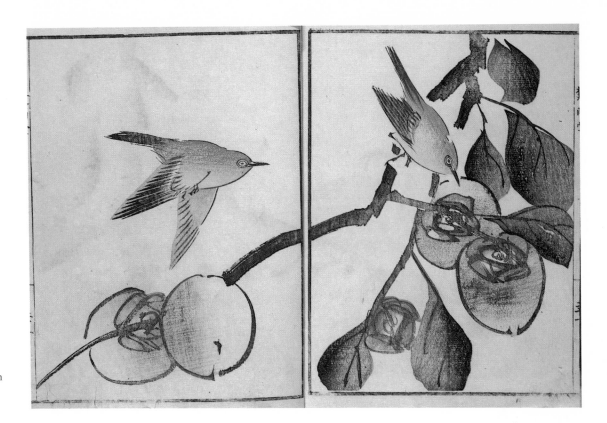

134 Ōnishi Chinnen
(1792–1851). Persimmon
bough; from *Sonan Gafu*,
1834.

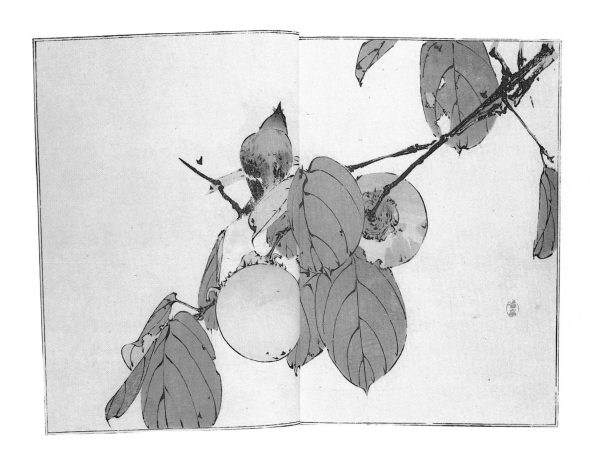

148 Watanabe Seitei
(1851–1918). Bird on
persimmon bough; from
Seitei Kachō Gafu, 1890-1,
vol. 2.

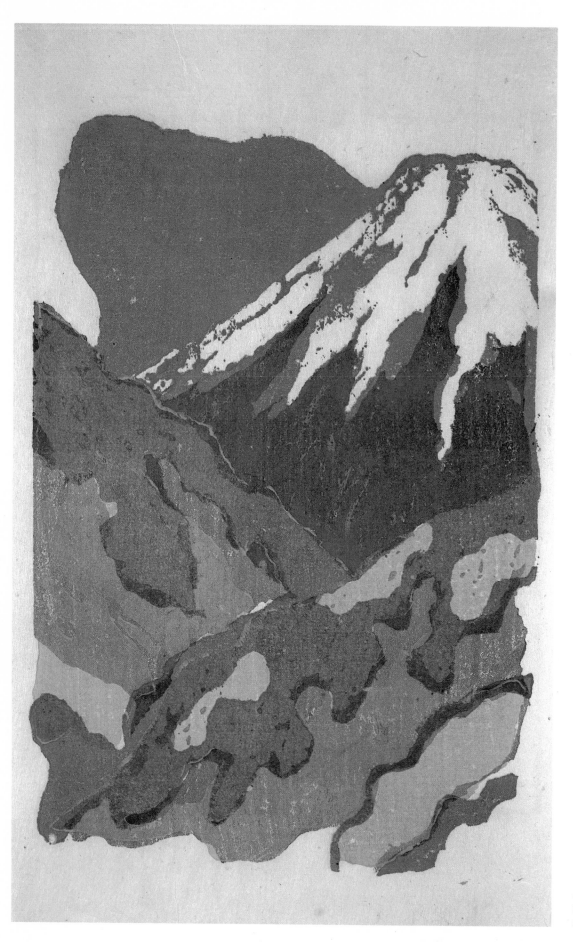

150 Kōshirō Onchi
(1891–1955).
Mount Fuji; from
Shinshō Fuji, 1946.

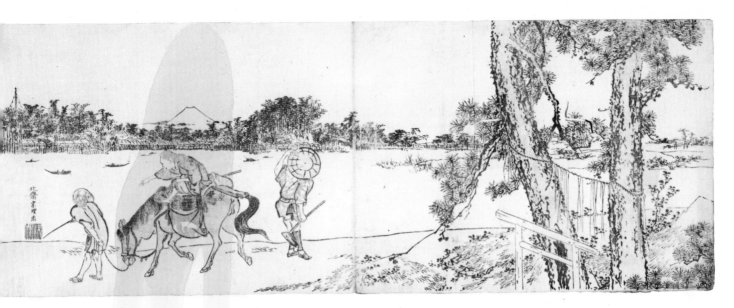

99

101 Hokusai and Shigemasa

Miyama Uguisu Nightingale in the Mountains

c. 1798
No publisher given, but probably Edo.
Folding album. 195 × 132 mm. Colour-printed.
Literature: Hillier (3), no. 72.

Hokusai and Shigemasa each contributed a single print. Hokusai's is signed 'Hokusai Sōri after a painting by Hokkyō Kōrin' (Ogata Kōrin, 1652–1716), and is on paper minutely embossed to suggest a silk weave.

Illustrated: Hokusai. Plum blossom; after Kōrin.

102 Hokusai

Tarōtsuki The First Moon *or* The Moon of Tarō

c. 1797–8
No publisher given.
Folding album. 225 × 165 mm. Colour-printed.
Literature: Louis V. Ledoux, *Japanese Prints: Hokusai and Hiroshige in the Collection of Louis V. Ledoux*, Princeton (N.J.), 1951, no. 1; Hillier (3), no. 77.

Kyōka, with a single colour print, signed Sōri. Tarō is the name of a *kyōgen* character who appears in the print in this book.

Illustrated in colour (p. 93): Kyōgen dancers.

103 Hokusai

Tōto Shōkei Ichiran Fine Views of the Eastern Capital at a Glance

1800
Publishers: Suwaraya Mohei, Suwaraya Ihachi and Tsutaya Jūsaburō, Edo.
2 vols. 260 × 170 mm. Colour-printed.
Literature: Brown, p. 181; Hillier (3), no. 88; *Ryerson*, p. 236.

The first of three major works depicting the sights of Edo in colour prints, to which the accompanying *kyōka* are quite subsidiary. The other two are nos. 104 and 105.

Illustrated in colour (p. 81): Landing at a teahouse on the Sumida River; vol. 1.

104 Hokusai

Ehon Kyōka Yama Mata Yama Picture book of Kyōka: Mountains upon Mountains

1804
Publisher: Tsutaya Jūsaburō, Edo.
3 vols. 264 × 175 mm. Colour-printed.
Literature: Brown, p. 181; Hillier (3), no. 114; *Ryerson*, p. 241.

Despite the title, the pictures relate to the only slightly elevated north and north-western areas of Edo. The printed wrapper of this set of volumes, with its fine design of Yama-uba and Kintoki, has, unusually, been preserved.

Illustrated: Pleasure-boat breaking through the ice; vol. 3.

101

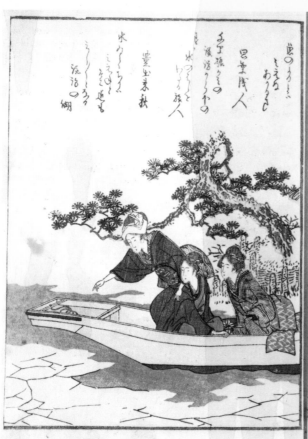

104

105 Hokusai

Ehon Sumidagawa Ryōgan Ichiran Panoramic Views on Both Banks of the Sumida River at a Glance

c. 1806
No colophon. *Ryerson* gives the publisher of the edition as Maekawa Zembei, Osaka.
3 parts (in 1 vol.). 266 × 181 mm. Colour-printed.
Literature: Brown, p. 182; Hillier (3), no. 124; *Ryerson*, pp. 243–4.

A continuous panoramic view extending from sheet to sheet over the three volumes and traversing the four seasons in the process. This is the boldest and freshest of Hokusai's three great books of Edo views, full of life and movement.

Illustrated: Ferry boat at dawn on Edo Bay.

106 Hokusai

Hida no Takumi Monogatari The Story of the Craftsman of Hida

1809
Publisher: Kadomaruya Jinsuke, Nagoya.
4 vols. (of 6). 218 × 153 mm.
Literature: F. V. Dickins, *The Story of a Hida Craftsman*, London, 1912 (a translation of the text); Hillier (3), no. 158; *Ryerson*, p. 254; Jūzō Suzuki et al., *Hokusai Yomihon Sashie Shūsei*, vol. 3, Tokyo, 1971–3.

Typical of the illustrations to numerous novels of Bakin and others made by Hokusai at this period. In this instance the novelist is Rokujūen (1753–1830).

Illustrated: Yamabito uses Murasaki's *obi* to haul her boat to the bank; vol. 3.

107 Hokusai

Hokusai Manga Hokusai's Ten Thousand Sketches

1814 (vol. 1)–1878 (vol. 15)
Publishers: Eirakuya Tōshirō, Nagoya, and others in Nagoya and Edo.
13 vols. 227 × 157 mm. Printed in ink, grey and pink.
The Hillier Collection has two different copies of vol. 1 (one the first edition) and volumes 3–12, 14–15.
Literature: Hillier (3), ch. 8; the finest western tribute is James Michener's *The Hokusai Sketchbooks: Selections from the Manga*, Rutland (Vt.) and Tokyo, 1958.

It is probably true to say that Hokusai's reputation in the West was made by this endlessly inventive series of picture-books, thirteen volumes of which were published during his lifetime.

Illustrated: Warriors at ease; vol. 9.

108 Hokusai

Hokusai Sōga Sketches by Hokusai

1820
Publishers: Eirakuya, Nagoya; Surawaya Mohei and seven others in Edo. (Colophon in tinted edition.)
1 vol. 255 × 180 mm.
Literature: Brown, p. 184; Hillier (3), ch. XII.

A rather superior form of *Manga* miscellany. Two editions, one in ink only (illustrated), another with pink and grey tints.

Illustrated: 'Snowy night'; black and white edition.

109 Hokusai

Ehon Sakigake Picture-book of Leaders

1836
Publishers: Suzambō and Hokurindō, probably Edo.
1 vol. 222 × 161 mm.
Literature: Brown, p. 183; Marco Fagioli, *Hokusai Wakan Ehon Sakigake*, Florence, 1978; Hillier (3), no. 245; *Ryerson*, p. 263.

A book of 'warrior' pictures, *mushae*, typical of a number of *ehon* designed about this time by Hokusai, but certainly the best of them with some of the largest subjects printed vertically down the two sheets of an opening (as illustrated).

Illustrated (pp. 6 and 32): Endō Morito doing penance under the waterfall.

110 Hokusai

Fugaku Hyakkei One Hundred Views of Fuji

1834, 1835, *c.* 1849
Publishers: Eirakuya Tōjirō, Nagoya (main).
3 vols. (dated as above). 227 × 157 mm.
Literature: Brown, pp. 179, 183; F. V. Dickins, *Fugaku hiyaku-kei or A Hundred Views of Fuji (Fusiyama): by Hokusai*, London, 1880; J. Hillier, *One Hundred Views of Fuji*, New York, 1958, Introduction; *Ryerson*, p. 362.

Acknowledged as one of the supreme illustrated books of Japan and, with the *Manga* (no. 107), the most influential in the West. The first editions of each of the first two volumes, because of title slips printed with a falcon's feather, are known as the 'Falcon Feather' editions. The third volume, issued much later by a different publisher, does not match the earlier volumes in refinement of black and white printing.

Illustrated: Fuji from the sea; vol. 2.

111 Shumman and Tōshū

Yomo no Yama Mountains of the Four Quarters

c. 1805–10
No publisher given.
Folding album. 195 × 135 mm. Colour-printed.
Literature: Not recorded in standard works but one other copy is known, in the Museum of Fine Arts, Boston.

An album of *kyōka* with six outstanding colour prints in *surimono* style by Shumman and Tōshū. The prints all illustrate *Nō* plays.

Illustrated: Shumman. Scene from a *Nō* play.

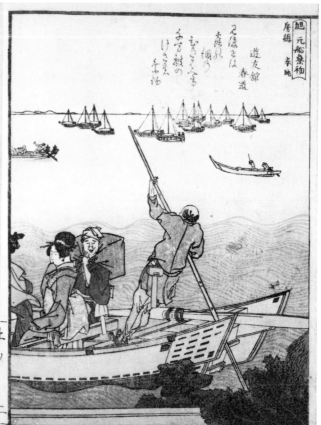

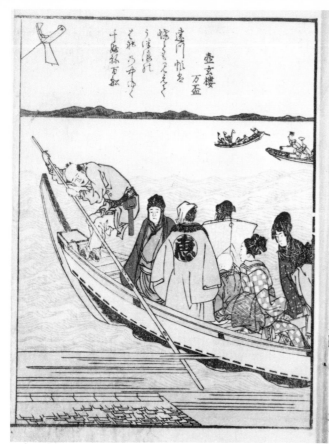

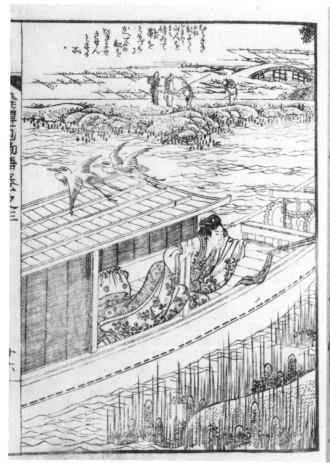

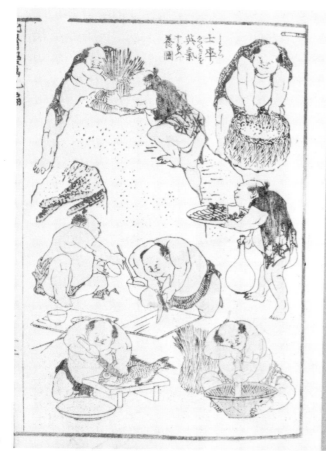

107

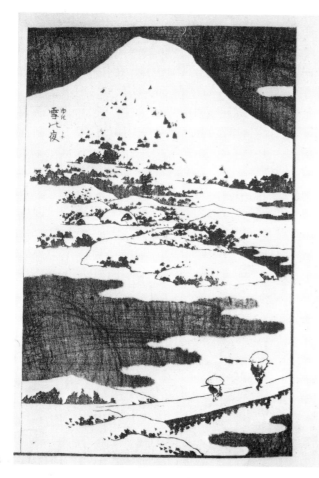
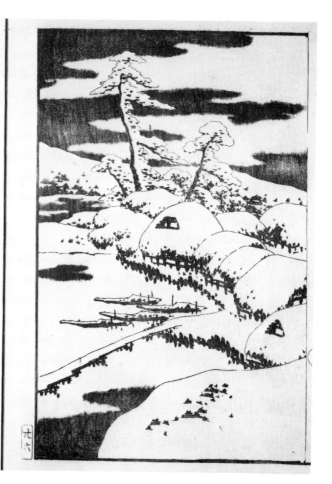

108

海上の不二

110

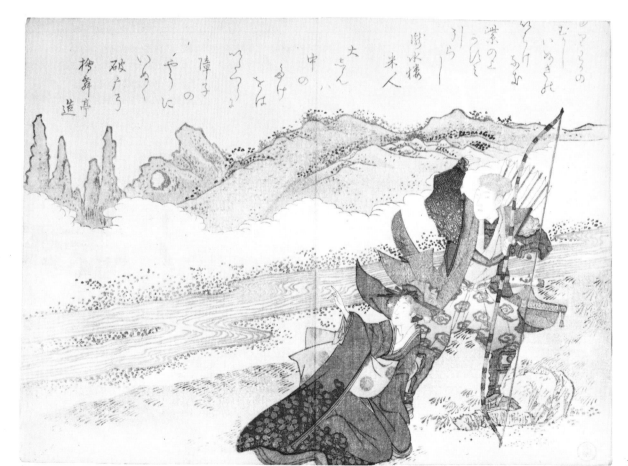

111

112 Various artists

Rampō Jō The Album of the Fabulous Bird
1806
Publisher: Kikuya Tahei, Kyoto.
Folding album. 265 × 185 mm. Colour-printed.
Literature: Hillier (2), pp. 165, 258, 268, 272; Mitchell, p. 446.

An anthology of *haiku*, with prints by the Shijō artists Hōen (not the well-known artist of this name), Rankō, Nangaku and Tetsuzan (illustrated). One of the finest of *Shijō* albums. The 'Jō' (or 'Chō') of the title is more often used for folding albums of paintings, and these prints are exceptionally close to the feeling of original brushwork.

Illustrated: Tetsuzan. Ducks in a stream.

113 Kawamura Bumpō 1779–1821

Bumpō Gafu Bumpō's Picture-album
1807, 1811, 1813
Publishers: Yanagiwara Kihei, Osaka; Yoshida Shimbei, Kyoto.
3 vols. (dated as above). 260 × 177 mm. Printed in light colours.
Literature: Brown, p. 104; Hillier (2), ch. XI; Holloway, no. 7; Mitchell, pp. 227–8; *Ryerson*, p. 384.

Of all the non-*Ukiyoe* artists Bumpō is probably the most widely known and enjoyed, not for his paintings but for his picture-books. In the three *gafu* he is seen at his most genial and versatile. Few artists have had such rapport with the interpretative print-makers.

Illustrated: Traveller in the snow; vol. 1.

114 Bumpō

Teito Gakei Ichiran Choice Views of the Capital at a Glance
1809–16
Publishers: Yoborokoya Seishichi, Tsū; Yoborokoya Genjirō and Shutten, Kyoto.
4 vols. 257 × 163 mm. Printed in very pale colours.
Literature: Brown, p. 104; Hillier (2), pp. 238–43; Holloway, no. 10; Mitchell, pp. 518–19; *Ryerson*, p. 385.

The 'Capital' is, of course, Kyoto, to the seasonal beauties of which Bumpō shows an extreme sensitivity in these lyrical volumes.

Illustrated: Plum blossom at Gion in Kyoto; vol. 1.

115 Bumpō

Bumpō Sansui Gafu Bumpō's Landscape Album
1824
Publisher: Bunchōdō (Yoshidaya Shimbei), Kyoto.
1 vol. 257 × 173 mm. Printed in pale colours.
Literature: Brown, p. 104; Holloway, no. 12; Mitchell, pp. 228–9; *Ryerson*, p. 387.

This became a source book for several *Ukiyoe* artists, both Kuniyoshi and Kunisada lifting details to use in their prints.

Illustrated in colour (p. 94): Watering-place in moonlight.

116 Kawamura Kihō 1778–1852

Kafuku Nimpitsu The Ups and Downs of Life Represented by the Brush
1809
Publishers: Kawachiya Kihei, Osaka; Yoshidaya Sahei and Yoshidaya Shimbei, Kyoto.
1 vol. 257 × 183 mm. Colour-printed.
Literature: Brown, p. 105; Holloway, no. 31; Mitchell, pp. 322–3; *Ryerson*, pp. 387–8.

A very genial work of everyday scenes.

Illustrated: Country women.

117 Kihō

Kihō Gafu Kihō's Picture-album
1827
Publisher: Bunchōdō (Yoshidaya Shimbei), Kyoto. Brown and *Ryerson* copies lack colophon.
1 vol. 258 × 177 mm. Colour-printed.
Literature: Holloway, no. 32; Mitchell, pp. 360–1.

The book has a very fine cover printed with wave patterns in mica.

Illustrated (p. 24): Finch on bough.

118 Koshū

Koshū Gafu Koshū's Picture-album
1812
Publisher: Yoshidaya Shimbei, Kyoto.
1 vol. 260 × 180 mm. Colour-printed.
Literature: Brown, p. 100; Mitchell, p. 378; *Ryerson*, p. 367.

There were later issues in 1814 and 1824 of this very individual book.

Illustrated: The Immortal Kinkō on his carp.

119 Various artists

Meika Gafu Picture-album by Celebrated Artists
1814
Publisher: Eirakuya Tōshirō, Nagoya.
2 vols. 277 × 190 mm. Colour-printed.
Literature: Brown, p. 127; Hillier (2), ch. XIII; Mitchell, pp. 407–9; *Ryerson*, pp. 382–3.

The most comprehensive of the artistic anthologies, containing specimens of the work of a great number of *Nanga*, *Shijō/Maruyama*, *Kishi* and other painters, mostly alive at the time, though a few of the more famous deceased artists are represented. The original intention was to issue three volumes, but for unknown reasons it seems that volume two of the three was never prepared.

Illustrated: Hoji. Frog; vol. 3.

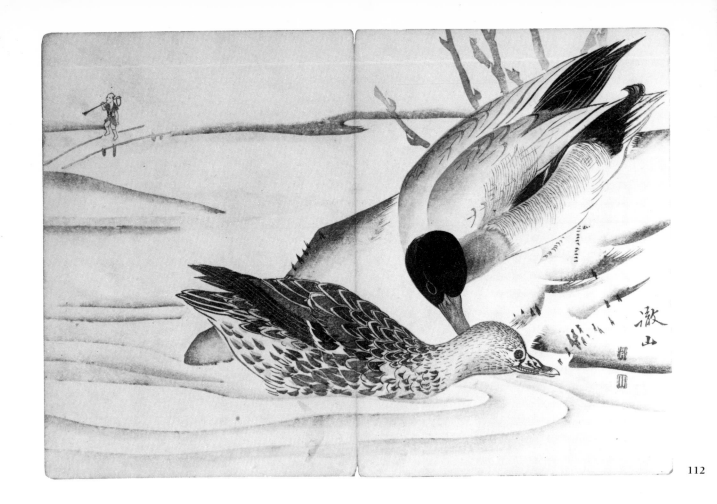

112

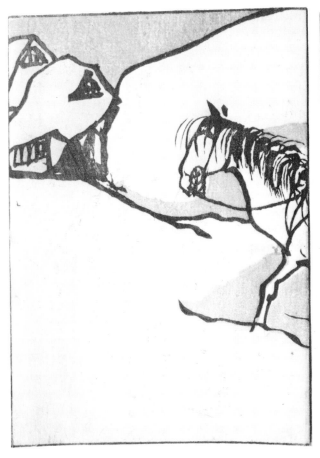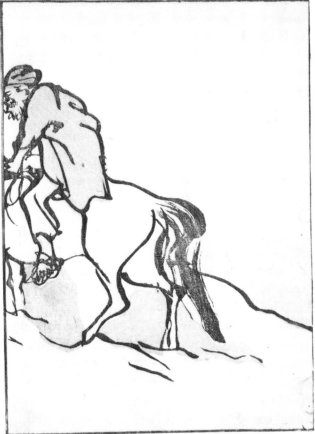

113

114

116

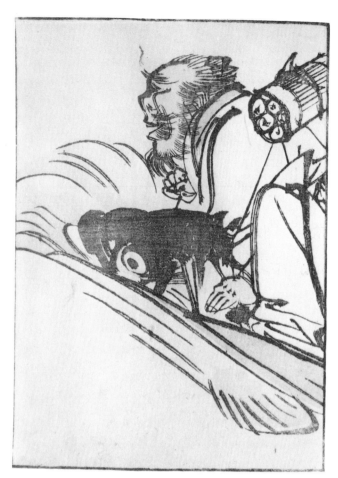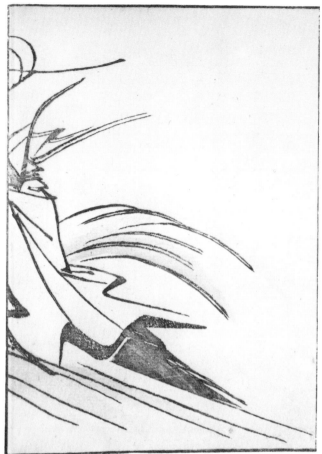

118

120 Various artists

Keijō Gaen A Garden of Pictures by Kyoto Artists

1814
Publisher: Yoshidaya Shimbei, Kyoto.
Folding album. 275 × 190 mm.
Literature: Brown, p. 126; Hillier (2), ch. XIII; Holloway, no. 30;
Mitchell, pp. 352–3; *Ryerson*, pp. 378–9.

Another important anthology, with prints by Goshun, Soken, Zaimei, Kosei, Tōyō, Shōdō, Gantai, Keibun, Toyohiko, Kōkan, Roshū, Shōin, Kihō, Kosen, Hakuei, Chikudō, Kōkei, Nangaku, Gyokurin, Minwa, Bummei, Ōzui, Ōju, Geppō, Koshū and Gitō. It includes several graphic masterpieces.

Illustrated (p. 30): Keibun. Swallow.

121 Satō Suiseki *fl. c.* 1806–1840

Suiseki Gafu Suiseki's Picture-album

1814
Publishers: Tennōjiya Ichirōbei, Kyoto, and three others in Edo and Osaka.
1 vol. 255 × 177 mm. Printed in ink and pale colours.
Literature: Brown, p. 92; Hillier (2), ch. IX; Holloway, no. 51; Mitchell, pp. 505–6; *Ryerson*, p. 379.

This is the first of two series by Suiseki and consists of square-cut figure studies in a style that immediately singles the artist out as an individualist, whatever training he may have had under Goshun.

Illustrated: Carpenters (left); pine needles from the decorated inside cover (right).

122 Suiseki

Suiseki Gafu Nihen Suiseki's Picture-album, Second Series

1820
Publishers: Tennōjiya Ichirōbei, Kyoto; Suwaraya Mohei, Edo; Kawachiya Kihei, Osaka.
1 vol. 258 × 177 mm. Colour-printed.
Literature: Brown, p. 93; Holloway, no. 52; Hillier (2), ch. IX; Mitchell, p. 506.

In this volume Suiseki confined himself to flowers, birds and still life, and, aided by print-makers of exceptional understanding, produced a work of which every page has the stamp of genius.

Illustrated in colour (p. 93): Flock of birds.

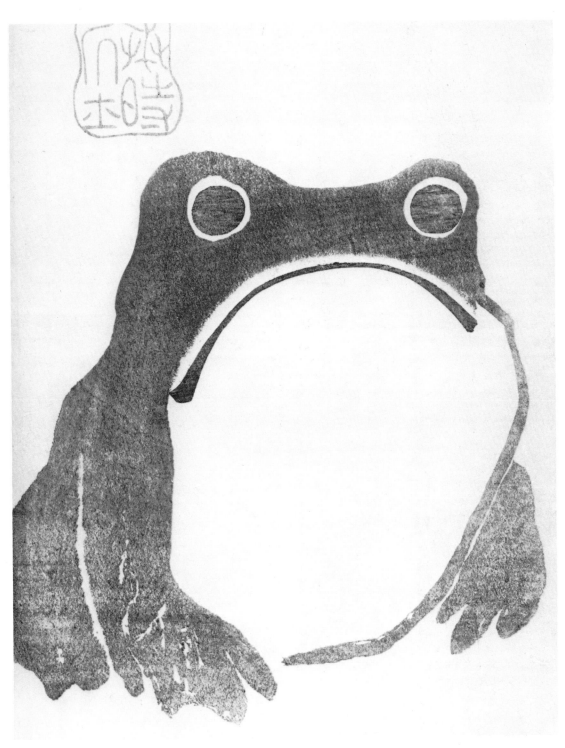

119

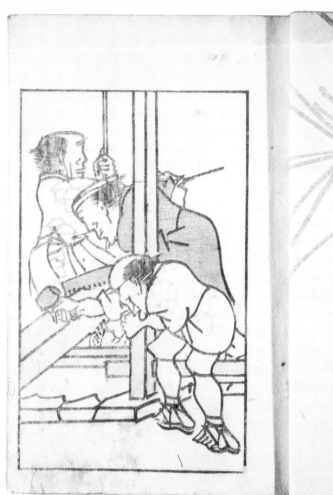

123 Kameda Bōsai 1754–1826

Kyōchūzan Mountains of the Heart

1816
Publishers: Izumodera Bunjirō, Kyoto, and others in Osaka and Edo.
1 vol. 266 × 184 mm. Colour-printed.
Literature: Brown, p. 121; Holloway, no. 4; Mitchell, pp. 383–4;
Ryerson, p. 421.

These landscapes are the epitome of *bunjinga*, 'paintings of the literati' with their superficial roughness disguising great sensitivity and poetry. The crayony texture of the prints on super-delicate paper is a technical triumph. The colophon with a date of 1809 in some copies is not considered authentic.

Illustrated in colour (p. 94): Chinese lakeside landscape.

124 Tani Buncho 1763–1840

Shazanrō Gahon A Book of Pictures by Shazanrō

1816
Publishers: Asakura Hachiemon, Edo, and three others in Kyoto, Osaka and Edo.
1 vol. 276 × 188 mm. Partly colour-printed.
Literature: Brown, p. 118; Mitchell, p. 470; *Ryerson*, p. 393.

Shazanrō was one of Buncho's art-names. For all his eclecticism Buncho was fundamentally a *Nanga* artist, and this fine book demonstrates his mastery of ink painting, which was his greatest strength.

Illustrated: Narcissi.

125 Aikawa Minwa d. 1821

Kōrin Gashiki Kōrin's Style of Painting

1818
Publishers: Kikuya Kihei and Kikuya Shichirōbei, Kyoto; Tsurugaya Kuhei, Osaka.
1 vol. 255 × 180 mm. Colour-printed.
Literature: Brown, pp. 60, 107; *Ryerson*, pp. 361–2.

In the first decade of the nineteenth century there was a revival of interest in Ogata Kōrin (1652–1716) and the *Rimpa* style that he had pioneered. Hōchū and Hōitsu, who led the revival of the movement, prepared books based on Kōrin's paintings – Hōchū's *Kōrin Gafu* (no. 130), 1802, and Hōitsu's *Kōrin Hyakuzu*, 1815 and 1826 – and Minwa's book seems to have met a popular demand.

Illustrated: The ox and his boy (a Zen classic story); after Kōrin.

126 Tsuji Hōzan *fl.* 1820–1840

Bitchū Meisho Kō The Sights of Bitchū Province

1822
Publisher: Gyokushōen (no place of publication given).
2 vols. 264 × 185 mm. Partly colour-printed.
Literature: Brown, pp. 93–4; Holloway, no. 58; Mitchell, p. 224;
Ryerson (variant title *Bitchū Meisho Zue*, 4 vols.), p. 388.

This is the most artistic of all *meishoki*.

Illustrated: Deer in the snow at Mount Iyataka; vol. 1.

127 Yashima Gakutei *c.* 1786–1868

Ichirō Gafu Ichirō's Picture-album

1823
Publisher: Gasendō, Edo.
1 vol. 227 × 158 mm. Colour-printed, with gauffrage.
Literature: Brown, pp. 190–1; *Ryerson*, p. 277.

Ichirō was one of Gakutei's art-names. The prints appeared first in a privately published *kyōka* book in two volumes entitled *Sansui Kikan Kyōka-shū*, 'Collected *kyōka* and Landscapes of Strange Sights', undated but *c.* 1820. This and nos. 128, 129 and 131 show the continuing vitality of the tradition of *kyōka* illustration in the woodblock book.

Illustrated: Night scene with bridge over a ravine.

128 Gakutei, Utagawa Kunisada 1786–1864 and a pupil of Kunisada

Uta no Tomobune A Friends' Boat of Verses

c. 1830
No publisher given, but Edo.
3 vols. 225 × 152 mm. Colour-printed.
Literature: Brown, pp. 158, 191.

This is a set of volumes privately printed for the Hommachi *kyōka* society of Edo. One volume is illustrated by each of the three artists, for the third of whom there is no signature. The landscapes of Gakutei are remarkable for their manneristic treatment and the subtle use of the colour-print medium, and this volume is much the finest. The *hashira* gives a stylised form of the character which is the *mon* of the poetry club commissioning the book.

Illustrated: Wood yards on the Sumida River at Edo; vol. 1.

129 Aoigaoka Hokkei 1780–1850

Sansai Hana Hyakushū Three Aspects of Flowers in a Collection of One Hundred Verses
Sansai Tsuki Hyakushū Three Aspects of the Moon in a Collection of One Hundred Verses
Sansai Yuki Hyakushū Three Aspects of Snow in a Collection of One Hundred Verses

1828–30
Publisher: Shunyatei, Edo.
3 vols. 225 × 160 mm. Colour-printed.
Literature: *Ryerson*, p. 274.

A set of three anthologies, based on the classical trilogy 'Snow, Moon and Flowers' (*setsugekka*), each with three colour prints. The *Sansai* of the title derives from Chinese philosophy and implies the separate principles of Heaven, Earth and Man. Thus, the three prints in each book obliquely relate to Heaven, Earth and Man: for example, in the 'Moon' volume Heaven is invoked by the moon in a pine-tree; Earth, by *chidori* flying over waves; and Man, by a figure in an autumn field.

Illustrated: Cherry blossom over a stream; from *Sansai Hana Hyakushū*.

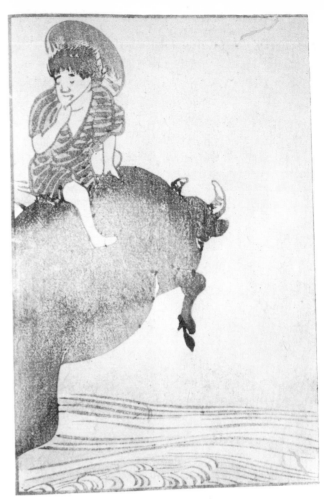

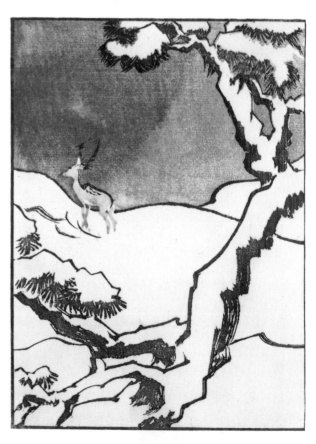

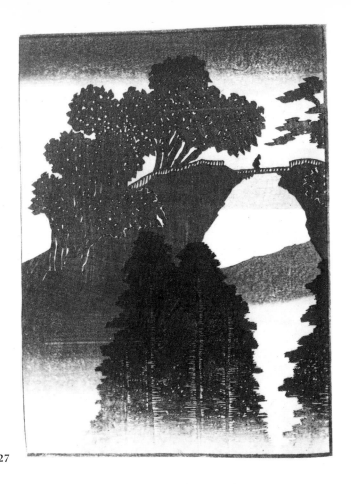

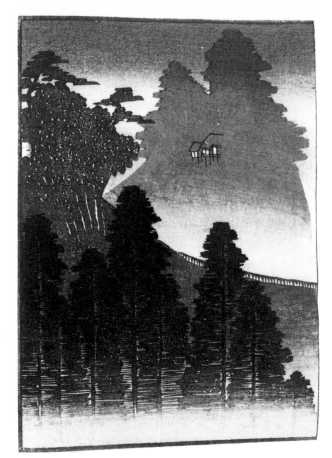

27

花咲庵 米守

さうゆうら
矢の
かっつ
百歩
と
ちらくく船の
ちく柳
もく

岳亭

曽根拓根

あらう
あみ毎も
りとよう
宇き草の
さゆる
根の
元
言も
なる己

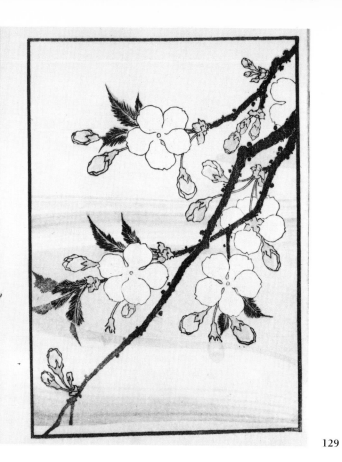

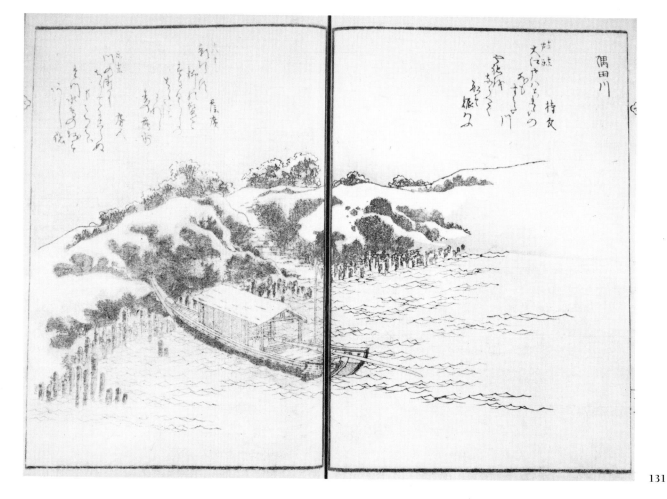

130 Nakamura Hōchū (*fl.* early 1800s)

Kōrin Gafu Kōrin's Picture-album

1826
Publisher: Izumiya Shōjirō, Edo.
2 folding albums. 273 × 192 mm. Colour-printed.
Literature: Sotheby sale catalogue, 7 July 1975, no. 200.

This is a new edition, from recut blocks, of the very rare first issue of 1802 but recaptures in large measure the exceptional quality of the original. Hōchū was one of the revivalists of *Rimpa* referred to under no. 125 and succeeded in re-creating in graphic form the spirit of the great Ogata Kōrin (1652–1716).

Illustrated in colour (p. 84): Nobleman with attendant crossing a bridge; vol. 1.

131 Yanagawa Shigenobu 1787–1832

Kyōka Meisho Zue Kyōka Illustrated with Fine Views

1826
The *saishū* was Yūzantei Chōshū.
1 vol. 228 × 161 mm. Colour-printed.
Literature: Brown, p. 192; *Javal* (II), no. 228.

Illustrated: Pleasure-boat laid up in snowy weather on the Sumida River in Edo.

132 Ōishi Matora 1794–1833

Sōga Kokufū Sketches of National Customs

1828
Publishers: Yoshinoya Nimbei, Kyoto; Tsuruya Kiemon, Edo; Kawachiya Kihei and Kawachiya Kichibei, Osaka.
2 vols. 281 × 199 mm. Printed in ink, pink and grey.
Literature: Brown, pp. 109–10; Holloway, no. 37; *Odin*, no. 179; Mitchell, p. 497; *Ryerson*, p. 391.

In *Odin* Vignier remarked on the 'Tirage d'une delicatesse remarquable'. Matora was one of the leading lights of the *Fukkō Yamatoe* (Revival *Yamatoe*) movement which sought to renew ancient styles of art.

Illustrated: Archery from horseback; vol. 1.

133 Ōnishi Chinnen 1792–1851

Azuma no Teburi Customs of the East

(Sub-title *Taihei Uzō* Scenes of the Great Peace)
1829
Publishers: Kobayashi Shimbei and Ōsakaya Gembei, Edo.
1 vol. 277 × 187 mm. Colour-printed.
Literature: Brown, p. 106; Holloway, no. 16; Mitchell, p. 214; *Ryerson*, p. 395.

The 'East' is the Eastern capital of Edo. The book is a racy account of Edo life and is also remarkable for its cover printed in mica.

Illustrated: Hauling ropes.

134 Chinnen

Sonan Gafu Sonan's Picture-album

1834
Publishers: Kobayashi Shimbei and Ōsakaya Gembei, Edo.
1 vol. 269 × 183 mm. Colour-printed.
Literature: Brown, p. 106; Holloway, no. 17; Hillier (2), pp. 320–5; *Ryerson*, p. 396.

One of the finest picture-books in the *Shijō* style, and Chinnen's masterpiece.

Illustrated in colour (p. 111): Persimmon bough.

135 Various artists

Kakusei Chō Album of the Crane's Cry

1828
Publisher: Kikunoya Hikobei, Osaka.
Folding album. 248 × 187 mm. Colour-printed.
Literature: Hillier (2), pp. 269, 277, 293, 299, 327 (the end-papers reproduce some of the cranes referred to below); Mitchell, p. 332.

The pictorial accompaniment to the verses in this book consists of four main designs, by the *Shijō* and *Nanga* artists Donshū, Nikka, Seiki and Gekkei Mototada (Oda Kaisen), and three sheets of cranes, each bird signed by a different artist and including such prominent names as Keibun, Toyohiko, Tōyō, Ōzui and Kihō.

Illustrated: Nikka. Riverside restaurants in Kyoto on a summer night.

136 Various artists

Aratama Chō Album of New Jewels

c. 1828
Publisher not given.
Folding album. 250 × 183 mm.
Literature: Brown, p. 106; *Ryerson*, p. 394; (both under the title *Shin-Gyoku-chō*).

A privately published *kyōka* album. The author of the preface, Utagaki Magao, died in 1829. The title refers to the New Year.

Illustrated: Nisshin. Sails in the mist.

泳鑓馬

笠懸

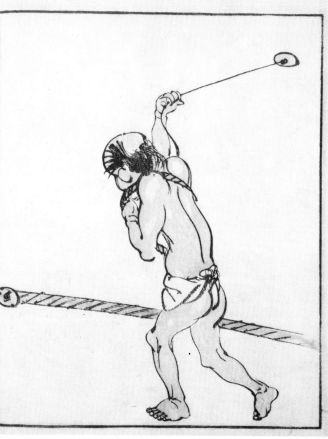

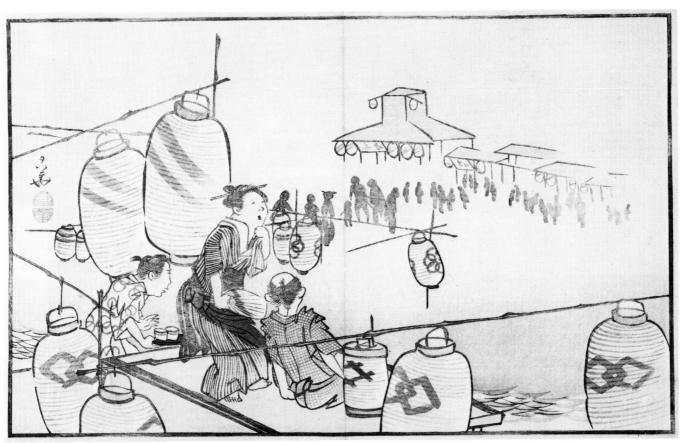

137

137 Masayoshi, Baitei, Kakei, Raian Genki and Keisai Eisen

Keisai Sōga Keisai Sketches

Dates of separate volumes uncertain; but vol. 5 1842
Publisher: Eirakuya Tōshirō, Nagoya.
4 vols. (of 5). 230 × 155 mm. Colour-printed.
Literature: Holloway, no. 3; Mitchell, p. 355; *Ryerson*, p. 215.

This is a revival of the *ryukuga-shiki*, the 'abbreviated style' of Masayoshi (see nos. 65–7), but the colour printing is of a different order, in that the different colours appear to have been applied to the block at the same time and only a single impression needed for the full-colour effect (in the West, a technique known as *à la poupée*). The gradations, and the chance suffusing of one colour with another, distinguish the technique from multi-block printing.

Keisai, one of Masayoshi's names, gave the title to the set, but there is some doubt about the publication date of the series, and he may not have been alive when the first volume was produced. It is doubtful whether Baitei is Ki Baitei (see no. 82). Nothing is known of Kakei and Genki.

Illustrated: Eisen. The Ryōgoku Bridge in Edo (top), the Asakusa Temple in Edo (bottom); vol. 5.

138 Andō Hiroshige 1797–1858

Kyōka Yamato Jimbutsu National Types in Comic Verse

c. 1850s
No publisher given, but probably Edo.
7 vols. 234 × 166 mm. Colour-printed.
Literature: Brown, p. 194, who gives the date as 1843–8.

The verses are on the theme of trades and professions and give Hiroshige opportunities for humorous figure drawings which are printed in light colours. The covers of the volumes are noteworthy for their decorations of dragon-flies in gold on blue.

Although this set of volumes is undated, dates of 1855 and 1857 are quoted in Japanese sources.

Illustrated: Geishas (left), an artist (right); vol. 1.

139 Hiroshige and Utagawa Yoshitora *fl. c.* 1850–1880

Kyōka Chaki Zaishū Collection of Tea Utensils and Materials in Comic Verses

1855
Publisher: Seiryūteizō ('owner of blocks'), Edo.
1 vol. 223 × 154 mm. Colour-printed.
Literature: Brown, p. 195 (as *Kyōka Chakisai Kashū*).

Appropriately, Hiroshige contributes three typically poetic landscapes of the Uji area, famed for its tea plantations. The remaining illustrations are portraits of the poets by Yoshitora.

Illustrated: The Uji River, near the town of Uji.

140 Kunisada and Hokkei

Yakusha Sanjū-rokkasen A Selection of Thirty-six Flowers of the Theatre

1835
Publishers: Nishimuraya Yohachi and Nakamuraya Katsugorō, Edo.
1 vol. 255 × 185 mm. Colour-printed.
Literature: Brown, p. 158 (as *Haiyū Sanjū-rokkasen*); *Ryerson*, p. 291.

The portraits of actors are by Kunisada. Hokkei provided three views, each of a famous landmark. The title is a pun on the 'Thirty-six Poets'.

Illustrated: The Kabuki actor Matsuemon.

141 Shibata Zeshin 1807–1891 and Kita Busei 1776–1856

Yume no Tadaji The Straight Path to Dreams

1839
No publisher given, but probably Edo.
1 vol. 213 × 159 mm. Colour-printed.
Literature: Mitchell, pp. 558–9.

A *kyōka* book with early work by Zeshin in true *Shijō* style. Busei was a pupil of Tani Bunchō (see no. 124).

Illustrated: Zeshin. Gourds twining round a broken bamboo fence.

142 Tanaka Nikka d. 1845

Kyūhōdō Gafu Kyūhōdō's Picture-album

1856
Publisher: Ikkyūsai (i.e. Kyūka), probably Kyoto.
2 folding albums. 300 × 196 mm. Colour-printed.
Literature: Brown, p. 95; Holloway, no. 43; Mitchell, pp. 401–2; *de Roos*, no. 262.

This posthumously issued work of Nikka, prepared and published by his pupil Kyūka, is one of the most handsome of later *Shijō gafu*.

Illustrated: Fish and weeds; vol. 1.

143 Various artists

Tama Hiroi A Gathering of Jewels

1861
Publisher: Ōmiya Matashichi, Kyoto.
2 vols. 258 × 170 mm. Colour-printed.
Literature: Brown, p. 127; Hillier (2), pp. 269, 278, 351, 355; *Ryerson*, p. 375.

One of the last comprehensive anthologies to embrace the designs of a large number of the artists currently working in the *Shijō* style. A great feature is the adroit *mise-en-page* of picture and calligraphy. Mitchell deals fully with the two different editions of the book, pp. 512–14.

Illustrated: Sōseki. Mitsugamine; vol. 1.

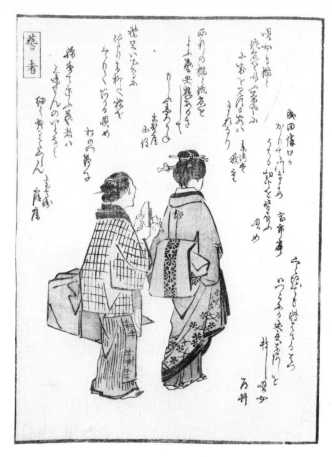
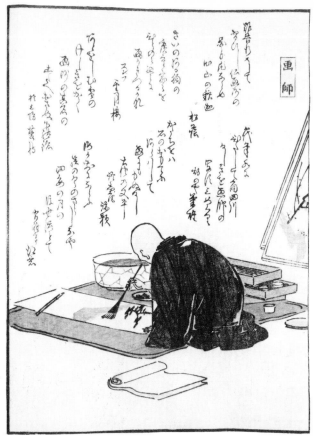

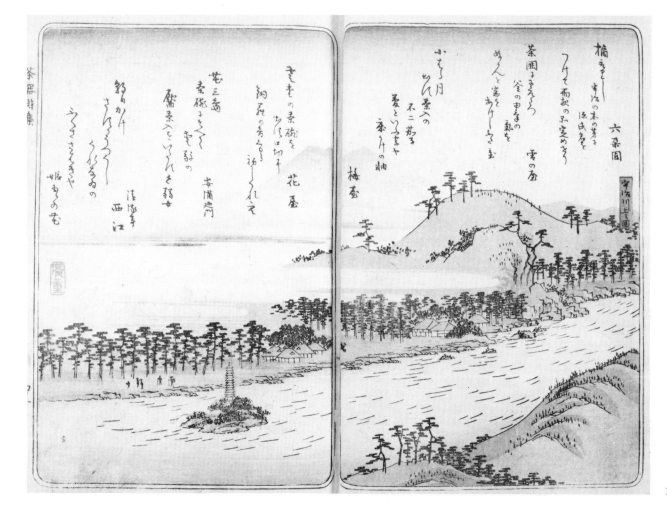

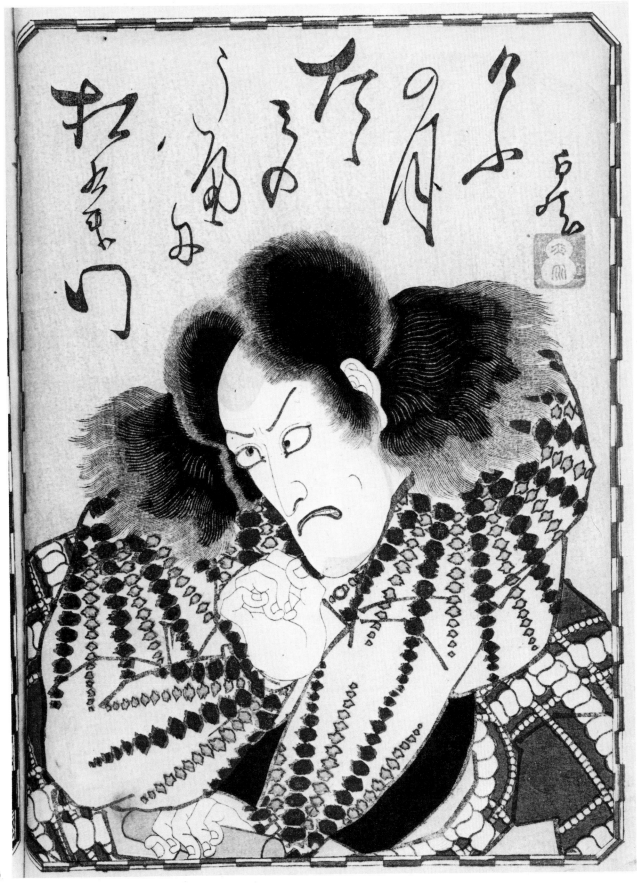

140

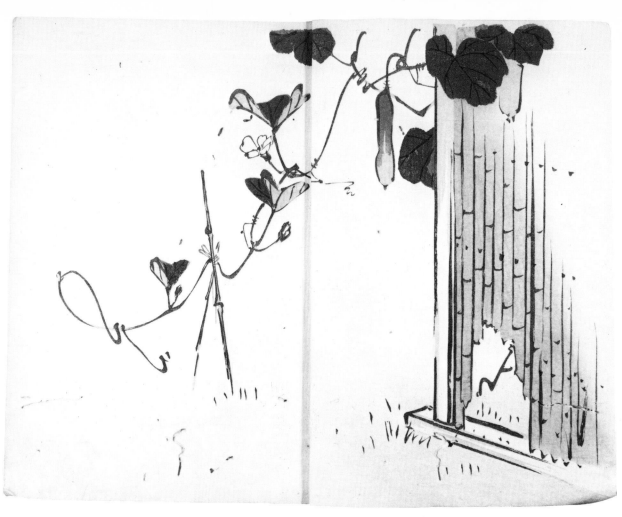

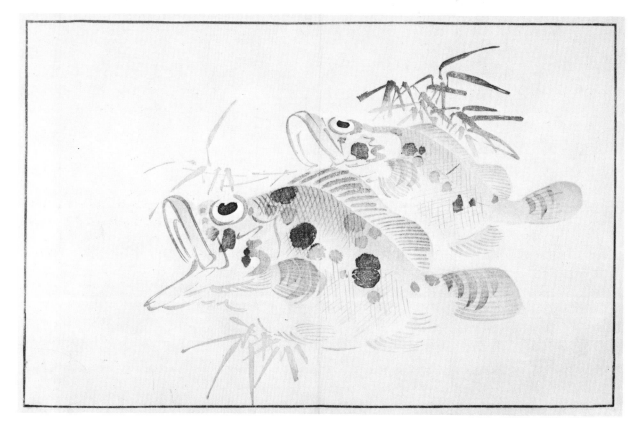

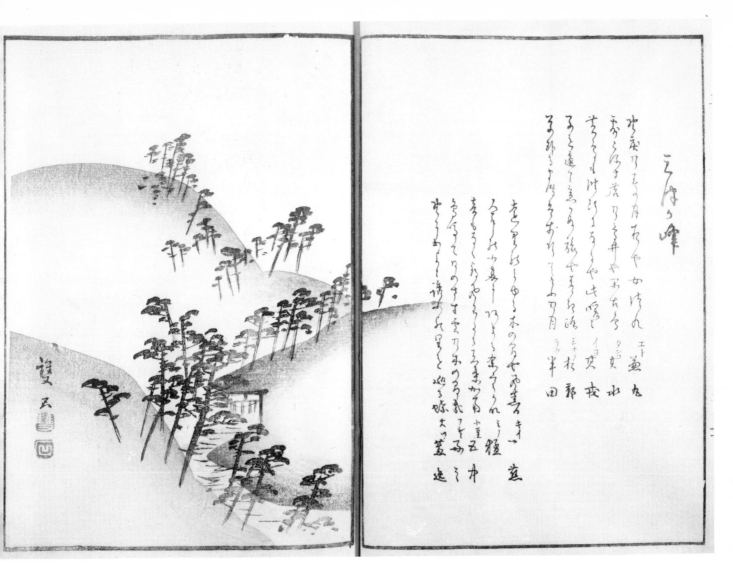

144 Gountei Sadahide 1807–1873

Yokohama Kaikō Kembun Shi An Account of the Opening of the Port of Yokohama

1862
No publisher given, but Edo.
3 vols. 245 × 177 mm.
Literature: Brown, pp. 196, 216; Ryerson, p. 442.

In this book Sadahide illustrates the establishment of the Western presence in Japan, and also gives pictures, imaginary or based on Western originals, of the Western world. Sadahide is unquestionably the most gifted of the numerous Japanese artists who reported pictorially this crucial period in the country's history. Their work in sheet-print form is known as *Yokohamae* (pictures of, not produced in, Yokohama).

Illustrated: 'Black women'; vol. 3.

145 Kawanabe Gyōsai 1831–1889 and others

Tsūzoku Isopu Monogatari A Popular Version of *Aesop's Fables*

1875
Publisher and translator: Watanabe Nukumi, Tokyo.
6 vols. 224 × 152 mm.

Aesop had appeared before in Japanese translations, the earliest as far back as 1593. The interest of this particular edition lies in Gyōsai's illustrations which are based very closely on the designs made by John Tenniel for an *Aesop's Fables* published in London in 1848, but which succeed in being very much more than simply pastiche.

Illustrated: 'The Travellers and the Monkeys'; vol. 6.

うらんみうをんな
黒人婦人之圖

144

146 Gyōsai

Kyōsai Gafu Kyōsai's Picture-album

1880
Publisher: Kinkadō, Tokyo.
1 vol. 228 × 160 mm.
Literature: Brown, p. 196; *Ryerson*, p. 309.

Kyōsai, confusingly, was an art-name of Gyōsai, and he is often known by it.

Illustrated: Long-nosed acrobats.

147 Gyōsai

Gyōsai Gadan Gyōsai's Account of Painting

1887
Publisher: Iwamoto Shun, Tokyo.
2 parts (in 4 vols.). 255 × 175 mm. Partly colour-printed.
Literature: Brown, p. 196; *Ryerson*, p. 310.

Part I gives Gyōsai's thoughts on painting; part II, a life of the artist by his pupil Baitei Gasō. One of the novelties of the book is the introduction of a synopsis in English (of a kind) of the Japanese text. The artist's ability to reproduce any Japanese style is remarkable and alarming.

Illustrated: Page of sketches from paintings by Rosetsu (1759–99); part 2.

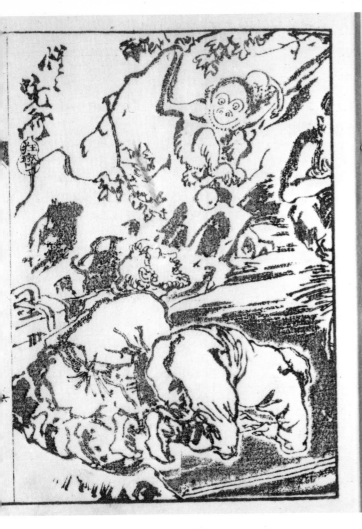

145

148 Watanabe Seitei 1851–1918

Seitei Kachō Gafu A Book of Pictures of Flowers and Birds
by Seitei

1890–1
Publisher: Ogura Shoten, Tokyo.
3 vols. 249 × 167 mm. Colour-printed.
Literature: Brown, p. 202; Mitchell, p. 466; *Ryerson*, p. 427; (the artist's
name is sometimes read as 'Shotei').

Illustrated in colour (p. 111): Bird on persimmon bough; vol. 2.

149 After Watanabe Kazan 1793–1841

Kamigata Fūzoku Seso Hyakutai One Hundred Forms of
Everyday Life in the Kamigata

c. 1900
No publisher given.
1 vol. 255 × 182 mm. Colour-printed.

There is, at this late date, a facsimile quality in the colour printing
which is a new development. It stems from a high technical
virtuosity, which compares unfavourably with earlier 'in-
terpretation' that translated original brush drawings into works
of art in a different medium. In the *Kamigata Fūzoku* we are
astonished by the illusionist simulation of water-colours; in
Suiseki Gafu or *Kishi Empu* we value the woodblock colour prints
as graphic works in their own right.

Illustrated: 'Hawking', 'Blow-gun', 'Fishing' and 'Ropemaker'.

150 Kōshirō Onchi 1891–1955

Shinshō Fuji Fresh Praise of Fuji

1946
Publisher: Fugaku Honsha, Tokyo.
1 vol. 289 × 201 mm.

An anthology with two prints by the foremost master of modern
Sōsaku hanga, 'creative' woodcuts. It has the traditional make-up
of 'verse and colour print' like so many of the finest Japanese
illustrated and decorated books of the eighteenth and nineteenth
centuries.

Illustrated in colour (p. 112): Mount Fuji.

鷹逗

呼矢

魚釣

網丁

長澤蘆雪ノ筆意

寛政五年印本
東韮記所載畫

147

141

Concordance

Glossary

biwa A stringed instrument resembling a lute.

bunjinga 'Scholar painting' – painting done in Japan in imitation of the works of the Chinese amateur scholar artists.

chidori A bird like a plover often shown with waves as a decorative motif.

chō Folding album.

ehon Picture-book in the stitched binding format.

fukibotan, fukie A method of blowing pigments through a pipe on to a stencil to produce a stippled effect.

Fukkō Yamatoe A self-conscious revival of the ancient *Yamatoe* (q.v.) style which took place in the early nineteenth century.

fukuro-tōji 'Bag binding' – book format in which each sheet was folded in half, the folded edge placed on the outside, and the unfolded edges sewn at the centre.

fusuma Painted sliding doors made of paper over a wooden lattice frame.

gafu 'Picture-album' or 'sketchbook'. A word used of both books and albums which illustrate the artistic style of a painter.

gajō Picture-album, of either paintings or prints, in folding format.

geisha A female entertainer trained in music, dance and conversation.

gō An adopted art-name, for example, Utamaro.

haiga A combination of a *haiku* (q.v.) poem with an appropriate abbreviated sketch; usually both are produced by the same man.

haiku A pithy, seventeen-syllable verse form developed in the seventeenth century. Every *haiku* is related to the season of the year.

hakubyōga 'White painting' – a style developed in the Middle Ages using only lustrous black ink as a pigment on white paper.

hashira Literally 'pillar' – the column at the 'turnover' or outer edge of each folded sheet in an *ehon* (q.v.), often containing title, volume and sheet number.

hiragana The more cursive form of the phonetic syllabary used as a supplement to the Chinese characters for writing Japanese.

hon A book in the standard stitched format.

hō-ō A mythical bird similar to the phoenix, much used as a decorative motif.

hototogisu A bird associated with spring.

Hyakunin Isshu A classical collection of 100 poems by 100 different poets, often illustrated with portraits of the poets.

iroha An accepted order of the Japanese syllabary based on the syllables of a poem beginning 'Iroha'.

ishizuri 'Stone-printing' – imitations of ink stone-rubbings done by various techniques.

kai-awase The Shell Game – a game played by matching up pairs of shells painted inside with a matching painting and poem.

Kamigata Western Japan – the Kyoto and Osaka area as opposed to Edo.

Kanō The dominant official school of painting from the late fifteenth century to the mid-nineteenth century. Its methods were based on fifteenth-century Chinese ink painting.

Kansai Western Japan as opposed to the Edo area.

kappazuri Stencil-printing – sometimes used for illustrated books, especially in the Osaka area during the eighteenth century.

kentō Simple device for registering colour prints, consisting of an angle cut in one corner of a woodblock and a short ridge along an adjacent side.

kimono The basic female garment, made up of squares and rectangles of material stitched together.

Kishi The school of painting founded by Kishi Ganku (1756–1838) characterised by chunky line, rather square figures and an individual use of colour washes.

koto A long, horizontal stringed instrument laid on the ground and plucked by a kneeling player.

kōzō Japanese mulberry used for paper.

kurobon 'Black books' – cheap editions, mostly of novels, with black covers.

kusazōshi Early form of printed fiction with simple illustrations, which began in the seventeenth century.

kyōgen Comic plays used as interludes between performances of *Nō* plays.

kyōka Very short humorous verses much composed by amateurs. Books of *kyōka* were often issued at the New Year.

manga '10,000 pictures' – the word used for miscellaneous sketches in book form and in modern Japanese for strip cartoons.

meishoki Books on local geography, history and customs for travellers.

Miyako 'The Capital' – a word used for Kyoto in the Edo period.

mon A badge or symbol of a family, an individual or of a business.

mushae Pictures of warriors.

Nanga 'Southern painting' – a general term for Chinese art styles, and in particular for those of the scholar painters.

Narae 'Nara pictures' – popular paintings in the *Yamatoe* (q.v.) tradition, often produced for MS books.

nishikie 'Brocade pictures' – the name given to the multi-block sheet prints produced in 1764 and after.

Nō Classic dramatic form combining words, music and stately dance.

nyohitsu 'Women's calligraphy' – cursive writing of characters or syllabary thought suitable for ladies.

obi Sash worn with *kimono* (q.v.).

origami Models made of folded paper.

ramma Transoms – the panels above sliding doors, often of pierced wood.

Rimpa School of stylised decorative painting founded by Sōtatsu in the early seventeenth century and taken up by Kōrin (1652–1716).

ryakuga(-shiki) 'Abbreviated painting style' – a form of pictorial shorthand devised by Keisai Masayoshi.

saishū The promoter or organiser of a private publication.

sambasō A form of popular street-dance.

setsugekka 'Snow, moon and flowers' – a classic series of subjects for pictures, sometimes used to number books one, two, three.

Shijō/Maruyama School of painting founded by Ōkyo and Goshun in the late eighteenth century, basing its methods on observation of nature.

Sōsaku hanga Twentieth-century movement of print artists who cut their own blocks.

sumi Black ink used for calligraphy, painting and printing.

sumō Popular form of wrestling.

surimono Literally 'printed thing' – a word for high-quality printed greetings-cards and stationery on thick paper.

takuhon A book of ink-rubbings.

tan A reddish pigment used in the hand-colouring of black and white prints.

torinoko A very thick high-quality paper.

Tosa A school of painters in the *Yamatoe* (q.v.) style who became official artists to the court.

tsuiate A free-standing screen, often painted.

uguisu A bird resembling the nightingale.

Ukiyoe 'Pictures of the Floating World' – a school of art devoted to the life and entertainments of the great cities.

ukiyo-zōshi Seventeenth-century fiction devoted to the affairs of townsmen.

wakushū A young man before coming of age, often with connotations of effeminacy.

yakusha hyōbanki An account of Kabuki actors and their strong points.

Yamatoe 'Japanese pictures' – the basic native style of painting based on outline, colour and certain strong pictorial conventions, regarded as different from Chinese painting.

Yokohamae 'Yokohama pictures' – prints of the activities of Westerners based in Yokohama after its opening in 1859

Index of artists

Index of albums and books